ANTHROPOLOGY AND ART PRACTICE

ANTHROPOLOGY AND ART PRACTICE

Edited by Arnd Schneider and Christopher Wright

B L O O M S B U R Y

LONDON • NEW DELHI • NEW YORK • SYDNEY

Bloomsbury Academic
An imprint of Bloomsbury Publishing Plc

50 Bedford Square	1385 Broadway
London	New York
WC1B 3DP	NY 10018
UK	USA

www.bloomsbury.com

Bloomsbury is a trade mark of Bloomsbury Publishing Plc

First published 2013

"Interview #5" was first published in *Yvette Brackman–Systems and Scenarios* by JRP|Ringier, Zurich 2012.
English edition ISBN: 978-3-03764-280-1

British Library Cataloguing-in-Publication Data
A catalogue record for this book is available from the British Library.

ISBN: HB: 978-0-8578-5179-6
PB: 978-0-8578-5180-2
ePDF: 978-0-8578-5223-6
ePub: 978-0-8578-5224-3

Library of Congress Cataloging-in-Publication Data

Anthropology and art practice / [edited by] Arnd Schneider, Christopher Wright.
pages cm.
Includes bibliographical references and index.
ISBN 978-0-85785-180-2 (pbk.) — ISBN 978-0-85785-179-6 (hardback) —
ISBN 978-0-85785-223-6 (epdf) 1. Art and anthropology. I. Schneider, Arnd, 1960–
II. Wright, Christopher.
N72.A56A64 2013
306.4'7—dc23 2013026896

A catalog record for this book is available from the Library of Congress.

Typeset by Apex CoVantage, LLC, Madison, WI, USA

CONTENTS

LIST OF ILLUSTRATIONS

Table

Plates

ACKNOWLEDGEMENTS

We would like to thank all our contributors, and we were really impressed by the innovative ways in which they took up the creative challenges of this volume. We also thank contributors for their trust and patience while working with us on this project, especially those who took part in recorded conversations. We also thank the anonymous reviewers for their helpful and constructive suggestions. Particular thanks go to Anna Wright, Louise Butler, and Sophie Hodgson, our editors at Bloomsbury, for seeing this book through to final publication. We also thank Torill Sørsandmo for compiling the index.

We are extremely grateful to all the institutions and individuals who have helped us with our research and made visual and written materials available to us, often waiving or reducing fees for copyright permission. In particular, we thank Søren Arke (Copenhagen) for having made available to us the truly remarkable *Pia Arke's Camera Obscura (1990) at Nuugaarsuk Point, Narsaq, 1990* of the late Pia Arke featured on the cover and Tone Olaf Nielsen and Frederikke Hansen (Kuratorisk Aktion, Copenhagen) for image materials and facilitating contact with Søren. We are also grateful to Yvette Brackmann and JRP Ringier publishers, Zurich, for generously allowing us to reprint her interview with Helene Lundbye Petersen.

We would also like to thank colleagues, hosts, and audiences at the following institutions and venues to whom we have presented our ideas over the last two years: Anthropology Department, Goldsmiths, University of London; Oslo National Academy of Arts (Therese Veier), Museum of Cultural History/Ethnographic Section, Oslo (Øyvind Fuglerud), University of Cologne (Kerstin Schankweiler, Stefanie Stallschuss), Academy of Media Arts Cologne (Karin Harrasser), Free University Berlin (Florian Walter), Musée du quai Branly, Paris (Anne-Christine Taylor), CNRS/LAIOS Paris (Caterina Pasqualino), University of Utrecht (Birgit Meyer), Maruška Svašek (Queens University Belfast), Ibero American Institute Berlin (Barbara Göbel), Photographers' Gallery, London (Johanna Empson), University of Applied Arts, Vienna (Christina Lammer), Duncan of Jordanstone College of Art and Design, University of Dundee (Tracy Mackenna and Edwin Janssen), panel conveners at the AAA, San Francisco (Thet Shein Win, Zhanara Nauruzbayeva), the organizer of The Art of Making the Difference conference, Turin (Anna Maria Pecci).

A Note on Illustrations and Copyrighted Material

Every reasonable effort has been made to trace and acknowledge the ownership of copyrighted material (including illustrations) included in this book. Any errors that may have occurred are inadvertent and will be corrected in subsequent editions, provided notification is sent to the editors.

CONTRIBUTORS

Yvette Brackman is a US artist who lives in Denmark. From 2000 to 2007 Brackman held a professorship at The Royal Danish Academy of Fine Arts in Copenhagen where she also chaired the department of walls and space. She recently published her monograph *Systems and Scenarios* (JRP-Ringier, 2012). www.yvettebrackman. info.

Brad Butler and Karen Mirza are UK-based artists and filmmakers who have worked together since 1998. Their practice is centered upon collaboration, dialogue, and the social, and their early works emerged from their interest in seminal avant-garde film. In 2004, they formed no.w.here, an artist-run organization that combines film production and critical dialogue on contemporary image-making. Mirza and Butler's work was recently presented at the Serpentine Gallery (London), Witte de With (Rotterdam), and Kunstverein Medienturm (Graz). A solo exhibition of their work will take place at the Walker Art Center in Minneapolis in 2013. www. mirza-butler.net.

Craig Campbell is an assistant professor of anthropology and cultural forms at the University of Texas, Austin. He is also a founding member of the Ethnographic Terminalia collective and has been studying indigenous Siberian peoples since the late 1990s; his concern is to focus on ethnographic and documentary photographic images.

Angus Carlyle is a researcher at CRiSAP at the University of the Arts, London. He edited the book *Autumn Leaves* for Double Entendre (2007), made the sound work "51° 32' 6.954" N / 0° 00' 47.0808" W" for the *Sound Proof* group show (2008), co-curated the exhibition *Sound Escapes* at Space Gallery in London (2009), and produced the CD "Some Memories of Bamboo" (2009) for the label Gruenrekorder.

Rupert Cox is an anthropologist and lecturer at the University of Manchester who works in Japan carrying out research into questions of sensory knowledge and using art practices as a form of research. His current work is on the anthropology of sound, investigating questions about the politics of noise from the perspectives of acoustic science, sound studies, and sound art. His most recent project, Air Pressure (2010—), about the effects of aircraft noise on human health and habitus, supported by the Wellcome Trust, resulted in a gallery-hosted sound installation, sound-films and CD (Gruenrekorder) as well as academic articles.

Jennifer Deger is an Australian Research Council Future Fellow at the Australian National University currently undertaking a four-year research project, Digital Relations: New Media in Arnhem Land. Deger has published widely on visual culture, Aboriginal aesthetics, and indigenous media including her book, *Shimmering Screens: Making Media in an Aboriginal Community* (University of Minnesota Press, 2006). Deger curated the exhibition Interventions: Experiments between Art and Ethnography at the Macquarie University Art Gallery in 2009; as a member of Miyarrka Media she cocurated the exhibition Christmas Birrimibirr at the Chan Contemporary Art Space in Darwin 2011; and she codirected and produced the film *Manapanmirr, in Christmas Spirit* (2012).

Kate Hennessy is an assistant professor specializing in media at Simon Fraser University's School of Interactive Arts and Technology (SIAT). As the director of the Making Culture Lab at SIAT, her research explores the role of new media in the documentation and safeguarding of cultural heritage and the representation of anthropological knowledge in new forms. Her video and multimedia works investigate documentary methodologies to address indigenous and settler histories of place and space. She is a founding member of the Ethnographic Terminalia Curatorial Collective. Her doctorate is from the University of British Columbia's department of anthropology, where she was a Trudeau Scholar.

Ruth Jones is an artist and curator based in west Wales. Jones has exhibited widely in the United Kingdom and internationally in Ireland, Poland, the United States, Spain, and Canada. In 2006 she was awarded an AHRC Fellowship in Creative and Performing Arts at the University of West England, Bristol, exploring the relationships between ritual, place, and community in lens-based and public art. Recent projects include sleepers (2006), film and public art project, Cardigan; and *Vigil* (2009). www.ruthjonesart.co.uk.

Christina Lammer is a research sociologist, collaborative multimedia artist, and lecturer based in Vienna. Her work combines sensory ethnography with video, performance, and body art in hospitals and clinics to focus on embodied emotion and sensory interaction between patients and physicians during the course of medical treatment. Her most recent books include *CORPOrealities* (Löcker Verlag, 2010) and *EMPATHOGRAPHY* (Löcker Verlag, 2012). Lammer holds a PhD in sociology from the University of Vienna. www.corporealities.org.

Anthony Luvera is an Australian artist, writer, and educator based in London. His book *Residency* was published by Belfast Exposed in 2011. www.luvera.com.

Thera Mjaaland was educated as an art photographer from Bournemouth and Poole College of Art, UK (1977–80). In 1996 she was called to teach photography at Bergen Academy of Art and Design, where she held a position as dean for the department of specialized arts (1998–2000). When pursuing her Cand. Polit. degree in social anthropology (2004), and likewise, based on anthropological fieldwork for

her PhD in gender and development (awarded 2013), the exploratory aspects of art practice and the evocative aspects of photographic representation have been integral to Mjaaland's approach to academic work. www.thera.no.

Juan Orrantia is postdoctoral fellow, Wits School of Arts, University of the Witwatersrand, South Africa (through December 2012). Orrantia works in the documentary arts, using photography and sometimes narrative text, old footage, and sound. Awards include the Tierney Fellowship in Photography as well as various grants and residencies at research institutes. He has exhibited in Colombia, South Africa, Italy, and the United States. www.orrantiajuan.wordpress.com.

Raul Ortega Ayala is a Mexican/British artist currently living and working in Mexico. Ortega Ayala studied painting in Mexico and has a master in fine arts from the Glasgow School of Art. His work is strongly linked with anthropology and is produced using some of its methodologies over extended periods of time. He has explored contexts such as the office world, food, and gardening, resulting in three different series: Bureaucratic Sonata, An Ethnography on Gardening, and Food for Thought. The artist is represented by Rokeby Gallery in London, and he is a council member and teacher at SOMA. www.raulortegaayala.com.

Caterina Pasqualino is an anthropologist, documentary filmmaker, and research fellow at CNRS (Bronze medal, 2000) and IIAC (LAIOS) and also teaches the anthropology of performance at EHESS, Paris. She first conducted research in Sicily (*Milena. Un paese siciliano vent'anni dopo*, Edizioni Scientifiche italiane, 1990), then on Andalusian flamenco, a musical genre usually perceived in folkloric terms, from a purely anthropological perspective (*Dire le Chant. Les Gitans flamencos d'Andalousie*, EHESS-CNRS, 1998) and created the film *Bastian et Lorie, Notes sur le flamenco gitan* (CNRS, 2009). She is currently researching the Palo Monte possession rituals in Cuba.

Kathryn Ramey is a filmmaker and anthropologist whose work draws on the experimental processes of both disciplines. She has exhibited her work internationally and currently teaches as an associate professor in the department of visual and media arts at Emerson College in Boston. Her essays have been published in the journals *Visual Anthropology Review* and *JumpCut*, as well as in the anthologies *Made to Be Seen: A History of Visual Anthropology* and *Women's Experimental Cinema: Critical Frameworks*. www.rameyfilms.com.

Arnd Schneider (editor) is professor of social anthropology at the University of Oslo. He writes on contemporary art and anthropology, migration, and film. His main publications include *Futures Lost* (Peter Lang, 2000) and *Appropriation as Practice: Art and Identity in Argentina* (Palgrave, 2006). He co-edited (with Chris Wright) *Contemporary Art and Anthropology* (Berg, 2006) and *Between Art and Anthropology* (Berg, 2010). He was a co-organizer of the international conference Fieldworks: Dialogues between Art and Anthropology (Tate Modern, 2003).

Experimental Film and Anthropology (co-edited with Caterina Pasqualino) will be published by Bloomsbury in 2014.

Laurent Van Lancker is a Brussels-based artist and lecturer in documentary and video art at INSAS and IAD (two Belgian national film schools), in visual anthropology at the Freie Universität Berlin, and is coach for the SoundImageCulture workspace. He both studied filmmaking (IAD) and anthropology (MA, MPhil, SOAS, London) and obtained a PhD in art at the University of Ghent. His most well-known work is the long-feature documentary *Surya*, which has won international awards (Golden Deer and Audience Award at Rodos Film and Visual Arts festival and the SCAM prize) and was shown worldwide in many major festivals. Laurent Van Lancker is one of the founders of Polymorfilms. www.polymorfilms.be.

Robert Willim is a cultural analyst and artist and associate professor of European ethnology, department of arts and cultural sciences, Lund University, Sweden. Willim's research has primarily dealt with themes such as digital and material culture as well as cultural economy. Willim has published a number of books and articles. His artworks are positioned close to his practices as a cultural analyst and ethnographer. www.robertwillim.com/.

Chris Wright (editor) is a lecturer in visual anthropology in the Anthropology Department at Goldsmiths, University of London. He has previously carried out research on photography and material culture in the Solomon Islands. He co-edited (with Arnd Schneider) *Contemporary Art and Anthropology* (Berg, 2006) and *Between Art and Anthropology* (Berg, 2010). He was a co-organizer of the international conference Fieldworks: Dialogues between Art and Anthropology (Tate Modern, 2003), and his book *The Echo of Things: The Social Lives of Photographs in the Solomon Islands* will be published by Duke University Press in 2013.

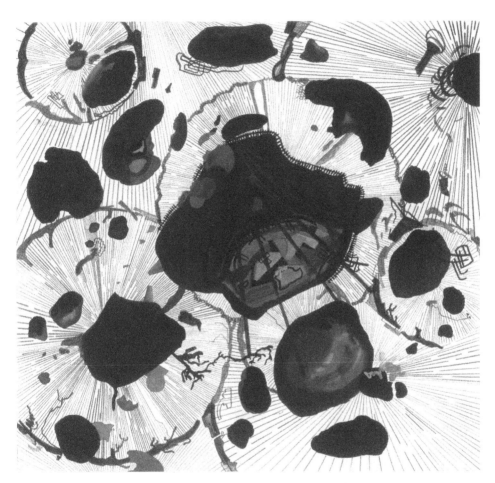

Plate 1 Franz Ackermann, *untitled (mental map: values of the west) (faceland III)*, 2003. Mixed media on paper, 28 x 29.6 cm. Private collection, France. Photo courtesy of the artist and neugerriemschneider, Berlin.

Plate 2 Fredi Casco, *Ghost Chaco*, 2007. C Print. Courtesy of the artist.

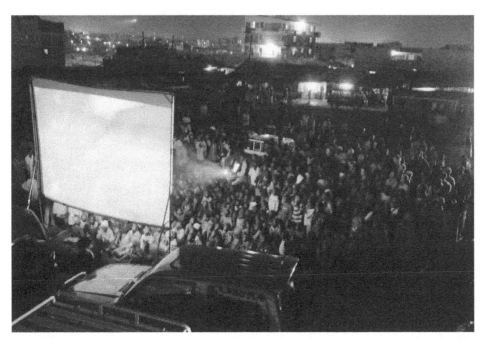

Plate 3 Slum-tv screening in Mathare, Nairobi.

Plate 4 The Full Dollar Collection of Contemporary Art (2012). Artwork by Shizu Saldamando as rendered by Kimberley Edwards, "The Window Goddess," at the storefront of local business Mi Vida. Courtesy of Outpost; © Armory, Full Dollar.

Plate 5 Aernaut Mik, *Training Ground*, 2006. Two-channel video installation. Courtesy of Carlier I Gebauer. Production photograph: Florian Braun.

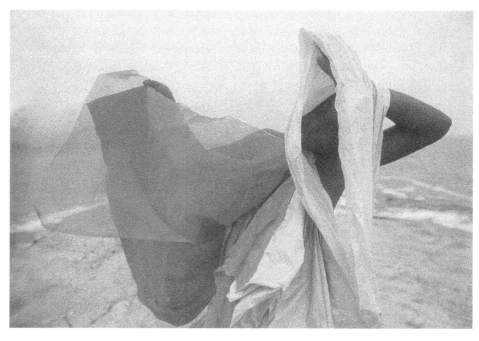

Plate 6 Hélio Oiticica, *Parangolé P4 Cape 1*, 1964. Photo: Sergio Zalis. Courtesy of Projeto Hélio Oiticica.

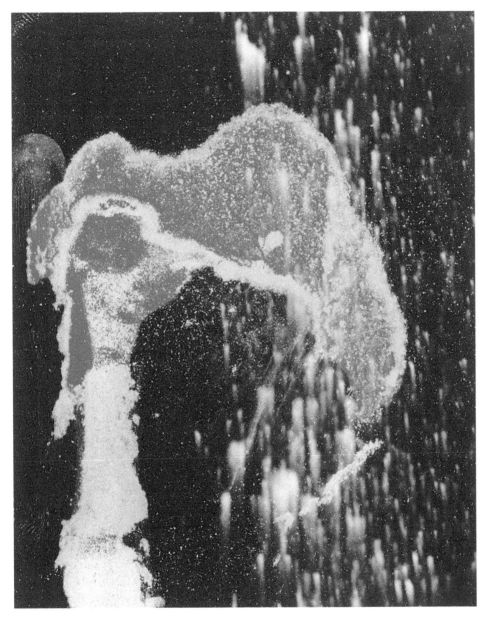

Plate 7 Kate Robertson, *Dust landscape #6*, 2012. Pigment print, 120 cm × 96 cm. Courtesy of the artist.

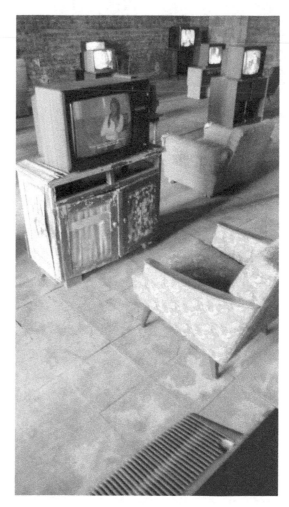

Plate 8 Kutlug Ataman, *Küba*. Multi-screen video installation.

1

WAYS OF WORKING

Arnd Schneider and Christopher Wright

In this volume, we want to emphasize the importance of "the way we work"[1] for the practices of both anthropologists and artists. Ways of working are central to the sorts of creativity employed within projects, the kinds of collaborations involved, and the production of outcomes whether those are artworks or anthropological representations of one kind or another. Partly, this signals a desire to explore and critically engage anthropologically with the practices of contemporary artists, but it also means approaching creativity and meaning as something often emergent, rather than prefigured or planned. Theory is now in the way of making, rather than outside it. This is a key area that suggests strong affinities between the work of anthropologists and that of many contemporary artists. Collaborations of various kinds are key to many of the encounters between art and anthropology that we present in this volume, and the kinds of productive dialogues we are concerned with are exemplified by contributors, such as Rupert Cox (anthropologist) and Angus Carlyle (sound artist), who produce co-authored works. But this is not just a dialogue between art and anthropology as disciplines, but concerns artists whose work—the material that is produced—consists of various kinds of dialogue and collaboration. This has always been the case for anthropologists with their long-term involvement with fieldwork. Whether left relatively open or staged within more controlled parameters, artists are increasingly using various kinds of social encounters as "the work."

Pia Arke (1958–2005) was an artist of mixed Danish and Greenlandic origins whose work has only recently started to achieve the international recognition it deserves. The image of Arke's massive pinhole camera at Nuugaarsuk in South Greenland in 1990 that is on the front cover of this volume and the black-and-white photographs that were taken with it (Figures 1.1 and 1.2) are both part of her long-term project to explore the notions of belonging through her own ethnic position, what she referred to as her "mongrel" status.[2] Arke built the camera on such a large scale so that she could physically get inside the camera and remain there when the photograph was being exposed—a way of literally and figuratively including herself in

the landscape in a corporeal way. This work forms a counterpoint to *Arctic Hysteria*, a video work she made in 1996, in which she struggles naked with a large map of Greenland, stroking it and touching it but in the process also gradually tearing it to pieces.[3] Throughout her work, Arke struggled with trying to find a space in-between her Danish and Greenlandic identities and questioned not just the anthropological representations of Greenlandic peoples under colonialism but also the automatic anthropological connection of place, landscape, and people—ideas of homeland—and its effective romanticization in terms of arctic peoples. She used some of her large landscape photographs (such as Figures 1.1 and 1.2) as the backdrops for later portraits of modern urban Greenlanders—including her own cousin. In these, it is uncertain whether people merge into the landscape or are divorced from it. In her exploration of the histories of people from the settlement of Scorebysund/Ittoqqor-toormiit,[4] Arke treats Greenlandic and Danish inhabitants in the same way, recording oral histories in relation to old photographs. But she also records the points at which there is no information or where people are unwilling to provide information. The result of long-term interactions with people in Greenland, Arke's work consistently sought to understand the complex trajectories of Greenlandic people in a world where the impact of the Internet might be as significant as that of earlier ways of hunting.

Arke's work is a powerful example of denarrating (in the sense used by curator and art critic Gerardo Mosquera[5]) the entangled colonial history of her birthplace, Scorebysund (in Danish)/Ittoqqortoormiit (in Inuit) on the east coast of Greenland.

Arke made a series of artistic investigations into thousands of family albums and colonists' and scientific explorers' photos of this remote place, to which an Inuit community (among them Arke's maternal relatives, her father was Danish) was forced to settle in 1925, 1,000 kilometers north from their homeland, together with Danish colonists, in order to claim this part of Greenland (in effect all of Greenland) for Denmark.[6] Much of the archival material was found by Arke in the colonial center, Copenhagen, and in painstaking work she identified Inuit individuals and spoke to descendants. The results, including her rephotographing of archival photos, were shown in exhibitions and published in a book, with critical chapters on cartography by Stefan Jonsson. In Arke's polemical text "Ethno-Aesthetics,"[7] she challenged the prevalent, well-meaning views of art historians on certain timeless qualities in Inuit art and, instead, situated the subject in its colonial and postcolonial context.

Arke is only one example of many contemporary artists whose work addresses anthropological themes, and as editors we have made a subjective choice of practitioners who for us represent particularly challenging and productive engagements with the shifting area between contemporary art and anthropology. A large and heterogeneous body of work is now being produced at this crossroads, but new work is sometimes presented simply as an assemblage by practitioners from different disciplinary backgrounds without really exploring in any depth what can be gained from such a juxtaposition. Richard Baxstrom and Todd Meyer's 2008 book *Anthropologies* included textual and visual interventions from anthropologists, medical anthropologists, philosophers, and filmmakers through essays, images, and

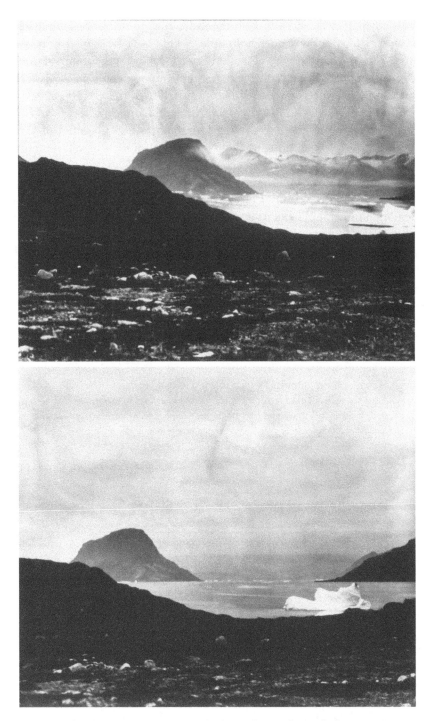

Figures 1.1 and 1.2 Pia Arke, *Nuugaarsuk alias Hulkamerafotografi alias Pointen* (Nuugaarsuk alias Pinhole Camera Photograph alias The Point), 1990, silver/gelatine on baryte paper print of Nuugaarsuk Point, Narsaq, 49.5 x 59.5 cm; collection of Brandts Museet for Fotokunst, Odense.

an accompanying DVD, and although the individual contributions are interesting in their own right, the book does not explore what is to be gained from such an encounter. The introduction to the volume suggests that "each contribution is informative and expressive, empirical and aesthetic, ethnographic and artistic; by refusing to choose between expression and interpretation, these works speak to the complex, unclassified, essential and yet approachable aspects of the world around us."[8] However true this may be, the joint and contrastive potential of the individual contributions—what bringing them into juxtaposition suggests—is not really explored further.

Arguably, much more could have been achieved in *Anthropologies*, through developing a sustained discussion or engagement with movie-making (as opposed to documentary filmmaking) in all its genre, and historical, diversity—not just another study of film but an engagement with film. Obviously, this was an ambition of the editors through including work on DVD, by directors Amir Muhammad and Ranja Ajami, but it is never overtly explored. Where such ambitions, informed by film's creative-theoretical drive (here represented by director Robert Bresson), might lead can perhaps be discerned from another of Baxtrom's interventions, this time into an interesting new student journal at the University of Edinburgh—*The Unfamiliar: Blurring the Boundaries between Art & Anthropology*. Here he writes:

> Even within Geertz's interpretive, literary version of anthropology, there exists a Cartesian partition between the concreteness of the world and the ideas that swirl around such a world seeking to contain it, understand it, change it. "Models of' and 'models for" the world fold back upon their own mistaken divisions, The Unfamiliar haltingly asserts ... We insistently return to our Unfamiliar task of facing up. After all, as Bresson has shown us what is a model except pure face. The Unfamiliar discards Geertz's interpretive duality for Bresson's formal singularity.[9]

Vortex Travel

The working and research methods involved in the projects presented here are probing, exploratory, and often remain fragmentary and open-ended in their results. The process of working with people and materials in ethnographic situations becomes as, or even more, important than the finished product. Anthony Luvera—whose work and practices are featured in this volume—has worked for many years with people who are homeless; with some individuals this has resulted in relationships that have lasted for over eight years and that are constantly being renegotiated. This is a very long-term commitment and involves Luvera and his collaborators in an ongoing process in which artworks are always relatively provisional outcomes. Sometimes this involves dealing with collaborators who come and go, those leading a transitory existence in which the presence of the artist is a temporary, although recurring feature. This all sounds familiar to anthropologists, who frequently have to maintain relationships with their collaborators under very similar circumstances. Both anthropologists and contemporary artists have to come

4

to terms practically, and theoretically, with some of the fragmentary aspects of experience in a globalized world. These experiences, ubiquitous and yet in an uncanny way also place- and site-specific, characterize the work of painter Franz Ackermann (see Plate 1). In 1991, Ackermann started to make a series of what he called "Mental Maps," small drawings, watercolors, and gouaches of his visual experience and perception of large cities, in Asia, South America, Australia, and elsewhere around the world. These Mental Maps constitute a kind of personal cartography, using elements of street maps, different points of perspective that provide views of city fragments, and bits of brightly colored surface painting—all combined in vortex-like arrangements.

As Caoimhín Mac Giolla Léith has observed, "With Franz Ackermann we are no longer dealing with 'anthropological place'—that is, as Marc Augé[10] has defined it, a concrete, symbolic construction of space conceived as relational, historical and concerned with identity. Rather we are dealing with an ambitious attempt to articulate in visual form one man's journeys through the non-anthropological, non-places of what Augé has called supermodernity."[11] While anthropologists have traditionally aimed to be site-specific in their fieldwork and the representations of their fieldwork, their actual practices and movements also involve Ackermann-like scenarios.[12] The prismatic and kaleidoscopic qualities of Ackermann's paintings, where some representations are naturalistic and in perspective but always fragmented, juxtaposed, and jumbled with patches of flat surface painting, are a good metaphor to think through the practices of the multisited anthropologist.

On the other hand, the work of Fiamma Montezemolo, both an artist and an anthropologist, speaks to the experience of urban dislocation, migration, and multiple border crossings in a global world from the perspective of those who are not so privileged. This gap—between those that can travel and those whose passage is restricted—is perhaps nowhere more visible than at one of its contemporary fault lines, the US-Mexico border. The book, *Here is Tijuana*, that Montezemolo produced jointly with an architect and a writer,[13] is a fast-moving collage, juxtaposing in flash-like sequences—not unlike those Ackermann assembles in his paintings—a wide range of black-and-white and color photos of Tijuana's vibrant and diverse street life and neighborhoods, grouped into chapters such as "Avatars," "Desires," and "Permutations." The photographs are accompanied by statements from residents, writers, and artists alongside government statistics. In a more recent work, *Tijuana Dreaming* (coedited with Josh Kun), Montezemolo conducts another probing enquiry into the contradictory trance/transience qualities of the border space that are thrown up in a kaleidoscopic way by the Mexican town, and its effective Other on the other side of the border, San Diego.[14] Montezemolo's own conceptual piece *Bio-Cartography* poignantly mixes and superimposes a uterine medical scan with statistical information to speak about Tijuana as both "mother" and "patient" (see Figure 1.3).

Laurent Van Lancker's collaborative film practices (which he discusses in this volume), which creatively span anthropological and experimental filmmaking concerns, involve a similar corporeality—both in relation to how the work is produced and in terms of the intended address to viewers.

5

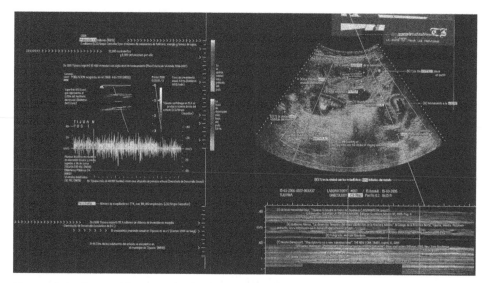

Figure 1.3 Fiamma Montezemolo, *Bio-Cartography of Tijuana's Cultural-Artistic Scene,* inSite_05, 2006; courtesy of the artist.

Many accounts of the relationship between art and anthropology focus on its historically and politically contingent role in colonial and postcolonial regimes. Significant instances of this encounter, such as the dissident surrealist journal *Documents,* which brought together anthropologists, writers, and artists in Paris in the 1920s and 1930s, are used by current writers to question anthropological theories and methods. The 2012 Triennale Show at the Palais de Tokyo, *Intense Proximity: an Anthology of the Near and the Far,* curated by Okwui Enwezor,[15] revisited these concerns, covering a large and heterogeneous array of artists juxtaposed with classic and more recent texts by writers, anthropologists, historians, art historians, and cultural critics (among them Aimé Cesaire, Frantz Fanon, Michel Leiris, Claude Lévi-Strauss, Benjamin Buchloh, Hal Foster, James Clifford, Johannes Fabian, and Michael Taussig), as well as works from those in the field of visual anthropology (including Jean Rouch and Timothy Asch). While this critical perspective and the long genealogy of encounters between the disciplines are important and necessary, we argue that an engagement between art practices and current anthropological theory is now required to push forward theory and practices in both those fields. Such involvement could genuinely benefit and influence artwork that deals with materiality, relationality, and personhood among many other themes.

The 2012 Triennale exhibition also reveals how the art world has produced a new kind of professional traveler in the figure of the freelance curator. Working with only temporary institutional affiliations and located somewhere between the artist and exhibition/gallery system, the roving curator has certain similarities with the ethnographer. Enwezor, commenting on the 2012 Triennale suggests, "Here we can begin to consider, in quick succession, the link between the historical and the

contemporary, between artists and ethnographers, comparing ethnographic field-work with contemporary curating. Or perhaps it is the obverse: the curator as ethnographer?"[16] He goes on to argue,

> In his own hunt for art, might the travel of the curator—in which he scours the global scenes of contemporary art in search of artistic forms and signs through their various embodiments in objects, systems, structures, images, and concepts—be propelled by a similar sense of intellectual vertigo that afflicts the ethnographer? Is the curator a co-traveler with the ethnographer in the same procedures of contact and exploration? What distinguishes the practices of curatorial fieldwork from those of ethnography? In the course of this process it seems even clearer that the path of curatorial fieldwork, while lacking the certainties of the ethnographic discipline, nevertheless shares in some measure a fascination for the tenuous and speculative; the psychic and spiritual; the cognitive and the symbolic.[17]

While Enwezor asks whether the curator might become a "co-traveler with the ethnographer," Jean-Hubert Martin (who curated the exhibitions Magiciens de la Terre [1989] and Africa Remix [2004]) suggests that curators should study anthropology, and Francesco Bonami thinks of curators as "visual anthropologists."[18] Contemporary curating discourse has also pondered the question of time—that is, socially effective time spent by artists and curators or, in other words, that time which becomes duration, as it does in the projects presented and researched by Paul O'Neill and Claire Doherty. They are interested in longer-term, durational, and cumulative approaches that are capable of moving beyond the older paradigm of short-term site-specific interventions and the reductive understanding of place being linked, or rather fixed, to location.[19] By working with ideas around "social forms of artistic production"[20] and "networked models of sociality" (via Ned Rossiter),[21] they suggest that long-term durational projects have the potential to counter the society of the spectacle and that the use of "social" time as a method in these projects amounts effectively to "de-spectacuralization."[22]

In a more general ontological sense, we might think of durational art practices, and their attendant production processes, as being able to both disrupt and irrupt time, working against the kinds of linear social time manifest in social formations. The philosopher and art critic Ticio Escobar makes the important observation that while the art of indigenous people is as contemporaneous (or *coeval*, to use the anthropologist Johannes Fabian's term) as the art of the West, and in this temporal sense contemporary art, at the same time art is set out of joint with its current time and thus works against time, disturbing progressive linear time.[23] The artist Freddi Casco, who occasionally collaborated with Escobar, renders this idea visible in his photographic series Chaco Fantasma, which shows indigenous Guaraní participants in the Arete Guasu ceremony from the town of Santa Teresita in Paraguay.[24] By deliberately blurring the picture, Casco withholds information from us, sets us "out of time" (in Escobar's sense) with the ritual in which these dresses are used and in

which we cannot participate. Paradoxically, with the blurred image Casco asks us to look for more, not in the image but elsewhere—perhaps in books or on the Web—to find extra clues to understanding (see Plate 2).

Critical Collaborations

Arguably much modern art is not overly concerned with large-scale stylistic changes—in painting, say—or with innovation in formal terms, but is more focused on various attempts to shift conventionalized patterns of thinking about a range of subjects and eliciting new kinds of responses from audiences. The same could be argued for certain strands of anthropological endeavor, both historically and in terms of contemporary anthropological practices. A focus on shifting the attitudes of a viewing public has necessarily brought art into contact with other fields—social activism, various forms of social science, urban planning, and so on—and one of the words often used in discussions of contemporary artworks that engage with social worlds of one kind or another is *collaboration*. But what exactly is intended and as-sumed through the use of this term covers a vast range of actual practices and kinds of interactions with others. Many of the discussions around collaboration, and what the critic Nicolas Bourriaud has famously called "relational aesthetics," have only seen the process in overwhelmingly positive terms.[25] Critics have suggested we are entering a new era of art that is focused on social relationships. Grant Kester has discussed the turn toward art practices that are concerned with the broader social and political world, but he is critical of art practices that, despite appearing collab-orative in some senses, do not actually engage with local communities and politics.[26]

Kester discusses a particular artwork by Francis Alÿs called *When Faith Moves Mountains*, which was commissioned for the 2002 Lima Biennial.[27] It is concerned with a perennial theme of Alÿs's—the notion of futile labor and exploitation of the poor and landless in Latin America—and was a performance on a vast scale, involv-ing 500 volunteers attempting to move a sand dune located near a shantytown called Ventanilla on the outskirts of Lima. But, as Kester points out, Alÿs brought in stu-dent volunteers recruited in Lima universities and did not engage directly with any of the shantytown inhabitants, even though he was ostensibly making a comment about their labor and exploitation. So Kester asks, in what way did *Faith* actually serve the interests of the shantytown inhabitants? And he argues that "precisely in refusing to engage the residents of the shantytown, by excusing them from the labor [*sic*] of the performance, they are all the more easily reduced to a generic abstraction (the 'landless worker'), whose mute presence lends the work its aura of political au-thenticity."[28] The work is circulated before a global audience, and Kester argues that the artistic gesture—the creativity—remains ostensibly that of Alÿs; the students are actors whose only volition is whether or not to do as directed by the artist. It is interesting that Kester critiques *When Faith Moves Mountains* as an artwork—one that fails to shift thinking—along lines that would be familiar to an anthropologist.

Engagement in various forms is a key concern of anthropologists, and thinking through the arguments put forward convincingly by Kester suggests that—with the focus on the relative positions involved in collaboration and the often open-ended nature of their interactions—anthropologists can make exemplary artists. There is an important border at work here: perhaps art has itself become too porous, and the notion of an actual art*work* is at stake. Hence our opening remarks about the processual character of social and material "works" in art and anthropology.

The work of the media collective slum-tv, which operates out of Mathare, a large slum of 500,000 people in Nairobi, seems to offer an alternative form of engagement to those of various artists criticized by Kester.[29] Formed in 2006 after a group show at the Alliance Française in Nairobi, the group included Austrian and UK artists working in collaboration with a group of Mathare residents. But here the contours of the collaboration are different from those of Alÿs. The collective is concerned with producing and distributing audiovisual material to a primarily local audience (see Plate 3). The work takes the form of documentaries created by local residents, as well as dramas and comedies made by youth groups—all of which focus on local issues and all with the intention of being screened within Mathare.

Here the notion of an artwork is itself put into question—although slum-tv has exhibited various elements of its output in art galleries, the primary audience is the population of Mathare. Over an extended and ongoing project that began in 2006, slum-tv has trained Mathare people to use visual media and provided a livelihood for a small number of people, as well as an effective space for political and social issues to be addressed at a local level. The international audience is secondary to that within Mathare, where monthly newsreels are screened before being made available online for that wider audience. This is a form of collaboration that foregrounds its commitment to local concerns and voices. No single individual is claiming the work produced as his or her own; the creativity involved is multiauthored in a very real sense. The ongoing activity of slum-tv makes apparent the kinds of questions that need to be asked of work that spans the gaps among art, anthropology, and activism. Described variously as the "ethnographic turn," "relational aesthetics," or a "documentary" shift, there are increasing numbers of artists who are dealing directly with some kind of social relations in their work.[30]

One problem with collaborations in the vein of relational aesthetics has been that they have failed to fully acknowledge the power differences that exist within a globally structured art world and global economic differences at large. It is also obvious that long-term durational work seems to offer quite a different set of issues in terms of participation than those involved with short-term collaborations.

For his project The Full Dollar Collection, Ecuadorian anthropologist Xavier Andrade collaborated with sign painter Don Pili to have famous works by contemporary artists Jeff Koons, Gilbert & George, and Paul McCarthy repainted in sign-painting fashion and provided with new ironic titles in Spanish. The subversive appropriation approach of The Full Dollar Collection questions ideas of authenticity and the creation of value in the global art world, as well as Ecuador's own peripheral

status (as a Third World and dollarized economy) within the international division of labor.[31] Andrade brought the idea of The Full Dollar Collection to Los Angeles, where in 2012 he was an artist in residence at the Outpost for Contemporary Art. Here, too, he works with sign-painters to interrogate the boundaries between high and low art and challenge the contemporary art system with a view from the south (see Plate 4).[32]

Andrade's approach implies critical collaborations across status and genre boundaries in the art world. On the other hand, artists such Anthony Luvera (featured in this volume) challenge in their long-term participative collaborations oppressive memory regimes (for example, through photographic archives) toward marginalized people (the homeless) and their taken-for-granted exclusion from representational practices (such as photography).

Clearly the kinds of encounters artists such as Anthony Luvera deal with are incredibly specific—shaped by often very intense personal, local, and also broader histories and often over very extended periods of time—and this contextual specificity is an area that is central to anthropological practices. Claire Bishop has called for a fuller consideration of the complexities of any collaborative work as a counter to the solely positive assumptions about collaboration that inform Bourriaud and as a remedy to the presumption of conviviality that underlines much artwork that deals with social encounters.[33]

This collaborative complexity is central to the work of Aernout Mik. *Training Ground* (2006) is a two-screen video installation by Mik that is part of an ongoing investigation into the social structures and relationships of contemporary European society[34] (Plate 5). If you are new to Mik's work, then *Training Ground* could resemble a documentary film of a police training exercise, as uniformed officers are instructed in how to deal with refugees and illegal immigrants. The police receive instructions while a group of what are presumably refugees sit around and wait. But we perhaps begin to feel that something is wrong—or rather uncertainty starts to creep in—when we notice that the people playing the refugees actually look the part; their ethnic diversity seems too real to be part of any simple role-playing. As the video progresses, we gradually realize that we are watching an enactment of a training exercise and not a real situation. The footage is shot from multiple viewpoints and attempts to convey a sense of physical immersion in the event. But the order established at the beginning of the video—a training exercise—begins to break down when we see refugees escape or take control of police officers—normal roles start to be reversed. Some of the individuals then seem to start to lose control of their bodies, they start to shake and drool, they appear to be possessed. Mik asked some performers to act out states of delirious possession similar to those shown in the anthropologist Jean Rouch's 1954 film *Les Maîtres Fous* (The Mad Masters). Rouch was interested in trance and possession as responses to colonialism, but in Mik's video we see the line separating oppressor and oppressed become blurred as police officers and refugees both enter trances. The ritual aspects of *Training Ground* reveal the exercise as a kind of exorcism.[35] Mik's work draws attention to the qualities of the relationships mediated or

staged by this kind of collaborative work, and, like Bishop, he argues for the "essential friction" that is necessary for any kind of genuine democratic or political dialogue.[36] The work acknowledges the tensions inherent in social relationships.

From an anthropological viewpoint, the use of words like *participation* and *collaboration* are charged forms of rhetoric that have been subject to much critical scrutiny. The difference between them—the former suggesting "taking part," the latter evoking a sense of working together or co-laboring—corresponds to a sliding scale of how the viewers of artworks or their coproducers are actually involved in the process and at which stages. Bishop points out the difference between participation and interactivity—the latter coming from computing and meaning the viewer takes part in the sense of pressing buttons, and so on—whereas for her participation is a much more socially grounded undertaking than the physical input of interactivity.[37] Advocates of participation in art argue that it presents a solution to problems of elitism and distancing the viewer, and it has certainly become a buzzword in many public art projects. But others have been suspicious of these democratizing claims for social inclusivity. Critics, such as Dave Beech, have pointed out that to enter as a participant in an artwork is to enter into a set of social relationships that often have a very specific form within which you are required to play a very defined role.[38] The participant is rarely cast as a subversive element. It is surprising given the extent and amount of collaboration involved in some artworks that the artists continue to be named as the sole authors. The aim though is not to single out those artists whose use of participation as a feature of their work is correct or more ethical, but to acknowledge that the role of participant is always a kind of specific invitation—the broad use of it as a term can mask a really wide range of actual practices and levels of involvement. In this sense, participation in artworks often involves the simultaneous creation of a particular kind of participant subject. There is considerable overlap and difference here with the ways in which participation can be configured within anthropology. The late 1980s saw an anthropological focus on the role of the anthropologist in the field, and—although this is something that is now seen as a ubiquitous element of anthropological thinking— the full acknowledgement of the kinds of power differentials involved remains a useful corrective to some collaborative work in anthropology, particularly visual anthropology. However, it is useful to move beyond the binary opposition between participation and exclusion or passivity and acknowledge a whole range of forms that participation can take. This continues to be a central feature of anthropological concerns about participation in fieldwork contexts. There is a whole constellation of different degrees and conceptions of agency and control at work. So despite the allure of curing some of the ills of art, participation needs to be strongly differentiated from collaboration and the specific complexities of particular contexts for collaboration acknowledged.

Some of the contributors to this volume tackle the issues around collaborative work directly. Jennifer Deger's discussion of her collaborative work with a Yolngu community in central Australia involves a range of collaborations and participatory

practices. She argues that the work in question—the collaborative video and accompanying exhibition Christmas Birrinbirr—is a form of "participatory cultural creation" and a kind of social performance that closely resembles Yolngu ritual. In her video *Active Pass to IR9*, the anthropologist and artist Kate Hennessy collaborates with Richard Wilson, a member of the Hwlitsum First Nation from British Columbia. Their relationship takes into account experiences of growing up on Galiano Island off Vancouver (where they both lived as children), but also the differences between Hennessy as an anthropologist of European descent and Wilson as a First Nation artist. Raul Ortega Ayala conducts long-term participatory fieldwork among office workers and as the basis for producing some of his artworks. The ethical complexities arising from Yvette Brackman's collaborative work with the Kildin Sami artisans of the Russian Kola peninsula (bordering Norway and Finland) are central to her reflexive artworks. As a result of her collaborations with the Kildin Sami, Brackman wrote a play, *The Catalyst*, in the tradition of the Brechtian *Lehrstück* (learning play) (see the interview with Brackman in this volume). Transcending disciplinary boundaries between participant observation, camerawork, art, and medical practice, Christina Lammer, on the other hand, works with plastic surgeons and their patients in Vienna exploring their various visualizations beyond the realms of the operating theater. Ruth Jones's performance projects are about tenuous and temporary collaborations that aim to draw participants into liminal spaces to create transformative potentials. All of the artists and anthropologists featured in our volume share a concern with the politics of collaboration within specific local and historical contexts, and they forcibly demonstrate the utility of bringing anthropological and artistic concerns into dialogue in the creation of collaborative works.

Performance

Anthropology has much to teach artists about the kinds of negotiations and culturally relative inflections of terms such as *participation* and *collaboration*, particularly in colonial and postcolonial contexts. But it also has much to contribute in terms of discussions of performance. One example of how this might result in fruitful projects is the work of British artist Jeremy Millar; for his 2009 series As Witkiewicz, Millar took photographs as though they had been taken by a historical figure. In 1914, the Polish artist Stanislaw Witkiewicz was invited by his childhood friend, the anthropologist Bronislaw Malinowski, to join him on a fieldwork expedition in New Guinea in order to act as his draftsman and photographer. However, upon arriving in Australia, they argued about how to respond to the recent breakout of WWI, and Witkiewicz left for Europe to fight. Malinowski stayed and continued his research, which is now considered seminal work in social anthropology. Millar travelled to Kiriwina (formerly known as the Trobriand Islands) off the coast of Papua New Guinea—where Malinowski conducted his most famous fieldwork—and made a series of photographs As Witkiewicz, in what might be considered a form of performance (see Figure 1.4).[39]

Figure 1.4 Jeremy Millar, As Witkie-wicz, 2009; courtesy of the artist.

The works by Anthony Luvera and Thera Mjaaland, both featured in this volume, concern their subjects' participation in the photographic process, but they also reveal the deliberately staged character of these events. While there are innumerable possibilities of manipulation in photography during all its stages (from set-up, to shoot, to picture), and photography already implies a materially mediated interference in the lived world by an outside actor, here we want to focus on its staged or in a wider sense performed quality. Staging has a long history in photography both inside and outside of the studio. Initially, from the early nineteenth century until the early twentieth century, staging was also a necessity and a desired element of photography, both for technical reasons (i.e., the complicated set-up, long exposure times, and a fixed camera position) and aesthetic intentions, where photographers drew compositional inspiration, indeed models, from painting, and often wanted to emulate painterly tableaux. From the early twentieth century onward, and facilitated by portable lightweight cameras, a new dividing line arose between studio and street, with composed, prearranged—in other words, staged—studio photography as opposed to the intimate and instant direct capture of "live" as it presented itself seemingly unruly, un-distanced, and uncontrolled on the street. However, as Ute Eskildsen reminds us, while the lightweight equipment opened up the practice of instant street, outside-of-the-studio photography, the staged, constructed scene for

13

photographs equally has continued to mark practices for photographers in both arenas of street and studio.[40] Some contemporary photographers, like Jeff Wall, entirely invent and stage their photographic scenes like stills from a movie set.

The staged, performed character of photographic works leads us to a wider set of considerations concerning performance more generally. These go beyond the mere attestation of staging being a fundamental characteristic of (certain) photographic practices and point to altogether different theoretical concerns. This is, that through performance new materials and qualities are created in relation to body, time, and space; in other words, these "perennial fundamentals" of theater and performance[41] are rearranged and brought into contact to produce new things, transcending their previous or original status.

This transformative potential of performance can be well illustrated with the work of Brazilian artist Hélio Oiticica (1937–80). Oiticica's work is remarkable for the number of ways in which the art/anthropology relationship can be rethought. One is Oiticica's radical reconceptualization of color, in time, and space, where color becomes both a "physical body and [a] sensorial environment," leading to a dematerialization of color, in what Oiticica called nonobjects and transobjects.[42] Oiticica also suggested that the conceptual, theoretical, and sensorial potential of objects had to be revealed and developed from the "inside out"—unlike in classical, academic painting where the beholder captures the meaning from the "outside in."[43] The other important issue resides in the intended performative qualities of his work—or said otherwise, the work and its theoretical fulfillment only become effective through performance and active viewer participation. Oiticica's work had developed from early concerns of the neo-concrete movements in São Paulo and Rio de Janeiro in the mid-1950s, the latter being more interested with the spatial and especially temporal qualities of color.[44] Oiticica was occupied with profound investigations of space, structure, and, more importantly, influenced by the philosophy of Henri Bergson, the time-based qualities of colors and materials.[45] Performative aspects were already inherent in many of Oiticica's earlier works, which often invited direct viewer participation, such as the Bilaterals (1959), which were hung to be viewed from both sides, and the Bólides (1963–69), glass and wood objects that allowed and demanded inspection by the viewer.[46] However, it is with the *Parangolés* (1964–68) that Oiticica pushed the conceptual limits of his phenomenologically inspired investigations and also marked the most radical break with the confines of his previous, studio-produced artwork in an upper-middle-class neighborhood of Rio (see Plate 6).

Parangolés are capes made from fabric, pigment, plastics, netting, and other materials. Worn by the artist, or others, a *parangolé* becomes a "'habitable' and 'active' color-structure in space that has both a tactile-corporal and a visual dimension … Its purpose is to be worn by anonymous members of the audience who move to the rhythm of samba."[47] Oiticica's concept of color-in-action was a direct outcome of the artist's performative intervention into street life, samba, and carnival procession, which he explored in the Mangueira shantytown neighborhood of Rio—a social

world very different from his studio. Significantly, Oiticica did not conceive of this move out of the studio in terms of an exoticizing strategy, but rather wanted to confront his ideas of movement, time, and color with lived experiences and explore their limits in performance as colors-in-action. "What is at stake—as one might be misled to believe by the word *parangolé's* derivation from slang—is neither a merger of folklore with my own experience nor any such identification, whether transposed or not, both of which are totally superficial and useless."[48] Oiticica was interested in the "how," in process, and ultimately striving toward "transobjecthood" for his works.[49] Parangolés, when they come alive in performance, both have to be worn and to be watched. In this sense, they function not unlike the performance of the ethnographer in the mise-en-scène, who also with his or her body, foreign questions and concepts, and the audiovisual recording apparatus immerses himself or herself into a different cultural scene but at the same time is watched and in a transfigurative sense "worn" by his or her audience of interlocutors in the field. A recent exhibition at the Antwerp Museum of Modern Art, A Rua: Rio de Janiero and the Spirit of the Street, also attests to the fertility of Oiticica's and fellow artists Lygia Clarke's and Lygia Pape's ideas in the context of contemporary Brazilian art working in urban contexts of shared and public spaces, through concepts of precariousness in *favela* (shantytown) architecture, viewer participation, and collaboration and cooperation.[50]

Oiticica's work opens a conceptual avenue to "transmateriality," the idea that ephemeral, transitory phenomena (anything between social actions and extrasensorial experiences) produce and leave material traces that refer back and point forward to similar events not any longer or not yet manifest. The material capture of such ephemeral events is behind Kate Robertson's series of photographs Dust Landscapes (2012) that

> record dust collected from ConFest; a festival held by an alternative healing and spiritual community in the arid landscape of New South Wales [see Plate 7]. Throughout the festival, as participants move around the site, the dry land is unsettled and clouds of dust are created that linger listlessly above the ground. The wind stirs the dust particles across the ConFest site, clinging onto festival goers as they immerse themselves in community rituals and spontaneous happenings.[51]

While having themselves materiality (as photographs) and being representations of material (i.e., dust), they are also making translucent the actions or events from which they originate. Robertson's final works are made in the studio with dust particles she brought back, but she could have chosen to photograph the dust at a high shutter speed when it lingered above the ground, for a more "instant" picture (or low-speed for a blurred picture). In a related sense, this work also pushes us to consider slow motion and what it can reveal about performed emotions. Slow motion, the deliberate dilation of time in film, makes visible the minutiae of human movement and expression of inner feeling (especially when used with close-up), normally imperceptible at

regular speed. This, too, is connected to transmateriality, not least to that which comes in-between the subjective experience and expression of (extra) sensorial things, and only becomes palpable when film time returns to normal where it persists as an "afterglow," as Caterina Pasqualino writes in her contribution to this volume.

We think that not only performative practices, such as those by Oiticica, but also photographic and filmic practices (for example, by Robertson and Pasqualino) offer a radical potential to engage anthropology on a theoretical level, indeed for art and anthropology to meet on a theoretical plane, not just through ethnographic engagements with critical representations of exoticism in postcolonial societies (Brazil being one of them), as important as these certainly are. Practitioners in our volume often dwell on the aspects of representation and ethnography, even, and especially, when these are fractured/ruptured by experimenting with stylistic and formal means. The works of filmmaker/anthropologist Kathryn Ramey and photographer/anthropologist Juan Orrantia are particularly good examples of this. We think that beyond the practices (documented here) there is still more of a genuinely theoretical conversation to be had, not necessarily with words but with works concerning, for instance, theories of materiality, personhood, relations, actor-network theory, and perspectivism, to name but a few. There are also interesting possibilities for the new digital and media anthropology to engage with artists (and their theoretical concerns) who work with new media.

One aspect of performance has to do with structures of impermanence. In the ethnographic record, they are familiar to us from hunter-gatherer and nomadic societies that use quickly removable and portable tools and implements for food gathering and preparation, habitation, and animal husbandry (in the case of nomads). Tents are one such type of removable equipment, and making camp in this impermanent, intransient way can also be said to have performative qualities to a degree that sedentary building structures do not possess. Craig Campbell's proposal for a tent (presented in our volume), based on the propaganda expeditions of early Soviet cinematographers into Siberia, then achieves a double performance, as the lit tent would have been visible from a distance in the tundra (and now is in the installation space) and the projection of film within the tent itself.

Toward a New Conceptualism

The notion of ethnography as a form of conceptual art has been proposed by a group of anthropologists from Cambridge retrieving some concerns of twentieth-century conceptual art in the widest sense (and particularly, in some instances, early socialist realist and Agit-Prop) and applying these, combined with Maussian and Strathernian gift theory, to new research design-thinking about ethnography. They term their approach *ethnographic conceptualism*, by which they want to refer to "ethnography conducted as a conceptual art," and they also inquire into "performance as research tools" and further "the performance of anthropological concepts."[52]

The term "ethnographic conceptualism" was coined during work on an exhibition of gifts to Soviet leaders at the Kremlin Museum in 2006. The curators expected this

exhibition to be controversial, and thought that the process of curating and the exhibition itself could be an excellent way to explore a post-socialist audience and its politics of memory. From this vantage point, they explored the exhibition visitors' comment book as an artifact that the many visitors thought was actually part of the exhibition display.[53]

It can be said that their agenda shares some concerns with the earlier work of Neil Cummings and Marysia Lewandowska—namely, the Capital project, which applied Marilyn Strathern's (and Mauss's) text on the gift to a project involving the Tate Modern and the Bank of England and which we featured in the 2003 conference Fieldworks: Dialogues between Art and Anthropology.[54] In a different way, and with somewhat different precedents, George Marcus has been rethinking the design of the mise-en-scène of fieldwork for some time.[55] Theo Barth, based at Oslo's Art Academy, has been trying, in a theoretical conversation that spans George Marcus, Nicolas Bourriaud, and Giorgio Agamben, among others, to rethink design practice from an anthropological vantage point and vice versa, and Alberto Corsín Jiménez, Chris Kelty, and George Marcus have explored the usefulness of "prototypes" to connect anthropological and design/art thinking.[56] The exhibition *Animism* (curated in 2010 by Anselm Franke) is a good example of how such theoretical thinking can coalesce—in this case, around a term that has been in the anthropological discussion ever since Edward B. Tylor and time and again occupied anthropologists and social scientists of very different theoretical persuasions, from Claude Lévi-Strauss, Philippe Descola, and Michael Taussig to Eduardo Viveiros de Castro and not least Bruno Latour. Animism, both old (or "primitive," as it was presented for Tylor) and new (among contemporary indigenous people, spiritualists, and cultural analysts),[57] as well as mechanical and technological animism of image practices in modernity (significantly, photography, animation film, and so forth), is critically reflected in this exhibition through a large host of diverse artworks challenging the presumed and self-constructed divide between a rationalist modernity (built on artificial animation), and "savage" animism, showing how the former subjugated, repressed, and appropriated (through mimesis) the former. For instance, filmmakers/anthropologists Anja Dreschke and Martin Zillinger made a video installation for the Animism exhibition based on video materials from Zillinger's nine-year-long ethnographic work on the trance practices of the Isawa and Hamadsa, Moroccon Sufi sects (known through Vincent Crapanzano's earlier work).[58] These Sufi groups have also incorporated video and DVD into their performances and mediatized their transnational networks of ritual performances.[59] Zillinger sees the experience of estrangement as a central concept to understand trance on its own terms, through his and the participants' film works, which are part of the installation:

> Through their films, we, the viewer, partake in their ritual activities, which bring about, affirm and do justice to an aspect of human experience, that has come under siege by modernizers and their work of purification. The rituals remind the adepts, spectators, and viewers of who we are are—men and women subject to manifold experiences of estrangement, moved and acted upon throughout the course of our life [see Figure 1.5].[60]

Figure 1.5 Martin Zillinger/Anja Dreschke, *A Man in the Trance State of the Camel, Agitating the Crowd from a Cactus* (VHS-videostill), part of video installation *Trance/Media*. The "ʾIs wa in Morocco 1992–2012," 2010–12; courtesy of the artists.

In all these attempts, or "probes" (to use Robert Willim's expression in his contribution to this volume),[61] to expand theory, the ethnographic then becomes second stage (or order), despite remaining a strong element, as for instance in Zillinger's case. Obviously, this does not mean that ethnography becomes unimportant, or negligible, but the initial theoretical motivations arise from a different plane. Paradoxically, the theory is now also in the process of making work, as Craig Campbell (contributor to this volume and a member of the Ethnographic Terminalia collective) expressed it: "How things serendipitously produce meaning in ways we don't necessarily anticipate."[62]

Experimental Truths

Alongside a concern within contemporary art to reconnect with social realities, and with collaborations of various kinds, has been an increasing use of the word *documentary* in relation to artworks. As well as performance and sound-based works, this has resulted in a convergence between artists using moving and still photographic imagery to explore documentary themes, along with an increasing experimentation

within documentary filmmaking—including ethnographic filmmaking—on structure, form, and content of films as well as the ways in which they are exhibited. An apparent clash exists between the authenticity or realism that documentary has laid claim to—however contentiously—and the association of imagination and experimentation with art practices. There has been much recent work across a range of fields that directly questions this binary equation, and many of the contributors to this volume have been active in questioning these assumed positions.

As discussed in a survey of recent documentary work in film, Clarisse Hahn spends long periods of time filming her subjects—she works like an anthropologist but exhibits as an artist. Hahn says she makes her films "because I think I do not have a clear idea of how I have to behave with the 'other' and how to find a common space with the 'other.' So my work questions how we live together and how we manage to live with others."[63] Her work exhibits an observational aesthetic[64] with its close attention to detail and its focus on following its central characters through their daily lives—it would not look out of place in an ethnographic film festival, and yet when it is exhibited in an art gallery, does its relationship to ideas of authenticity and realism shift in any way? The shift from the kinds of distribution normally associated with documentary films—festival screenings, theatrical release, or TV broadcast—to art galleries allows the use of multiple screens, and moving image work can become an installation that allows for a different kind of physical encounter with the work. Jane and Louise Wilson's 2003 video installation *A Free and Anonymous Monument* was arguably the largest, most ambitious such project ever staged in the United Kingdom. The work filled an entire gallery floor and used thirteen separate projection screens to show images of the industrial landscape of northeast England to make a comment on contemporary political visions of renewal in an area that has seen massive economic decline, contrasting high-tech assembly lines with the rusting shells of former industrial buildings. Taking an iconic example of English Utopian postwar architecture—Victor Pasmore's Apollo Pavilion—as a model, the installation recreated the rough shape of the pavilion with video projection screens that were above, below, and surrounding the viewer.

For some artists and filmmakers, installations like this are a way of solving issues of narrative construction—of avoiding the tendency toward a single linear narrative that the use of a single screen imposes on material; installation denarrates in a spatial fashion. This has its counterpart in anthropological concerns over narrative voice[65] and allows two things to happen. First, it allows an enhanced experimentation with form, and in this sense film is perhaps a misnomer for the kinds of multiple-screen blurring that occurs in gallery spaces. Second, it also allows for a more haptic cinema[66] and a corporeal encounter with intended audiences, such as that discussed by Laurent Van Lancker and Kathryn Ramey in this volume. The notion of installation is also one that extends beyond the art gallery as Brad Butler and Karen Mizra's film work installed on a large public screen in Canary Wharf—discussed below—powerfully demonstrates. These kinds of installations and interventions have been a feature of artworks for a long time but are relatively new ground for anthropology. The relationship of the multiple narratives made possible

through multiscreen installations brings about a simultaneous shift in the relation of the work to truth. It draws attention to the multiplicity of truth in a way that even a single-screen, linear narrative film that contains many voices does not. The installation allows for a literal overlapping of narratives. What is the effect though of allowing the audience a greater role in watching on the kinds of responsibilities for representation that documentary filmmakers and visual anthropologists feel for their subjects? Installations like these provide a space for rethinking the ethical notion of fidelity to reality.

The anthropologist Paul Basu has argued that the video work of artist Kutlug Ataman—particularly a multichannel work called *Küba* (2004)—can be seen as ethnography[67] (see Plate 8). Ataman spent two years living intermittently with the people of Küba on the outskirts of Istanbul recording what he calls "research documents"—the video testimonies of many of its inhabitants. People voice their fears and concerns for the future of their community—threatened by Istanbul's urban sprawl, and not only is the collaborative process involved a deeply ethnographic one, the work itself, in its multiscreen incarnation, is a form of installation that is fundamentally ethnographic in its intentions. *Küba* confronts the viewer in the form of some forty old television sets each on a battered box and each with an equally battered secondhand armchair in front (see Plate 8). In total, more than thirty hours of footage, the entirety of *Küba* is impossible to encompass; instead each viewer takes in an essentially different story comprising a wide variety of viewpoints on similar themes. Viewers are confronted with the partiality of the experience as they physically move from one screen to another, while the murmur of more than forty voices suggests the multitude of voices they have not yet heard. Basu claims that the audience members are themselves transformed into "audience-ethnographers" within the actual exhibition space,[68] and suggests that similar kinds of experimentation suggest a positive future for anthropological representation that is concerned with combining narratives in complex ways.

This convergence of art and documentary has meant a renewed focus on the aesthetics of reception by artists using visual and aural media. As with the discussion of participation and collaboration above, the former schema of artist, art object, and viewer is complicated by a widening out of work to a broader social context that has to take into account specificities of cultural setting. This has brought renewed contact between artists and anthropologists. Perhaps documentary says something about the relationships involved in making a work rather than anything productive about the actual form a work takes? There is overlap between art and documentary in several respects—the use of interviews and confessional material, the use of found objects (getting footage that is out there rather than staged for the camera) including the use of actual found or archival footage (see Ramey in this volume), the combination of staged and unstaged events, and a concern for duration—making demands of the viewer in terms of experiencing the time of others. Documentary has been concerned with reaching

as wide an audience as possible—in contrast to the charges of elitism addressed at art practices—and there has been a subsequent emphasis on communicating to audiences. Artists as much as documentary filmmakers, want to effect change and challenge existing attitudes, and there are increasing areas of overlap. One of Jennifer Deger's collaborators—Paul Gurrumuruwuy—argues that as a result of this kind of work that crosses borders between contemporary art and anthropology "you've got doors everywhere now. It doesn't matter if you stay at an outstation ... [Through this work] you've got doors and you can walk out to the world. To another world."[69] This situation suggests that there is an urgent need for further dialogues between art and anthropology that continue to explore this fertile area.

Notes

1. Tim Ingold and Elizabeth Hallam, "Creativity and Cultural Improvisation: An Introduction," in *Creativity and Cultural Improvisation*, ed. Tim Ingold and Elizabeth Hallam (Oxford: Berg, 2007).
2. Pia Arke, *Ethno-Aesthetics* (Copenhagen: Kuratorisk Aktion, 2010), 28.
3. Ibid.; Pia Arke, *Stories from Scoresbysund: Photographs, Colonisation, and Mapping* (Copenhagen: Kuratorisk Aktion, 2010); Pia Arke, *Tupilakosaurus: An Incomplete (able) Survey of Pia Arke's Artistic Work and Research* (Copenhagen: Kuratorisk Aktion, 2012).
4. Arke, *Stories from Scoresbysund*.
5. Gerardo Mosquera (co-curator with Selene Wendt) about a recent exhibition, *The Storytellers* (where artists reacted to works of literature), pointed out how artists, such as Milena Bonilla, play with the double-bend of narration that is both narrated sequentially and "denarrated" and deconstructed through their works; they literally "debook" and "unbind" the book, working at its "crosscurrents of objecthood, image text and representation"; see Gerardo Mosquera, "Denarrations, Unbindings," in *The Storytellers: Narratives in International Contemporary Art*, ed. Selene Wendt (Milan: Skira Editore, 2012), 107. Of course, the "book" can be also conceived of in broader conceptual terms, as meaning a master narrative—in the case of Greenland, that of an apparently seamless continuity between colonial and postcolonial knowledge regimes.
6. The historical background was a Norwegian counterclaim to the area; in 1933 the International Court of Justice in The Hague settled in favor of Denmark.
7. Originally her master's thesis at the Royal Academy of Art in Copenhagen (1995); republished in English, as Arke, *Ethno-Aesthetics*.
8. Richard Baxstrom and Todd Meyers, eds., *Anthropologies* (Baltimore: Creative Capitalism, 2008).
9. Richard Baxstrom, "Facing the Unfamiliar: an Introduction in four Short Movements," *The Unfamiliar: Blurring the Boundaries between Art & Anthropology* 1, no. 1 (2011): 3.
10. Cf. Marc Augé, *Non-Places: Introduction to an Anthropology of Supermodernity* (London: Verso, 1995).
11. Caoimhín Mac Giolla Léith, "Ireland, Ackermann, and the Erasure of Toponomy," in *Franz Ackermann* (Dublin: Irish Museum of Modern Art, 2005).
12. There is a long tradition in anthropology to choose field sites in order to test particular theoretical hypotheses—for example, in relation to notions of kinship and personhood, in either Melanesia or Amazonia, and so on.
13. Fiamma Montezemolo, Rene Peralta, and Heriberto Yépez, *Here is Tijuana* (London: Blackdog, 2006).

14. Josh Kun and Fiamma Montezemolo, eds., *Tijuana Dreaming* (Durham, NC: Duke University Press, 2012).

15. Okwui Enwezor, "Introduction" and "Intense Proximity: Concerning the Disappearance of Distance," in *Intense Proximity: An Anthology of the Near and the Far*, ed. Okwui Enwezor, Mélanie Bouteloup, Abdellah Karroum, Émilie Renard, and Claire Stabler (Paris: Palais de Tokyo, 2012).

16. Enwezor, "Introduction," 12.

17. Enwezor, "Intense Proximity: Concerning the Disappearance of Distance," 21.

18. Jean-Hubert Martin, "Independent Curatorship," in *Cautionary Tales: Critical Curating*, ed. Steven Rand and Heather Kouris (New York: Apexart, 2007), 38; and Francesco Bonami, "Interview/Essay," in *Words of Wisdom: A Curator's Vademecum*, ed. Carin Kuoni (New York: Independent Curators International, 2001), 32.

19. Paul O'Neill and Claire Doherty, "'Introduction," in *Locating the Producers: Durational Approaches to Public Art*, ed. Paul O'Neill and Claire Doherty (Amsterdam: Valiz, 2009), 4–5.

20. Ibid., 6.

21. Ibid., 8. The reference is to Ned Rossiter, *Organized Networks: Media Theory, Creative Labour, New Institutions* (Rotterdam: NAi, 2006).

22. Ibid., 13. The reference is to Guy Debord, *Society of the Spectacle* (Detroit, MI: Black & Red, 2000).

23. Johannes Fabian, *Time and the Other: How Anthropology makes its Object* (New York: Columbia University Press, 1983), 31; and Ticio Escobar, "The Art Maps: Reflections on the Line of the Tropics," in *The Tropics: Views from the Middle of the Globe*, ed. Alfons Hug, Peter Junge, and Viola König (Berlin: Goethe Institute, 2008), 310.

24. Ticio Escobar, *The Curse of Nemur: In Search of the Art, Myth and Ritual of the Ishir* (Pittsburgh: University of Pittsburgh Press, 2007).

25. Nicolas Bourriaud, *Relational Aesthetics* (Paris: Les presses du réel, 2002).

26. Grant Kester, *Conversation Pieces: Community and Communication in Modern Art* (Berkeley: University of California Press, 2004), and *The One and the Many: Contemporary Collaborative Art in a Global Context* (Durham, NC: Duke University Press, 2011).

27. Kester, *The One and the Many*, 67.

28. Ibid., 73.

29. See www.slumtv.org.

30. See Alex Coles, ed., *Site Specificity: The Ethnographic Turn* (London: Black Dog, 2000); and Hal Foster, "The Artist as Ethnographer?" in *The Traffic in Culture: Refiguring Art and Anthropology*, ed. George E. Marcus and Fred Myers (Berkeley: University of California Press, 1995).

31. See http://www.kcet.org/socal/departures/community/fulldollar/origins-of-the-full-dollar -collection-of-contemporary-art.html.

32. See http://www.kcet.org/socal/departures/community/fulldollar/.

33. Claire Bishop, "Antagonism and Relational Aesthetics," *October* (fall 2004): 51–79.

34. Michael Taussig, "Aernautiks," in *Aernaut Mik: Shifting Shifting* (London: Camden Arts Centre, London, 2007).

35. Ibid.

36. Bishop, "Antagonism and Relational Aesthetics," 70.

37. Ibid., 72.

38. Dave Beech, "Include Me Out!" 2010, http://visualintosocial.wordpress.com/2010/09/01/ include-me-out-dave-beech (accessed April 24, 2013).

39. Millar is currently working on an ongoing collaborative project to realize a traditional form of Balinese theater that tells the stories of the anthropologists Gregory Bateson and Margaret Mead and those they have influenced.

40. Ute Eskildsen, "Introduction," in *Street & Studio: An Urban History of Photography*, ed. Ute Eskildsen, Florian Ebner, and Bettina Kaufmann (London: Tate, 2008), 9.

41. Steve Dixon, *Digital Performance: A History of New Media in Theater, Dance, Performance Art, and Installation* (Cambridge, MA: MIT Press, 2007), 13.

42. Mari Carmen Ramírez, "The Embodiment of Colour—'From the Inside Out,'" in *Hélio Oiticica: The Body of Colour*, ed. Mari Carmen Ramírez (London: Tate, 2007), 20.

43. Ibid., 50.

44. Ibid., 32.

45. Ibid., 34, 43.

46. Ibid., 27–28, 61.

47. Ariane Figureido, María C., Gaztambide, and Daniela Matera Lins, "Chronology (1937–1980)," in *Hélio Oiticica: The Body of Colour*, ed. Mari Carmen Ramírez (London: Tate, 2007), 373.

48. Hélio Oiticica, "Cornerstones for a Definition of 'Parangolé,'" in *Hélio Oiticica: The Body of Colour*, ed. Mari Carmen Ramírez (London: Tate, 2007), 296.

49. Ibid.

50. Dieter Roelstrate, ed., *A Rua: Rio de Janiero and the Spirit of the Street* (Antwerp: Ludion, 2011), 13, 30, 154–6.

51. See http://edmundpearce.com.au/kate-robertson-dust-landscapes-april-04–21/ (accessed November 25, 2012).

52. See Sarah Wilson and Nikolai Ssorin-Chaikov, "Ethnographic Conceptualism: Performing Methodological Experiments," Abstract of a workshop at the Courtauld Institute, London, January 31, 2012, http://www.courtauld.ac.uk/researchforum/events/2012/spring/jan31_Ethnographic Conceptualism.shtml (accessed October 30, 2012).

53. See Olga Sosnina and Nikolai Ssorin-Chaikov, "Archaeology of Power: Anatomy of Love," in *Dary Vozhdiam/Gifts to Soviet Leaders*, ed. Nikolai Ssorin-Chaikov (Moscow: Pinakotheke, 2006), 12–37; and Nikolai Ssorin-Chaikov, "On Heterochrony: Birthday Gifts to Stalin, 1949," *Journal of Royal Anthropological Institute* 12, no. 2 (2006): 355–75.

54. George Marcus, "Contemporary Fieldwork Aesthetics in Art and Anthropology: Experiments in Collaboration and Intervention," in *Ethnographica Moralia: Experiments in Interpretive Anthropology*, ed. Neni Panourgiá and George E. Marcus (New York: Fordham University Press, 2008).

55. George Marcus, "The Green Room, Off-Stage: In Site-Specific Performance Art and Ethnographic Encounters," in *Performance, art et anthropologie*, December 1, 2009, http://actesbranly.revues.org/453 (accessed July 15, 2012); H. N. Deeb and G. E. Marcus, "In the Green Room: An Experiment in Ethnographic Method at the WTO," *PoLAR: Political and Legal Anthropology Review* 34 (2011): 51–76.

56. Theo Barth, "Romsås: Some Experiences of Socially Responsive Process (SVRD)—in a Field Where Art and Design Overlap," Kunsthøgskole/Art Academy, 2010, http://khio.academia.edu/TheodorBarth (accessed April 24, 2013); Chris Kelty, Alberto Corsín Jiménez, and George Marcus, eds., *Prototyping, Prototyping*, ARC, Anthropological Research on the Contemporary: Episode 2, https://sites.google.com/site/acorsinjimenez/articles (accessed April 24, 2013).

57. "'New animism,' which proclaims to have come closer to the realities of the cultures in question, which seeks to take 'animist' cultural practices seriously...considering forms of relational knowledge, and...*practices* different from those predominant in modernity"; see Anselm Franke, "Much Trouble in the Transportation of Souls, or: The Sudden Disorganization of Boundaries," in *Animism*, vol. 1., ed. Anselm Franke (Berlin: Sternberg Press 2010), 13.

58. Vincent Crapanzano, *The Hamadsha: A Study in Moroccon Ethnopsychiatry* (Berkeley: California University Press, 1981).

59. Martin Zillinger, "Passionate Choreographies Mediatized. On Camels, Lions, and Their Domestication Among the Isawa in Morocco," *Animism*, vol. 1, ed. Anselm Franke (Berlin: Sternberg Press 2010); and Martin Zillinger, *Die Trance, das Blut, die Kamera: Trance-Medien und Neue Medien im marokkanischen Sufismus* (Bielefeld: Transcript, 2010).

60. Zillinger, "Passionate Choreographies Mediatized," 226.

61. See also Robert Willim, "Irregular Ethnographies," *Ethnologia Europaea: Journal of European Ethnology* 41, no. 1 (2011): 5–13.

62. Craig Campbell in conversation with Arnd Schneider, Montreal, November 2011.

63. Clarisse Hahn quoted in Gail Pearce and Cahal McLaughlin, eds., *Truth or Dare: Art and Documentary* (Bristol: Intellect Books, 2007), 25.

64. See Anna Grimshaw and Amanda Ravetz, *Observational Cinema: Anthropology, Film, and the Exploration of Social Life* (Bloomington: Indiana University Press, 2009).

65. David MacDougall, "Whose Story Is It?" *Visual Anthropology Review* 7, no. 2 (1991): 2–10.

66. See Laura U. Marks, *The Skin of the Film: Intercultural Cinema, Embodiment, and the Senses* (Durham, NC: Duke University Press, 2000).

67. See Paul Basu, "Reframing Ethnographic Film," in *Rethinking Documentary*, ed. T. Austin and W. de Jong (Maidenhead: Open University Press, 2008).

68. Ibid., 105.

69. Quoted in Jennifer Deger, Chapter 11, this volume, 108.

AGIT-KINO: ITERATION NO.2

Craig Campbell

Preamble

The writing and images presented in this chapter should be considered as a companion piece to a work-in-progress called *Agit-Kino: Iteration no.2*. The first iteration was exhibited in 2009 at the Ethnographic Terminalia exhibition in Philadelphia. *Agit-Kino: Iteration no.2* is a proposed installation that recreates a mobile tent cinema in a dimly lit gallery space. The tent—shut to visitors—is saturated and overflowing with projected images of everyday life in Siberia as it was seen in the revolutionary upheaval of the 1920s. These shadows stretch out through the canvas, across the floor and up the walls of the gallery; they are specters sent into the world from machines housed within the tent. Anthropological research strategies underpin this cultural, historical art installation, and early expeditionary photographs have been rerouted from their limited archival circulation to be re-presented in this theater of critical mediation. My goal in this text, however, is neither to describe the *Agit-Kino* in its entirety nor to fully explain it. As a companion work, this essay is meant to be read as a semiautonomous entity, just as the *Agit-Kino* is its own thing—neither elaborating on nor disclosing fully what it is. Where writing in the art world is typically seen as a supplement to the work itself, these two pieces each walk in the shade of the other, not always in alignment or agreement. One thing that ties this writing and the installation together is that they are the product of the same research; they both turn on the absent geographies, economies, and identities necessary for representation. The design of both works as well as their relationship aims toward the provocation of a critical interval and gestures toward an unframing where art practice and critical inquiry can co-reside without exhausting each other. The writing and the art practice are movements that cannot be disentangled, for their points of departure are bound to the research; they emerge from the same inaugural position.

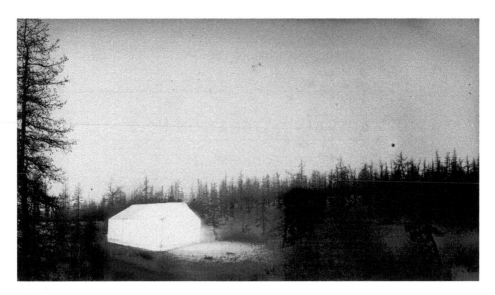

Figure 2.1 Composite photograph by Craig Campbell.

Agit-Kino, Vignette 1

Before entering the gallery room, the familiar sound of a projector motor and mechanism is heard. Its whirr and tick, its subtle clatter and the palpable sense of a motor, fan, and moving parts are instantly apprehended by the ear: the body is attuned by familiar sensations just as it is attuned by those that are unfamiliar to it. Passing the threshold of the gallery will bring the sensing body in closer proximity to something it is already aware of. Sound as a phenomenal object is diffuse and resolutely particular to the location where it intersects with a listening individual. The audible elements that seep out of one room and into the space of another are experienced as part of a very mundane mode of audio orientation and sensory attunement. This helps the perceptive/receptive subject distinguish what is here from what is there. *Agit-Kino* welcomes the visitor into an ambiguous representational landscape where here and there become destabilized categories. This destabilization is effected through plays on illumination and obfuscation heightened by only partially recognizable audio components.

The room itself is darkened, and the form of a tent, lit from the inside, colors the space with a faint sepia glow. The sound, form, and quality of light interpolates the visitor and sets out the basic undeclared rules of engagement: this is a sculptural work that occupies multiple senses. As a sculpture, it expands the space of encounter and refuses a single ideal position of observation. It invites an ambulatory experience where the spectator explores the different facets of the tent by wandering around the space.

Agit-Kino, Vignette 2

I've seen tents lit up like lanterns against the night. Anyone who has spent time camping and hiking through the wilderness is likely to be familiar with this sight. The spectacle of life-in-silhouette is a phenomenon of tent-life in the boreal forests

of the northern hemisphere. My first memory of being struck by the appearance of a canvas tent lit up like a kerosene lamp was out on the taiga in the northwestern corner of the Republic of Sakha (Yakutiia) in 1995. I was on a hunting trip with some friends in late November, when it was almost constantly dark and winter's cold had set in. I remember leaving the tent at night to go explore around the camp and look at the constellations. Though it was dark, the atmosphere was faintly luminous as light was cast all round, due to the stars reflecting off the snow. The larch trees (*Larix dahurica*), which are nearly all the trees in this part of the taiga, lose their needles in the winter and stand out like an incalculable expanse of skeletons. To the eye, the fine details of the branches that extend horizontally and circularly (like so many rays) play on revelation and obscurity. In numbers and by distance, they become dense and dark. When approached, through parallax effects, when the snow or sky becomes their background, the subtle particularity of the intricate growth of limbs, lateral branches, twigs, and abscission scars can be observed as silhouette in all their ornate beauty. The tent in the gallery reproduces this experience of shifting positionality; a kind of parallax is generated through the phantasmagoria of projected shadows and images.

Returning to camp after a short amble, I was struck by the appearance of shadows on the screen that our tent had become. The shadows reached their accuracy on the walls of the tent and stretched out into formless and faded shapes cast on the snow and trees surrounding us. Movement within the tent brought forms into proximal recognition before they were lost to indistinct blurring or

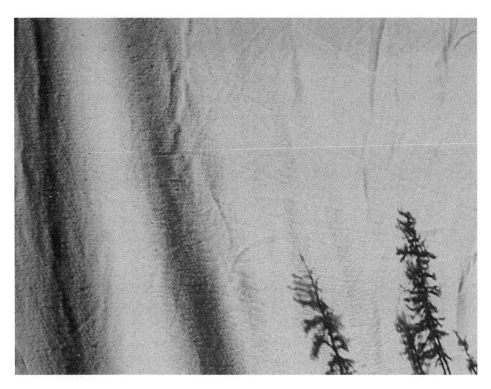

Figure 2.2 Still from *Agit Kino: Iteration no.2* by Craig Campbell.

melted into other shapes. In the long winter nights, canvas tents light up like fes-
tive lanterns. The soft orange and yellow glow of flame seeps out onto the snow,
illuminating the black forms of trees. Silhouettes of life inside are visible against
the wall and roof of the tent—which is generally an unbroken screen, its structural
form emphasized by the dark lines of the poles against the semi-opacity of the
tent wall. These silhouettes are variably recognizable and abstract, their legibility
depending on the shifting positions of the observer and the things observed.
Everything is in a state of motion when the twilight world imposes itself on this
everyday cinematic.

Quality of Light

Quality of light is arguably the phenomenon of greatest sustained concern and at-
tention for photographers. Their meters, aimed out at the world, are constantly
distinguishing, measuring, and marking figure from ground. In this effort, subjects
become the privileged concern of a refractive index, a calculus of optimal exposure.
Photography, as its name, practice, and intellectual history attest, begins and ends
in the lap of luminosity. "No matter which photographic technique is used, there is
always one thing, and one thing only, that remains: the light."[1]

In equatorial places, days and nights are roughly portioned into two equal parts,
each with a duration of twelve hours. As one moves further toward the earth's poles,
the variation in the length of day grows until it is either zero or twenty-four hours
at its annual extreme.[2] It is easy to imagine the heightened attunement to light and
darkness in the polar regions, where twilight is not an ephemeral occurrence but a
prolonged state of being in the world. Extended periods of *dusk* and *dawn* around
the summer and winter solstices persist with no regard to the industrial horologies
that structure daily life for most contemporary human societies. The terms them-
selves, dusk and dawn, seem wholly unfit to describe the protracted frontiers of
night and day in the circumpolar zones.

The quality of light in the subarctic and arctic regions of the northern hemi-
sphere has drawn the attention of writers for generations; the so-called white nights
of St. Petersburg are legendary, possibly due to their treatment by Dostoevsky in his
1848 short story of the same name (*Belye Nochi*), which forever tied dreaming and
waking together as an incidental effect of the northern summer. While the summer
months—north of the Arctic Circle, where night can seem indistinguishable from
day—are celebrated in film and literature and of course commoditized as a tourist
attraction, there has been somewhat less attention to the dark months at the bot-
tom of the year. The affective atmosphere at that time is something else: darkness
stretches out to eclipse daylight, and the sun's path across the sky becomes lower
and shorter, and then not at all. My own sense of being in winter's gloom from
having lived in Siberia as well as northern Canada has been not unlike a prolonged
moment of sleepwalking, where waking life and dreaming life can sometimes merge.
Rhythms and habits shift not simply because of the cold and snow but because

atmospheric cues indicate a collective ecological slumber. The anthropologist Piers Vitebsky describes a scene of Siberian camp life in his book *The Reindeer People*:

> Winter laid a hush over everything, and removed all sense of haste…Once, in the half-light of the midwinter noon, I noticed Peter sitting naked on a log in the snow, smoking a cigarette very, very slowly.[3]

The weird and sometimes magical atmosphere that prevails in winter's grey gloom can produce a surreal disquiet as much as it does a soporific familiarity. In the gloom, things are not always as they seem, and forms are notoriously difficult to distinguish from one another. Shadows are less certainly shadows; sometimes they are the things themselves. The gloom melts the border between things, burnishing the world with grey rather than blotting it out in black.

Indigenous peoples in the subarctic and arctic boreal forest in Siberia have, since time immemorial, developed economies based on a regular cycle of seasonal activities. Some indigenous people maintain such economies and live much of the year traveling from site to site, building and striking their tent-homes and on occasion returning to small settlements.[4] After the October Revolution of 1917, agents of the new Communist power chased down and met with the highly mobile hunters and herders of the northern taiga and tundra lands. In these encounters, these agents strove to convince the indigenous peoples to embrace communism. Eventually this project was eclipsed by overt coercion, but in the first decades after the Bolshevik victory, concerted effort was made to entice indigenous peoples to support and join the rapidly modernizing socialist state. This was a civilizing mission, and it was seen as a kind of Marxist enlightenment designed to wake the slumbering masses. The paternalist language of bringing the light of knowledge and progress to the supposedly dark, ignorant, and backward peoples of the north played a central rhetorical role. It seems the fervor of modernity sought to fix fleeting shapes and formlessness through categorization, order, and scientific method.

Chief among the instruments brought to bear on this so-called enlightenment project were machines and tools that not only served instrumental needs but that were part of a performative apparatus designed to mark the new regime as one that was modern, progressive, and powerful; rushing toward the Machine Age.[5] The visual rhetoric of enlightenment and modernization was everywhere, in posters, flyers, leaflets, newspapers, and photographs, and not only in Russia. The scene of a small group of people gathered together observing the projected image might be one of the emblematic moments of becoming modern. Eyes fixed on the screen, the spectator becomes further drawn into that "historically unprecedented amalgam of new practices and institutional forms (science, technology, industrial production, urbanization), of new ways of living (individualism, secularization, instrumental rationality), and of new forms of malaise (alienation, meaninglessness, a sense of impending social dissolution)."[6] When Communist agents set up machines to project films and educate the "northern masses," the flickering light that burst out past

the gate and through the lens did more than carry an image; it played a symbolic role in defeating the long arctic night and extending the state's civilizing mission. The clarity of electric light with its constant and harsh shadows differed from the dynamic light of flame, just as the violent activism of universalizing Soviet ideology differed from myriad particularities of lives lived by indigenous peoples in Siberia.

V. I. Lenin, the first leader of the Soviet Union, famously stated in 1920: "Communism is Soviet power plus the electrification of the whole country."[7] The projects of cultural enlightenment were paired with economic development; they both faced the challenge of enacting this project with a population of highly mobile nomads. The light promised by electricity and that promised through Marxist knowledge were connected and tightly bound to Soviet cinema's pedagogical mission. As Lenin's aphorism suggests, socialist modernity would be technological or it could not be. The lightbulb not only hung from the ceiling but was also cloistered in the projector's obscure interior.

Among the instruments of cultural enlightenment after 1917, cinema is perhaps the most famous. It was recognized in the earliest days of socialism as an ideal tool for propagandizing the masses.[8] One prominent Bolshevik cultural worker and theorist wrote in 1918 that "the technical novelty, relative cheapness, portability and diversity of repertoire will enable cinema to penetrate the most god forsaken holes of our country, profoundly affecting the inhabitants who have never seen such a spectacle. Everywhere we could have one million grateful viewers."[9] An itinerant projectionist with no more than a few reels of film and a hand-cranked, dynamo-powered projector could deliver the very same message across great distances to the diverse and largely nonliterate subjects of Soviet power. It was, as the film historian Yuri Tsivian writes, a "fragile but effective tool to gain support among the overwhelmingly illiterate peasant masses."[10]

While agents of Soviet power were building outposts and bases across Siberia, others were traveling directly to the remote settlements and camps of the northern peoples. Acting as organizers, educators, enumerators, and social agitators, these cultural workers met with the most remote groups of indigenous people across the Siberian north. Cinema was one of the most dramatic and spectacular items in their kit of technological gadgetry. The spectacle of the machine, its precise instrumentations and commanding presence, might have been as important as the films it showed in capturing the attention and imagination of the audience. Tsivian describes this fleeting moment of cinematic history as the ambulant age, a time when "no specific cinema architecture existed in Russia."[11] The vernacular architecture of the ambulatory cinematic space was improvisational. It followed the pragmatic demands of the medium: room enough for an audience, relative darkness, a clear surface on which to project the image. The ephemeral scenes fleeting across the back wall of a tent or a bedsheet slung opportunistically on a cabin wall competed with the hand-cranked machine and the body of the projectionist for the attention of the audience. While the production of the film was obscure to the spectators, the mechanism of its delivery was not. Out of this strange box and through the

Figure 2.3 Still from *Agit Kino: Iteration no. 2* by Craig Campbell.

specialist labor of the city-trained operator, compelling scenes of life from remote places were shared; the cinema thus began the work of producing new dream-worlds, new shared imaginaries.

One of the earliest accounts of cinema in Russia comes from Maxim Gorky, who wrote at the end of the nineteenth century the following review of a film program by the Lumière brothers projected at a fair in Nizhny-Novogorod:

> Last night I was in the Kingdom of Shadows. If you only knew how strange it is to be there. It is a world without sound, without colour. Every thing there—the earth, the trees, the people, the water and the air—is dipped in monotonous grey. Grey rays of the sun across the grey sky, grey eyes in grey faces, and the leaves of the trees are ashen grey. It is not life but its shadow, it is not motion but its soundless spectre.[12]

What kind of life was reproduced through these gloomy shadow documents shown through the farthest corners of the Siberian north in the long dusk-dawn of a summer night or winter's prolonged twilight? The images projected were traces made spectral and haunting not for producing nostalgia but for inciting a passion for the future sculpted in the Communists' own dreamworld. The soundless specter

31

Figure 2.4 Composite by Craig Campbell, based on an undated photograph by Kopylov from the Krasnoyarsk Krai Regional Museum archives (kkkm_150–009).

of life in Soviet agitational films bore a resolutely forward-looking agency to the intimate spaces of rural projection. *Agit-Kino* as historical parallax admits a glimpse of figures from the past, but it also amplifies the impossibility of their acquisition. The gap between there/then and here/now divulges implacable antagonisms. The gallery provides its own enclosure for the tent, which is itself an infallibly interesting spectacle of light and shadow, an inversion of communism's failed enlightenment in Siberia's protracted cycle of dusk and dawn.

Notes

1. This quote from Jean Baudrillard is in many ways emblematic of the literature; J. Baudrillard, "Photography, or The Writing Of Light," 2000, www.ctheory.net (accessed April 27, 2013).
2. The quality of light is a subjective metric. In contemporary photography, it is generally recognized as a difference between the "harshness" and "softness" of light (cf. Boyd Norton: "No meter can measure quality of light. You just know it and feel it. Most often that soft warm glow of sunlight at dawn or dusk has magical qualities."); see B. Norton, *The Art of Outdoor Photography: Techniques for the Advanced Amateur and Professional* (Stillwater, MN: Voyageur Press, 1993), 22.

3. P. Vitebsky, *Reindeer People: Living with Animals and Spirits in Siberia* (London: HarperCollins, 2005), 183.

4. Northern countries or regions are often examined comparatively as part of a "complex" that defines the Circumpolar North. This has tended to emphasize similarity of ecology (flora, fauna, geology) and culture (material culture, spiritual culture). The effects of light and darkness have received relatively less attention.

5. A more nuanced consideration of this moment must acknowledge that the Soviet regime not only had to mark itself as progressive and modern but also had to define these terms. Thus, revolution was not so much a matter of convincing people of something that was self-evident but was a matter of cross-cultural communication, of translation and conversion; cf. Robert Herbert., "The Arrival of the Machine: Modernist Art in Europe, 1910–25," *Social Research* 64, no. 3 (1997): 1273.

6. See C. Taylor, "Modern Social Imaginaries," *Public Culture* 14, no. 1 (2002): 91; this discussion might be extended by looking at Yuri Tsivian's investigation of the history of the famous train scene in *Early Cinema in Russia and its Cultural Reception* (London: Routledge, 1994), 144.

7. This famous quote from Lenin appeared on posters beginning in the 1920s (Widdis, *Visions of a New Land*) and has been republished and repeated innumerable times (See E. Widdis, *Visions of a New Land: Soviet Film from the Revolution to the Second World War* [New Haven, CT: Yale University Press, 2003], 26). It originated in a speech title "Our Foreign and Domestic Position and Party Tasks," which was delivered to the Moscow Gubernia Conference of the R.C.P.(B.) on November 21, 1920; see V. I. Lenin, *Lenin's Collected Works*, vol. 31, 4th ed. (Moscow: Progress, 1965), 408–26.

8. Cf. R. Russell, *Russian Drama of the Revolutionary Period* (London: MacMillan, 1987).

9. Platon Kerzhentsev quoted in J. Oille, "The Art and Politics of Soviet Agitation 1917–1925: Film, Poster, Theatre" (PhD diss., University of Sussex. 1977), 63.

10. Tsivian, *Early Cinema in Russia and its Cultural Reception*, ix.

11. Ibid., 15.

12. C. Harding and S. Popple, *In the Kingdom of Shadows: A Companion to the Early Cinema* (London: Fairleigh Dickinson University Press, 1996), 12.

3

ENTRADA PROHIBIDA (FORBIDDEN ENTRY)

Juan Orrantia

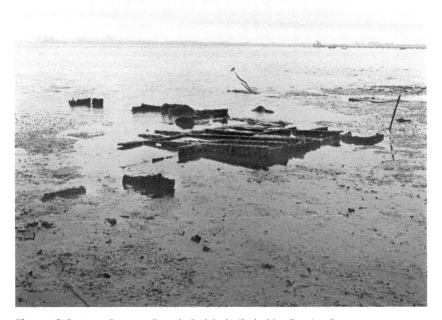

Figure 3.1 Juan Orrantia, Entrada Prohibida (Forbidden Entry), still photograph, 2010–11.

Imaginary Detours from the Other Side of the Fence

When I first entered the port in Beira, I was taken in by the magnitude of industry and commerce in this space. Electric wire, diesel trucks, and containers replaced the romantic imaginary of piers and harbors in cities such as these that were built facing the sea. I began to look for traces of sea life and its imaginaries within the

confines of the port. The photographs I started to make very quickly stopped being about a country or even about the enormous ships I saw. Rather, what drew me in were moments where I could feel the presence of quietude, or the openness of the sea increasingly restricted by a sense of encroachment. My images began to follow what I imagined to be elements of melancholy and nostalgia coexisting in this space with the materiality of capitalism.

Entrada Prohibida (EP; Forbidden Entry) was an effort to pursue the critical possibilities of evocation as a documentary approach. I was interested in exploring a form of documentation of that which has become difficult to see as a result of the private nature and seclusion of ports, as well as of the rapid rhythms defined by structures of economic efficiency that shape their functioning. The idea was to create a documentary piece based on images of industrial intimacy. Through them I wanted to engage what I felt were moments and feelings of alienation, desolation, and even nostalgia and melancholy present in the surfaces, textures, and conditions of these spaces.

> The waiter came back to our table, shooing the girl away, and set down four pieces of paper as placemats. They were shipping schedules, detailing lists of Ships, Ports of Call, ETA and ETD, Voyage Number, Flag, Agents and other indecipherables such as: Line Advert, Service, Terminal and EGM. The last column was To Load For ("sort of like 'to die for' but less intense")...and there were a wealth of place names: Riga, Ashkabad, Fos, Beira, Abidjain, Leixoes, Thesaliniki, Stavanger, Limassol, Monrovia, Lomé, Mouakchott, Port Gentile...I'd never before given thought to what it meant to be part of a port city, to leave the imprint of a tea-wet spoon on names of places that preferred coffee, to have these strange and foreign syllables intrinsically involved in the commerce of the place, to look at the man two tables from you and wonder if, for all his lack of external signs of affluence, he knew the word for "ocean" in thirty different languages or the taste of fish cooked in a hundred different spices, and knew too, despite all his traveling, that home meant this alley and these place mats and those different dialects swirling around him.[1]

In the ports of Mozambique, I looked for things that came at chance encounters, where being in a place allows one to ponder and think of how things were, are, or could have been. I looked for things or moments that can stand in for what is maybe just suggested there. Like a branch of a mangrove tree coming out of the water at high tide or an old man struggling out of the muddy beach (Figure 3.2). Devoid of any apparent direct meaning, they are images that derive from a critical contemplative approach to the surroundings, to what a repeated presence in the space can begin to open up to the visitor. In this way, they are informed by aspects of narrative ethnography as well as (experimental) documentary and some forms of contemporary photography and art that recognize the potential of the poetic and reformulate notions of witnessing, wanting to elide the contraptions of meaning.

Many of the elements that make part of the political economy of the contemporary port such as the seclusion from the city, worker's alienation, and the presence

Figure 3.2 Juan Orrantia, Entrada Prohibida (Forbidden Entry), still photograph, 2010–11.

of historical referents within the new structures of capital take place in slow motion and are restricted to our ways of seeing. Because of this, they demand a more open understanding of the photograph that goes beyond the mere representation of the moment. My role then was not to be there to "capture" and illustrate the events. Rather, I wanted to produce pieces that extract moments of these conditions or situations, some of which are not even actions (in the sense of traditional photo-journalism). My images are thus constructions that rely on aesthetics, mood, and even randomness, rooted in my thinking, intuition, and information of what is going on. What one has then is an approach (in this case) to a place where the viewer is allowed various forms of witnessing: you can imagine something else, you can describe what seem to be moments of a scene, or as in some images you can actu-ally see something that is providing some sort of referent about ports in such parts of the world: a lonely container open to a vista, a worker enmeshed in coal dust, a doubly dead fish. What all these images have in common is that they are rooted in the real but still provide the possibility of a detour from it.

Wanting to engage circumstances and not just individuals, my aim was to speak through and along the textures, moments, and even notions of time. It's not really a question about the people per se, in the anthropological sense. Rather, I was closer to the idea of portraiture of place, such as that in the works of Indian photographer

Dayanita Singh, where the framing, light, and composition of empty rooms or lonely streets brings out emotion present in the environment as a way of speaking to the viewer. Her black-and-white images and especially her recent works in color are apparently simple but have the capacity to trigger something that is not necessarily contained as information, reverting one to stories or imaginary conditions of the place.[2] This goes hand in hand with the way one shoots, with choices that are enabled by the medium of photography. For example, using medium-format film allowed my project to be reworked after I actually saw what I had and to give prevalence to details, textures, choice of color or black and white; in a sense, to use the materiality of photography to enable feelings or sensations. Black and white allowed me to abstract and distance myself from more realist approaches to ports and their usual representations (think colorful stacks of containers), and film's quality and current status suggests notions of past time. But still, within an anthropological context, such choices are in tune with aspects of what David MacDougall called a reconceptualized visual anthropology and its affinity to the sensual (topographic).[3] In this way, the work is permeated from various perspectives, all of which in a way pollute each another. As a result, the series is based on the frictions of both the conceptual thinking and the aesthetic production, where the images contain traces of concepts and ideas rooted in critical thinking about place, capital, and even history but communicate them (or at least intend to) through the poetic possibilities of the photographic medium.

This approach shapes the notion of the document in my work. The end product was not a visual representation of the port as such, of the working environment, but rather it was a document of feelings, moments, and textures that suggest something about melancholy and nostalgia as conditions in port life, past and future. The intention of this suggestive aspect is then to open a space for the imaginary within the real, as a form of exploring a place without describing it in detail, creating a platform where multiple dialogues are possible both within and beyond the frame. By doing this, the limits of place imposed by traditional ethnographic conception, as well as the meaning of the real through the notion of documentary representation, are blurred into a space where the evocative can fill in for both of them but is not restricted to either.

Recognizing the history of the critiques of representation in anthropology and cultural studies as well as to debates in art criticism and photography regarding definitions of documentary and art, one sees that even though the tension is still very much alive, the range of experiments, border crossings, and nurturing pollutions continues to grow. There are more works now that explore the intellectual possibilities of photography, leaving the individuality of the image in order to pursue the creative possibility of collaborations across media. It is this unresolved tension that continues to encourage my work. It allows me to explore ideas and conceptions of fictions and nonfictions, of immersing myself in the expressive as a real life critical experience. In the case of EP, I was faced with a partially abstract reality, that of the conditions in the port and its relationship to the changing face of sea life, to the implications of vast economic movements of import and extraction

into postcolonial, postwar countries. The representation of this reality, neverthe-less, can be engaged through its own detours, through paths into the complexity that lies beyond what the traditional approach of photography as the iconic image or the (ethnographic) illustration with captions can deal with. But it doesn't mean either that one jumps off in the direction of art as total subjectivity. Here, I remem-ber South African photographer Jo Ractliffe speaking about her own work on the landscapes of postwar Angola. Working through the tensions of shooting straight (sharp focus, the recognition of a subject, careful looking, and clarity), she had to negotiate and recognize what she calls "[my] need for mimesis, an anchor to the real, but equally, my need to shift the fixity of the photograph, to call into question the acceptance of the real and insert something of the 'unreality' of experience."[4] So one has to continuously search and experiment with ways of getting immersed in these muddied terrains, of opening up the idea of photography and its relation-ship to text, to the idea and forms of the book, to sounds and multimedia, to how and where the work is shown, and of course, to the way of conceiving and produc-ing still photographs. In all, it requires embracing the possibilities of the expressive within a certain sense of limits.[5]

This does create a distance with traditional notions of ethnography, even if part of my intention was to speak to the conditions of people that work, and make up, this environment. Because I am actually not there to visually tell a story, to spend a long time of fieldwork in order to recognize situations or events as they (temporary) are, or even to obtain a sense of understanding of the people por-trayed. When people appear in my series, they are either cropped in some way, blurred through low light situations, their faces or bodies covered or obstructed by structures or clothing, or simply just shot at a distance where they are seen as part of the industrial environment. These weren't choices done for any "ethical" reason but rather for the emotive quality that the aesthetic creates through the suggestion of human presence-as-an-emotion within the industrial atmosphere of the port. My relationship with them was not an "ethnographic" one in the tradi-tional sense. Rather, it was about creating moments where the interaction stood in for an emotion or feeling, but one that was left to the encounter or reading of the viewer. I think an interesting approach that is somewhere in between mine and strict portraiture is the work by anthropologist and photographer Thera Mjaaland in her series Encounters.[6] Here, even if the picture itself is a portrait that, as she states, was self-defined by the person represented, the layout of the images in a grid of continuous shots creates a more cinematic version of the portrait. This use of repetition and sequencing interrupts the traditional approach that has to capture the essence of the person in a frame and opens up the space for a dialogue with the image. This dialogue can be with the conditions of production of the image and even with the possibilities of photography to re-craft stories and produce com-mentaries in different ways.

Such an approach was crucial for me to be able to leave the ethnographic present and follow imaginary paths into ideas of the past and the future of ports.

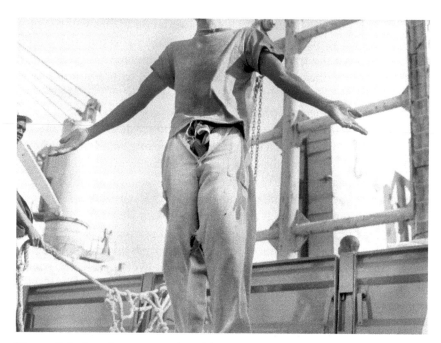

Figure 3.3 Juan Orrantia, Entrada Prohibida (Forbidden Entry), still photograph, 2010–11.

Things Past as Musings on the Future

> The beach then, is the ultimate fantasy space where nature and carnival blend as prehistory in the dialectical image of modernity.
>
> —Michael Taussig[7]

The contemporary maritime world is the space of migrants, refugees, pirates, military fleets, petty traffickers, political activists, and floating sweatshops. The rise of new economies, strategic alliances, and ongoing conflicts has increased the presence of financial capital hubs, Chinese and Indian industry and workers, Islamic militias, and narcotics trade routes in the African continent. Today, in quiet voices, people in Maputo speak about tacky malls that serve as money laundering facades of businessmen with ties to the Middle Eastern narcotic trade that use Mozambican ports to smuggle drugs into this new rising distribution hub. Somali refugees flee to Tanzania and Mozambique, some taking the risk on small rafts along the sea. Mombasa and Beira are now the southern border of the official Indian Ocean pirate zone, a passage that has increased the insurance costs of cargo ships in the region. Partly in response, military training operations take place along the east African coast, as the United States and Europe try to retain their control in a post–Cold War and post-9/11 environment.

The current landscape of east Africa thus involves a historical relationship with the sea. In it one will find—but more so cannot ignore—the traces of slavery, colonialism, migration, and economic control that were set in motion years before and that now share a space with aid, consumption, and new rising economic powers. The presence of the sea is therefore crucial in discussions around contemporary globalization and the future of Africa.[8] The future as such is contained in the sea. This requires that we pursue new ways to address the tensions between the past and the present/future within in it.

Works by artists such as Allan Sekula and the Otolith Group have focused on the sea and its relation to notions of past and future. Sekula's work, informed by Marxist thought, approaches art as a form that goes beyond the mere act of representation and seeks to act as political intervention on the workings of capital(ism). His photo series Fish Story and the more recent film *The Forgotten Space* (2010)—coproduced with Noel Burch—have aimed their critical eye towards political economic issues around the transformation of ports and the social implications of this new economic landscape around the world. In a more experimental approach, the Otolith Group follows the legacy of Chris Marker to create film works where the future and the past are discussed in their own relationships as aesthetic and experimental political forms. Works such as *Hydra Decapita* rely on imagined worlds that step in as reflections on the ongoing (historical) conditions of capitalism and the legacies of slavery. What works like these have shown is that through artistic forms of documentary, spaces such as the sea and its ports can be read through their own poetic conditions, a kind of poetics of possibility if you may.

With these possibilities in mind, my own approach to the sea and its ports was to engage the rugged or even fantastical spaces of sea and industry as places that contain nostalgic elements that speak to the futuristic. Amidst the ships, the piles of containers, the stains of coal, and the rumble of engines, there are elements of some imagined possibility of what was and what is. I focused on water, on the changing movement of tides as reminders of the constant play between concealment and revealing. These elements, however, are not based on economic or sociological projections of the future of capital but rather are expressed through the poetics of nostalgia, where traces and specters continue to inhabit the industrial landscapes of the present/future. Through their subtlety, through their own unresolved meaning, they have something to say about what is not there yet resolved but rather is being resolved—or what Sarah Nuttall sees for other such contexts as "contested stories whose full meaning is only beginning to come into play."[9]

It is to these specters, to these traces that my work pointed to by focusing on textures, walls, situations, and other such things that forms of documentary arts allow. As an expressive form of documentary, exploring the futuristic through the nostalgic and melancholic can become a critical speculation on the power of remnants and the (il)logics of capital. In the search for things, for light, and in the constant sense of looking, one can find such remnants, some materially present and others suspended and inscribed in textures or objects being reused: for example,

41

buildings that were once Portuguese sailors' quarters, customs offices, and lodges, today are nothing more than decrepit pieces of walls covered in human shit and old writings, serving as shelters for private security guards on the perimeters of the port. Their inscriptions, textures, and mere presence speak to the history of the port through a sense of dilapidated existence being reused and acquiring new meanings. This of course is not restricted to objects or walls but also to the changing circumstances of workers. That is why the picture of a man with his arms extending in a Christ-like figure with the focus on his crotch will stand in for a series of tropes that the image contains (Figure 3.3). It invites but also closes off—much like the port itself. Thus, I want it to suggest, to reveal, to contest, and to speculate. The same goes for vistas with glimpses of submerged metal structures that once were ships and are rotting subjects at the will of the tides but that sometimes also serve as scraps of recyclable metal for the poor that live on the other side of the fence (Figure 3.1).

These things lying within the port space seemed to me to speak as much as the silent workers. They share the space, they make it, they inhabit it, and, sometimes, like the rotting ship that serves as home for an old sailor (Figure 3.4), they even become the space of inhabiting themselves.

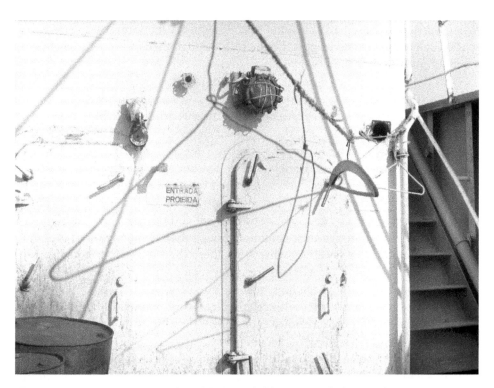

Figure 3.4 Juan Orrantia, Entrada Prohibida (Forbidden Entry), still photograph, 2010–11.

Notes

1. Kamila Shamsie, *Kartography* (Orlando, FL: Mariner Books, 2004), 234.
2. See her works *Privacy* (Göttingen: Steidl, 2004), *Sent a Letter* (Göttingen: Steidl, 2008), and *House of Love* (Santa Fe, NM: Radius Books, 2011).
3. Describing new principles in visual anthropology, MacDougall refers to the topographic as that which encompasses the anthropology of place and space; of rootedness and displacement, migration, diaspora and memory; questions of cultural boundedness, locality, and history; colonial and postcolonial struggles for identity; and the study of social life-worlds as they are materially and culturally constructed. See David MacDougall, *The Corporeal Image. Film, Ethnography, and the Senses* (Princeton, NJ: Princeton University Press, 2006).
4. Jo Ractliffe, "Introduction: Terreno Ocupado: Extracts from Letters to Okwui," in "Exodus of the Dogs," ed. Okwui Enwenzor, Special issue of *NKA, Journal of Contemporary African Art,* Winter 2009: 62–77.
5. See Mark Nash, "Reality in the Age of Aesthetics," *Frieze* (April 2008), http://www.frieze.com/issue/article/reality_in_the_age_of_aesthetics/ (accessed April 2013); Elizabeth Edwards, "Beyond the Boundary: A Consideration of the Expressive in Photography and Anthropology," in *Rethinking Visual Anthropology,* ed. Marcus Banks and H. Morphy (New Haven, CT: Yale University Press, 1997), 53–80; and Michael Taussig, *My Cocaine Museum* (Chicago: University of Chicago Press, 2004).
6. I thank the editors for introducing me to the work of Thera Mjaaland. I am specifically referring to the presentation at her website: http://thera.no/?document_id=351. See also her contribution to this volume (chapter 5).
7. Michael Taussig "The Beach (A Fantasy)," in *Walter Benjamin's Grave* (Chicago: University of Chicago Press, 2006), 109.
8. See Pamila Gupta, Isabel Hofmeyr, and Michael Pearson, eds., *Eyes Across the Water. Navigating the Indian Ocean* (Pretoria: Unisa Press, 2010).
9. Sarah Nuttall, "Notes from a City in the South," in *South-South: Interruptions and Encounters,* ed. S. Tejpal, Aji Soske, and John Soske (Toronto: Justina M. Barnicke Gallery, 2009), 61.

4

SPEAKING NEARBY: ANTHONY LUVERA IN CONVERSATION WITH CHRIS WRIGHT

Anthony Luvera

Anthony Luvera (AL)—I first began working with people who have experienced being homeless around 2001. Since then I've worked with hundreds of people in cities and towns across the UK, including London, Colchester, and Belfast. Over this time I've accumulated a large collection of material made by the participants, created independently and in collaboration with me, including photographs, writing, maps, and video recordings. Recently, I've been preparing to continue this work in Brighton, and I'm excited by further exploring the potential of using still photographic images with sound recordings.

While I was working in Belfast to create *Residency*, I made a number of audio recordings. But in doing so my intention was to record something of the conversations I had with the participants about representation and their experiences of photography, rather than to conduct interviews that focused directly on the stories of their lives or their issues with accommodation. I wanted to try and find out something about how they felt about being inscribed as homeless and to get a sense of their view on the process of working with me.

A number of selections from the collection have been shown publicly in different contexts in festivals, conferences, exhibitions, and publications. For a recent exhibition in Dublin, part of an international photography festival called Photo-Ireland that was curated around the notion of diaspora, I presented work about a particular individual called Ruben Torosyan. The installation included photographs made by Ruben, an *Assisted Self-Portrait*, Polaroids, and hand-drawn maps related to our working together between 2004 and 2009. Ruben and I chose the selection of material and devised its arrangement for the wall for an earlier exhibition in London in 2009 at a festival called This Is Not A Gateway.

At the time that this work was created, Ruben was sleeping rough in various places across London. Sometimes he'd sleep in offices; he would go in at the end of the day, hide himself somewhere on the premises, sleep there overnight, and then get out first thing in the morning. Ruben would draw maps in order for me to find

Figure 4.1 *Assisted Self-Portrait of Ruben Torosyan,* Ruben Torosyan/Anthony Luvera, *Photographs and Assisted Self-Portraits,* 2002–ongoing.

Figure 4.2 Installation view of *Ruben Torosyan/Anthony Luvera,* exhibited at PhotoIreland Festival 2012: Migrations, Diaspora & Cultural Identity.

him. These maps served an important purpose at the time in enabling me to locate him and now serve to represent something of the process of our working together.

With much of the material in the collection, in many different ways, I know something of what the participants were trying to communicate in the photographs they made. But in making the collection available to others, it is not always possible to convey their intentions or my understanding of them, and this information might then be disaggregated from the images. I'm interested in how using some kind of oral recording could serve as a way to address that separation.

Chris Wright (CW)—One of the things students often do when they start to use audio recordings within anthropology is say they are going to interview someone, and that's often the death of actually generating any useful material. People have suddenly got to think about what information you want; then they try to second-guess that. It's often far more useful to set up situations where people can talk much more open-endedly, rather than try to conduct something you describe as an interview.

AL—So much of what I do involves getting to know people, spending time together, talking, and listening. I've always been interested in the problems of documentary representation and in exploring the potential of finding ways for participants to express aspects about themselves in the work I make. A statement once made by Trinh T. Minh-ha about not intending to speak about her subjects but rather to speak nearby has always stuck in my mind.[1]

In recording conversations with participants, I want to hear the individuals speak about their experiences and points of view. I certainly don't see these recordings as interviews in a formal sense, even though I may ask questions or guide the conversation toward certain ideas or topics that I am interested in hearing about.

CW—Your work seems to throw up questions about what it means to document someone and their life. Lots of contemporary artists appeal to an idea of documentary, but with the particular content of your work, is there a necessary tension between documentary and evidence?

AL—There's definitely a tension between the notions of documentary and evidence. Both have a slippery relationship to each other and in turn to ideas of truth, authenticity, and the real. This tension is what drives my work in some respects. Critiques directed at documentary over the past thirty years or so, by writers and artists such as Martha Rosler, Allan Sekula, and Abigail Solomon-Godeau, that call for a critical, self-reflexive use of the medium and its contexts interest me a great deal. Perhaps there can't ever be a perfect form of documentary, and I'm certainly not striving to find one. I'm just interested in hearing and telling stories about other people and to try to say something about the process of undertaking this work at the same time.

CW—An ethics of witnessing is apparent in your work, and *ethics* is a word that provokes some artists into a strong denial of the kinds of responsibilities that come with it. But you make a very clear set of decisions about the way you witness, in terms of what it means to bear witness. There are a set of ethics involved in

producing the kind of work you do—in the process—but also a set of ethics in what becomes of that work afterwards, what happens to the archive.

AL—I was once asked if one of the methodologies I employ is to form long-term relationships with people. I never embarked on this work with this in mind. I don't think, Right, I need to know this person for a long time, and then strategize to make this happen. Relationships develop and grow and change, and that's all part of the process of knowing anyone. I am still in regular contact with some of the participants I have worked with since 2001, while I have lost contact with many others. Part of what I'm interested in is not only to try to mediate something about the experiences and points of view of the participants who take part in my work but to also try to say something about the process of working with them and the material they entrust me with and the questions I ask myself along the way.

The kinds of questions I feel compelled to ask in my work are inextricable from certain ethical considerations. What does it mean to give consent? Can consent ever be truly informed? What implications could arise when the work is presented in a particular context? How can I maintain the participant's intentions for their photographs in the collection when I no longer have direct contact with them? What are the ramifications of authorship in a practice that uses photographs made by other people?

I do feel a sense of representational responsibility, but I don't see the consideration of ethics as a burden. In many ways I see it as productive force.

CW—Do you feel you draw on a model of ethnography?

AL—Not specifically. However, I am very interested in many of the debates and practices coming out of ethnography and visual anthropology that examine the power relations involved in making and showing representations of other people. I'm also particularly interested in how the processes of working with subjects/participants can be represented and how understandings of reflexivity can inform the process, production, presentation, and reception of work conducted in these fields.

CW—Anthropologists often come in to contact with people who have very different notions of what a document is, what it means to document something, along with different ideas of how representation itself functions. But they often fail to think about what implications those have for their own representations. Our ideas of documentary come out of particular genealogies of thought and practice. Anthropologists sometimes fall back into using that word as if deciding to document something is somehow more value-free or that it exists somehow outside of representation—there is representation and then there is another category which is documenting.

AL—In trying to represent something of the process of making *Residency*, I recognized a difficulty in making the selection of documentation images that feature in the body of work. It seemed to me that they would still serve as a depiction that would narrate from a particular point of view, despite the fact that the images were made by a number of people ranging from passersby on the street, friends of the participants,

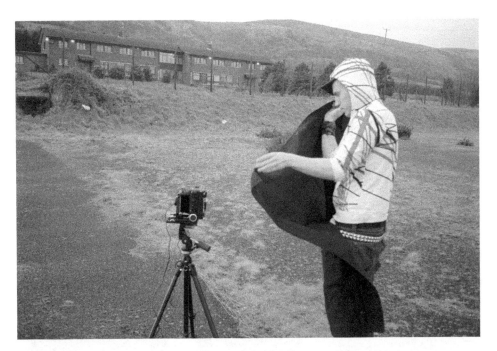

Figure 4.3 Documentation of the making of *Assisted Self-Portrait of Chris McCabe, Residency*, 2006–08.

the participants themselves, as well as me. The representation of the process of documentary representation would still subject to the vagaries of representation itself!

It seems to me that some of the work that is being done in anthropology and the questions it asks of representation can be useful in that it's subject to different kinds of influences than documentary photography and art practices. Especially in relation to the gallery system—and the impacts this can have on a photographic practice both methodologically and ethically. I'm really interested in thinking through how contexts I present work in can be used. I'm not averse to using a gallery, but there are a whole set of issues that come with this particular context which weigh differently to presenting work in an environment like the London Underground, a public square, or a disused retail space.

CW—Your work constantly questions what a document is; you're constantly pushing at that category.

AL—One of the things I'm constantly thinking about in my work is how process can be represented and how the contexts in which the work is shown will affect its reception by an audience. It seems to me that work which self-reflexively undertakes to explore the process of representation requires a different set of criteria for handling and judgment than an approach that might be described as being more traditional or that which is made for the commercial gallery system.

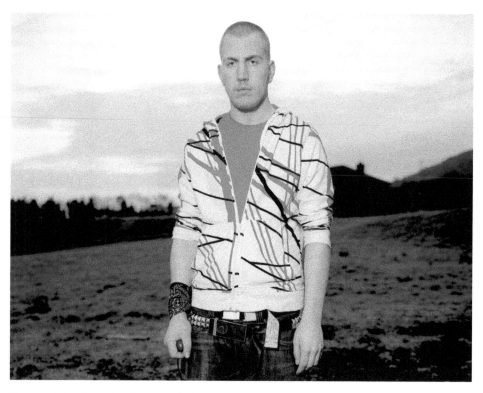

Figure 4.4 *Assisted Self-Portrait of Chris McCabe*, Chris McCabe/Anthony Luvera, *Residency*, 2006–08.

While I was working with Ruben, over a period of time, he produced a set of self-portraits taken from a frontal view and a side view. To an audience with some knowledge about the history of photographic representation, these images may be seen to resonate with the kinds of anthropometric studies made by the pioneer of composite photography, Francis Galton.[2] But Ruben's intention in making these images was to see how his body was changing and his health was deteriorating. I don't have any recorded descriptions by Ruben about his intentions in making this set of images, but this is an example of the kind of gap I mentioned earlier that I think could be useful to explore through sound recordings.

CW—Are sound recordings part of what you refer to as your archive? Particularly when you think about the ways in which an accent often forms part of people's identity and sense of attachment to a location.

AL—I think you're right. Accents, other sounds, and ways of speaking often do situate people in various ways. I consider all of the material that I have gathered, including sound recordings, as part of the archive. Most of the audio I have recorded up until now was done without a specific intention of broadcasting or presenting it. I've

seen it more as being part of a broader process of recording my exploration of the photography work I undertake with the participants. However, I think taking the use of sound recordings further might enable other dimensions of the work to come forward—not only in terms of recording the participant's intentions, descriptions, and ambitions for the photographs they make but also to represent the dialogues we engage in and to depict other dimensions of who they are and our process of working together.

CW—Of course, when we start to think about photography as a social process—it is as much about those kinds of conversations, oral histories, and relationships as it is about a particular kind of object—then the ways in which that process appears, or not, in an archive or collection is fundamental.

AL—I didn't embark on this work with a fixed idea of assembling a collection or an archive. As the work has developed over the years, a sense of guardianship for the safekeeping of the photographs, negatives, and other pieces of ephemera related to the participants and our working together has grown stronger. At the same time, it became ever more apparent to me that the collection in parts and as a whole might be able to usefully contribute to discussions about issues related to homelessness. That's really how I started to think of it as a collection. These are some of the ethical concerns that come with doing this kind of work, and I think they need to be taken up by artists as much as anthropologists.

Notes

1. The Vietnamese-American filmmaker, writer, composer, and academic, Trinh T. Minh-ha released her first film, *Reassemblage*, in 1982, created through ethnographic field research conducted in Senegal over three years. In this film Minh-ha critically reconsiders traditional conventions and techniques of ethnographic filmmaking through the use of nonlinear narrative, experimental soundtrack, and disjunctive editing. In the opening narration to the film Minh-ha states, "I do not intend to speak about / Just speak near by."

2. Sir Francis Galton (1822–1911) was, among many other things, an anthropologist and eugenicist who devised a technique called composite photography. Images were produced by superimposing and combining multiple photographic portraits of different individuals to make one photographic image to represent a sort of natural kind—criminals, patients with tuberculosis, and so on. The intention was to arrive at a composite that could generalize the facial appearance of his subject into a type. Galton hoped his technique would aid medical diagnosis and even criminology through the identification of typical criminal face, but, after many experiments, he concluded that such types were not attainable in practice.

5

TRAVERSING ART PRACTICE AND ANTHROPOLOGY: NOTES ON AMBIGUITY AND EPISTEMOLOGICAL UNCERTAINTY

Thera Mjaaland

When established as a subdiscipline to social anthropology in the 1970s, visual anthropology came to mean film, not photographic still images. In spite of situating the filmmaking process in an intersubjective ethnographic encounter, observational ethnographic film—entailing remnants of a positivist attitude toward objectivity that deal with photographic representation as evidence—did not inspire a revisioned use of still photography in modern anthropology. Similarly, the increased focus on the archival ethnographic image from the perspective of asymmetrical power relations was—together with the postmodern discussions of the photograph's truth-value, which took place as photography pushed its way into the contemporary art scene—not conducive to a reentering of the photographic still image in anthropological research. Relegated to a use as *aide-mémoire*, the photographic still image continues to inhabit an inferior position within anthropological texts, not least due to the insignificant role these, most often amateurish, visual illustrations from the field play in anthropological analysis. Rather, being aware of the illusions about objectivity implied in photographic representation, Fredrik Barth emphasized the distraction that taking photographs represents for the full immersion in participant observation during fieldwork.[1]

Based on the discouraging outcome of her own (inadequate) photographing during fieldwork, Kirsten Hastrup also argued that still photography was not able to transform the sensory experience and totality of a social event into a two-dimensional photographic image.[2] Hastrup used this realization to assert that text and visual representations in anthropological research assume a hierarchical relationship in terms of authority. Her much quoted argument hinges both on the failure of photography to provide authentic representation in an objectivist sense *and* the assumption that because the photographic representation is realistic it "*must* be taken at face value."[3] While her argument downplays the problematic aspects of textual representation, Hastrup does point, even though implicitly, to the ambiguity of photographic

representation. As Mary Warner Marien asserts, the photographic image simultaneously confirms and denies truth while emphasizing the appearance of accuracy.[4] It is this disruptive nature of photography and the visual ambivalence entailed which Barbara Wolbert terms "the subversive potential of photography"[5] and which she suggests is the reason for photography's marginality in modern anthropology, since this disorder "tends to undermine ethnographic authority."[6] In the following, my photographs from Tigray, in northern Ethiopia—with the title Ethiopian Encounters (Figure 5.1)—which traverse the fields of art and anthropology alike, will together with the art projects Houses/Homes[7] and Self-Portraits form the practice base for the rethinking of photographic representation in anthropological research that is attempted here. My discussion evolves from the question, if ambiguity is approached as the most potent aspect of photographic representation, what is the role that photography *can* play in anthropological research?

While postmodernist discussions ranged from a focus on aesthetic styles within art, architecture, and literature to a radical critique of styles of discourses and research in general in the humanities and social sciences,[8] photographic representation did not receive much critical attention in the "crisis of representation"[9] and "writing culture"[10] debates that followed in anthropology. However, the postmodern scrutiny of photography's truth-value within art, feminist engagement with autobiography as a mode of reflexivity,[11] and the recognition that science is fraught with uncertainty has, in my opinion, opened up for transgressions between art practice and an academic pursuit in an epistemological sense. Since I started on my photographic art project Ethiopian Encounters in 1993—eventually leading me to the study of anthropology and research that includes photographic art practice—a disciplinary field of art and anthropology has also emerged.[12] For example, in the book *Redrawing Anthropology*, edited by Tim Ingold, a major concern is with understanding the processes implied in different art practices in order to establish "an approach to creativity and perception capable of bringing together the movements of making, observing and describing [anthropology]."[13] Instead of basing the anthropological knowledge project on descriptions of what has already passed, the concern is with the possibility of establishing a "non-retrospective ethnography,"[14] which would also enable a letting go of usual patterns of thinking.[15] Central in this attempt to bring making, observing, and describing together is, therefore, a shift in epistemological perspective that joins forces with forward-moving processes attuned to emergent knowledge.[16] As part of the postmodern critique of representation in the writing culture debate, Stephen Tyler's conceptualization of "evocation" as that which "makes available through absence what can be conceived but not presented"[17] was likewise informed by sentiments common to art practice. As Tyler writes:

> The whole point of "evoking" rather than "representing" is that it frees ethnography from *mimesis* and the inappropriate mode of scientific rhetoric that entails "objects," "facts," "descriptions," "inductions," "generalizations," "verification," "experiment," "truth," and like concepts that, except as empty invocations, have no parallels either in the experience of ethnographic fieldwork or in the writings of ethnography.[18]

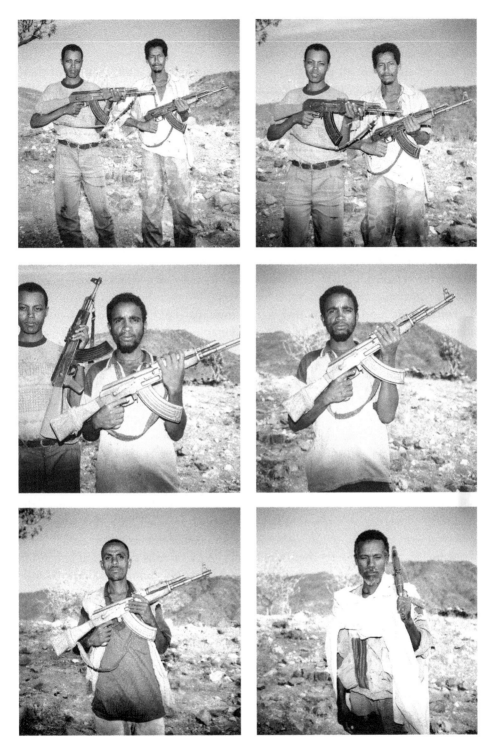

Figure 5.1 From the series Ethiopian Encounters: Mayshek, Tigray, Ethiopia, 2001; Goytom, Gidey, Abrahaley, Teklay, and a friend (originals in color). Photo and copyright: Thera Mjaaland/BONO.

Tyler's concern with the meaning of sociocultural processes that are evoked in the dialogic encounter between the author, the text, and the reader concurs with my interventionist use of photography in the field and the interpretation of these photographic images as "evocative encounters."[19] However, photography's entanglement with realism continues to inform the interpretation of photographic images in terms of realist (and truthful) descriptions. It is in this context that C. S. Peirce's semiotic theory, with the concepts "icon" (likeness/substitute), "index" (pointing to/indication), and "symbol" (rule/convention), has been frequently used to sort out the relationship between the photographic image and reality.[20] While other images are classified as icons, Peirce emphasizes that photographs are indices, albeit with iconic qualities.[21] The reason why the photograph is classified as index is due to the fact that the photographic image not only produces a likeness as an imprint of reality produced by light, but creates a connection to the referent (understood as that which was present in front of the camera when the picture was taken) by pointing back to the referent. By way of observation, the index, according to Peirce, establishes "a *real* connection between his [and her] mind and the object."[22] One aspect of photographic representation that is less emphasized in Peirce's understanding of indexicality is the potential implicit in photographs to point to and indicate something that is beyond the frame of the photographic image and hence not directly (or only partly) observable in the actual photograph. If linking the index up with qualities commonly assigned to the metonym—based on accepted causal links in time/space or conceptual relationships based on closeness that can stand in for each other, like smoke indicating fire—the indexicality of photographs can in a cognitive sense be extended beyond what is actually observed in the image.

Roland Barthes's reflections on photography in *Camera Lucida* provide a link to this metonymic aspect of photographic representation.[23] Opposed to the denotative level of the photograph that Barthes calls *studium* and that involves mere registration of what is represented in the photograph with detached distance, the connotative level he calls *punctum* has—by way of personal attraction or distress, even pain—the potential to move the viewer's imagination beyond the actual frame of the image. Barthes asserts that implicit in the *punctum* is a power of expansion that is often metonymic. He continues: "The *punctum*, then, is a kind of subtle *beyond*—as if the image launched desire beyond what it permits us to see."[24] Peter Larsen ends his discussion on Barthes' interpretive approach to photographs— where Larsen links the *studium* to voyeurism and the *punctum* to fetishism—by asserting that "the Photograph is the most ambiguous of all known image forms. Photographs are always closeness, eternal presence, and fullness. And always—at the same time—absence, eternal past, and loss."[25] Discussing indexicality in the context of the metonymic beyondness implied in Barthes *punctum* encompasses the potency of absence in photographic images, expanding the connection made by pointing to, from what can be observed, to what can be imagined.

One example here is my art project Houses/Homes (Figure 5.2), with photographs of mostly middle-class houses.[26] The fencing, in terms of actual or more

symbolic fences, points to demarcations of privacy and the need for different degrees of protection. By way of absence in the images, the presence of the inhabitants is evoked in the viewers' imagination by objects left outside and well-kept gardens, which indicate that somebody is actually living in these houses. The visual strategy of including parts of the fencing around these houses also indicates that someone is standing outside the fence looking in. Due to the fact that the viewer of the photograph always sees the image from the same viewpoint as the photographer, this positioning is used to point to both voyeurism and exclusion from these homely spheres. To be a trained photographer means, in my case, to work with the specific visuality created by the technicalities of a particular camera (which is not identical to human vision)[27] and to strategically use photographic conventions to challenge common perceptions. At stake in my art project Houses/Homes is, therefore, more than a realist documentation of fences around people's homes. This visual strategy utilizes the fact that the photographic image is always a fragment of reality, not only in time (by freezing the moment) but also in space (by being a cutout of reality from a specific perspective). By emphasizing (rather than denying) the fragmental character of the photographic image, and the absences implied, the viewer can be involved in the filling in of a visual narrative. This way of playing into the viewer's imagination by indicating a continuation of reality beyond the frame of the actual image has a parallel in the cognitive theory of connectionism which assumes that, instead of predefined concepts, our thought processes involve a linking of fragmental building blocks into loosely defined "scripts" or "schemata."[28] This linking together and filling in the gaps between fragments therefore situates imagination as an inherent aspect of cognition. As Maurice Bloch notes,

> the concept of house is not a list of essential features (roof, door, walls, and so on) which have to be checked off before deciding whether or not it is a house. If that were so we would have no idea that a house which has lost its roof is still a house. It is rather that we consider something "a house" by comparing it to a loosely associated group of "houselike" features, no one of which is essential, but which are linked by a general idea of what a typical house is.[29]

From a connectionist perspective of human cognition, there is no reason to underestimate the viewers' ability to read the photograph as fragment. A conventional understanding of the photograph as evidential description might, however, have trained viewers of photographs to expect an unambiguous and objective representation of reality. It is therefore interesting in an epistemological sense that Wilton Martinez's study of students' reception of ethnographic films shows that the scope for expanding understanding by way of visuals that comply with the realist principles for objective photographic representation is limited.[30] Drawing on Umberto Eco's (1979) distinction between "open" works (or "work in movement") as opposed to "closed" works,[31] Martinez's study showed that those films that were open invited more elaborate and reflexive responses.[32] Contrary to more closed ethnographic films based on realist principles of objective representation—which to a

Figure 5.2 From the series Houses/Homes: Uppsala, Sweden, August 1998, and Simonstown, South Africa, April 2000 (originals in color). Photo and copyright: Thera Mjaaland/BONO.

larger extent resulted in the reaffirmation of stereotypes of the Other—the open films used narrative and experimental or reflexive styles, allowing the viewers "space to negotiate meaning in a more dialogic, interactive way of reading, generally resulted in more complex interpretations."[33] This point also relates to what Elizabeth Edwards calls the "ambiguity of the realist paradigm," which implies that "the more general, ambiguous, the image, the more *incisive* it can become in its revelatory possibilities."[34]

These perspectives, therefore, address the epistemological limitations of a conventional use of photography as objectivist description based on nonintervention and a "holism" (from a distance) that, according to Karl Heider, implies "whole bodies," "whole people," "whole interaction," and "whole acts."[35] This is also why Edwards's assertion—that, rather than realist ethnographic photographs, it is the expressive (and ambiguous) aspects of photography utilized within art that are in tune with the theoretical intentions of modern social anthropology[36]—makes epistemological sense. In the same vein, Wolbert asserts: "Working with ethnographic photographs today, then, requires a completely different type of interest, an interest in experimentation and a curiosity about pictures which *disturb our visual conventions.*"[37] In my photographic work that traverses both art and anthropology, my concern is neither with reproducing reality in photographic images nor denying a link to reality but with utilizing the notion of photographic realism and the ambiguities implied to bring about a leap in the viewer's imagination. For example, the portraits in the series Ethiopian Encounters (see Figure 5.1) from Tigray, attempt, on one level, to evoke—by way of the photographic realism involved—a visual disruption of the stereotypical image of the Other: in the Ethiopian case, based on the

hard-lived image in Western media of a catastrophe-ridden and victimized people.[38] On another level, the ambivalence implied in photographic representation can be, and is, used by Tigrayans themselves to produce an ideal self-image.[39]

In the art project Self-Portraits (Figure 5.3), which has followed me around on my travels as well as field trips for more than two decades, I point my camera back on myself at arm's length in a reflexive move.[40] These images, which are mostly out of focus because I work beyond the focus range of that particular camera, have also come to represent rather ambiguous expressions. Instead of ideal images, these photographs constitute what would be considered not-ideal self-representations, which comment on the (Western) portrait tradition. When provided with titles with the names of the places and when the photographs were taken, they also relate to places with their own (potent) meanings (e.g., Eritrea, New York, Ethiopia, Derry), which, while not distinguishable in the images, points to a traveling between them. In spite of blurring the traces of aging because of being slightly out of focus, and without explicating what has actually taken place in this particular life, these self-portraits nevertheless develop a time line of a lifetime when placed together. Hence, these self-portraits draw on the other *punctum* that Barthes asserts is contained as an undercurrent in all photographs—as a painful realization. Precisely because the photograph is a fragment in time, it points to Time, creating a connection with a now of the viewer and a that-has-been of what is actually represented in the image, reminding us of death.[41] Furthermore, if this series of self-portraits is placed in an anthropological context, the reference to place can also be read as a reflexive comment on the "I know because I was there" still underpinning the ethnographic knowledge project.

Figure 5.3 From the series Self-Portraits: New York, 1998, and Derry, Northern Ireland, 2008 (originals in color). Photo and copyright: Thera Mjaaland/BONO.

All the examples presented from my art practice relate to how presence and absence implicit in the photographic image have been explicitly worked with. Hence, my point has not been to reinvent photography to suit an anthropological enquiry more adequately but to acknowledge the inherent "ambiguities of the realist paradigm"[42] as a potent communicative asset of the medium, not only within art photography but also within anthropological research. Instead of restricting the photographic image by objectivist requirements to enable its use within anthropology, a way forward is to utilize its ambiguity—and the epistemological uncertainty entailed—as a potential in knowledge production. This uncertainty can be situated in what Nicky Hamlyn has classified as "places of epistemological doubt,"[43] where habitual patterns of assumption are questioned both in relation to knowledge production and the media of mediation. Due to the fact that photography continues to pose a challenge to anthropological authority, the visual in anthropology therefore presents itself as a *punctum* that has the potential to expand the anthropological discipline beyond its own realist representational conventions, to harness its critical aspirations.

Notes

A first version of this essay, titled "Traversing Art and Science; Examples from Photographic Practice" was presented as a paper in the panel Photography as Mediation, chaired by Anna Laine and Thera Mjaaland at the SANT-NAF (Sveriges Antropologförbund & Norsk Antropologisk Forening) conference in Stockholm May 4–6, 2012.

1. Fredrik Barth, "Hva skal vi med kamera i felten?" *Antropologinytt* 3, no. 3 (1981): 51–61.
2. Kirsten Hastrup, "Anthropological Visions: Some Notes on Visual and Textual Authority," in *Film as Ethnography*, ed. P. I. Crawford and D. Turton (Manchester: Manchester University Press, 1992), 9.
3. Ibid., 21, emphasis added.
4. Mary Warner Marien, *Photography, a Cultural History* (London: Laurence King, 2002), 234.
5. Barbara Wolbert, "The Anthropologist as Photographer: The Visual Construction of Ethnographic Authority," *Visual Anthropology* 13, no. 4 (2000): 338.
6. Ibid., 322.
7. Thera Mjaaland, *Houses/Homes* (Bergen: Kunsthøgskolen i Bergen, 2000). This publication contains a small selection of this project (which is still ongoing) in its first phase (1996–2000).
8. George E. Marcus, "On Ideologies of Reflexivity in Contemporary Efforts to Remake the Human Sciences," *Poetics Today* 15, no. 3 (1994): 384.
9. George E. Marcus and Michael M. J. Fischer, *Anthropology as Cultural Critique. An Experimental Moment in the Human Sciences* (Chicago: University of Chicago Press, 1999 [1986]).
10. James Clifford and George E. Marcus, *Writing Culture. The Poetics and Politics of Ethnography* (Berkeley: University of California Press, 1986).
11. For example, Judith Okely, "Anthropology and Autobiography: Participatory Experience and Embodied Knowledge," in *Anthropology and Autobiography*, ed. J. Okely and H. Callaway (London: Routledge, 1992), 1–28.
12. For example, Arnd Schneider and Christopher Wright, *Contemporary Art and Anthropology* (Oxford: Berg, 2006), and *Between Art and Anthropology: Contemporary Ethnographic Practice* (Oxford: Berg, 2010).

13. Tim Ingold, "Introduction," in *Redrawing Anthropology. Materials, Movements, Lines*, ed. T. Ingold (Farnham: Ashgate, 2011), 2.

14. Arnd Schneider, "Expanded Visions: Rethinking Anthropological Research and Representation through Experimental Film," in *Redrawing Anthropology. Materials, Movements, Lines*, ed. T. Ingold (Farnham: Ashgate, 2011), 188.

15. Brenda Farnell and Robert N. Wood, "Performing Precision and the Limits of Observation," in *Redrawing Anthropology. Materials, Movements, Lines*, ed. T. Ingold (Farnham: Ashgate, 2011), 97.

16. Ingold, "Introduction," 16, and Amanda Ravetz, "Both Created and Discovered," in *Redrawing Anthropology. Materials, Movements, Lines*, ed. T. Ingold (Farnham: Ashgate, 2011), 158.

17. Stephen Tyler, "Post-Modern Ethnography: From Document of the Occult to Occult Document," in *Writing Culture. The Poetics and Politics of* Ethnography, ed. J. Clifford and G. E. Marcus (Berkeley: University of California Press, 1986), 123.

18. Ibid., 130.

19. Thera Mjaaland, "Evocative Encounters: An Exploration of Artistic Practice as a Visual Research Method," *Visual Anthropology* 22, no. 5 (2009): 393.

20. Charles Sanders Peirce, "The Icon, Index, and Symbol," in *Collected Papers of Charles Sanders Peirce*, vol. II, ed. C. Hartshorne and P. Weiss (Cambridge, MA: Harvard University Press, 1958–60), 156–173, and "What is a Sign?" in *The Essential Peirce: Selected Philosophical Writings*, ed. N. Houser and C. J.W. Kloesel (Bloomington: Indiana University Press, 1992), http://www.marxists.org/reference/subject/philosophy/works/us/peirce1.htm (accessed April 5, 2012).

21. Peirce, "The Icon, Index, and Symbol," 159.

22. Ibid., 162, emphasis added.

23. Roland Barthes, *Camera Lucida* (London: Vintage, 1993).

24. Ibid., 59.

25. Peter Larsen, *Album. Fotografiske Motiver* (Oslo: Spartacus Forlag, 2004), 285, my translation from Norwegian.

26. See more examples from the series Houses/Homes at http://thera.no/?document_id = 116.

27. For example, Susan Sontag in *On Photography* (London: Penguin Books, 1977) asserts that the "photographic distortion"—the difference between the way cameras and the human eye depict and interpret perspective—was often commented on in the early days of photography. Since then we have become accustomed to a "photographic seeing," which is in reality a distorted way of seeing. Likewise, Mette Sandbye notes in *Mindesmærker. Tid og erindring i fotografiet* (Copenhagen: Forlaget Politisk Revy, 2001) that the realism of the photographic image, which is based on both convention and belief, has shaped not only how we see reality but also our understanding of what realism is.

28. Maurice Bloch, "Language, Anthropology, and Cognitive Science," in *Assessing Cultural Anthropology*, ed. R. Borovsky (New York: McGraw-Hill, 1994), 276–83.

29. Ibid., 277.

30. Wilton Martinez, "Who Constructs Anthropological Knowledge? Towards a Theory of Ethnographic Film Spectatorship," in *Film as Ethnography*, ed. P. I. Crawford and D. Turton (Manchester: Manchester University Press, 1992), 131–61.

31. Umberto Eco, *The Role of the Reader. Exploration in the Semiotics of Texts* (Bloomington: Indiana University Press, 1979).

32. Martinez, "Who Constructs Anthropological Knowledge?" 135.

33. Ibid., 136.

34. Elizabeth Edwards, "Beyond the Boundary: A Consideration of the Expressive in Photography and Anthropology," in *Rethinking Visual Anthropology*, ed. M. Banks and H. Morphy (New Haven, CT: Yale University Press, 1997), 55, emphasis added.

35. Karl G. Heider, *Ethnographic Film* (Austin: University of Texas Press, 2006 [1976]), 5.
36. Edwards, "Beyond the Boundary."
37. Wolbert, "The Anthropologist as Photographer," 338, emphasis added.
38. See more examples from the series Ethiopian Encounters at http://thera.no/?document_id = 344.
39. Thera Mjaaland, "Ane suqh' ile. I Keep Quiet. Focusing on Women's Agency in Western Tigray, North-Ethiopia," Cand. Polit. Thesis (University of Bergen, 2004) and "*Saleni*, fotografer meg! Om sammenhenger mellom fotografisk representasjon og forståelse av personen i Tigray, Etiopia," *Norsk Antropologisk Tidsskrift* 17, no. 1 (2006): 33–47.
40. See more examples from the series Self-Portraits at http://thera.no/?document_id = 181.
41. Barthes, *Camera Lucida*, 96.
42. Edwards, "Beyond the Boundary," 55.
43. Nicky Hamlyn, *Film Art Phenomena* (London: BFI, 2003), 126.

SURGERY LESSONS

Christina Lammer

Cutting into a living body to remove diseased tissue or organs is commonly reserved for the craft of surgery. The operating hand is equated with cure or alleviation of suffering and disease. In the operating theater, a field of action is circumscribed. Cuts are made, which lead to wounds that leave scars. A sterile area is created in which a frame is marked, similar to that of an image. The actions of the surgeon—his hands—stay within the sterile area with drapes neatly defining boundaries. In my chapter, I focus on the handiwork of the surgical team. I draw each step of the process, hand by hand, designing a model of the various movement scenarios. Furthermore, I am dealing with my own hand movements as a camerawoman and ethnographer in the operating room.

A Hand Movie

During the period in which I worked regularly on writing this text,[1] I participated as an observer in two plastic surgery operations: breast surgery and facial surgery. The surgeon was in both cases Manfred Frey, head of the Division of Plastic and Reconstructive Surgery at the Medical University Vienna. I used writing as a tool, a process of reflection, to ponder the experiences I had in the operating room and also while editing to develop a concept that should correspond with my ideas of a *Hand Movie*. I sketched a design for a work process with the aim of creating an artistic video about the *movement material*—a term that the Austrian choreographer Doris Stelzer[2] recently used in a conversation with me—of the surgeon's hands.

> The movement of the hand that draws the outline of a now visible or before seen object...expresses best the outer reality of reproductive activity. This movement *creates* the shape of the object as a value. Here is the authorship of the body, the rebirth of man, his incarnation in *significant* flesh...This movement creates a significant, positive final boundary.[3]

In the book *Author and Hero in Aesthetic Activity*, one of the early writings by the Russian philosopher Mikhail M. Bakhtin (1895–1975), the fabric of relationships between self and other in the arts becomes clear. I use Bakhtin's remarks to examine the actions in the operating theater of plastic surgery. "I create the outer body of the other actively as value by having a certain emotional-volitional attitude towards him as the other."[4] The surgeon makes something similar with his hands; he models and reconstructs the bodies of the sick. Manfred Frey perceives himself as a designer.

There are parallels between artistic creativity—an aesthetic activity that restores the living body of another person as a value, based on a particular cultural setting—and the field of plastic surgery. Almost like a sculptor, the surgeon approaches the other and his or her mental images and revises the reality by penetrating into it. It is the equivalent of the camera operator, as Walter Benjamin notes in his studies of art sociology: "The attitude of the magician who heals the sick by laying on of hands is different from that of the surgeon who performs an intervention in the patient's body."[5] According to Benjamin, the relation of magician to the surgeon is the same as the painter to the cameraman.

> The painter maintains in his work a natural distance to reality, whereas the camera operator penetrates deeply into the fabric of reality. There is a vast difference between the images that remains with them. That of the painter is whole, that of the camera man is in many ways fragmented, and its parts combine themselves following a new law.[6]

At the beginning of *Hand Movie*, I describe a breast surgery (Figure 6.1). A breast cancer patient I met for the first time in 2006 during an ethnographic study I conducted on plastic surgery allowed me in February 2012 to observe the corrective operation on her right breast and make video recordings of her during her narcotic slumber. I regularly take part in facial surgeries as an ethnographer and artist but had never before filmed or experienced other surgical procedures.[7] I was inspired by the choreographer and dancer Yvonne Rainer, who created a dance with her hands during a hospital stay—a minimalistic performance, which was filmed with a super 8 camera by fellow dancer William Davis.

I used video to record the movements of the surgeon's hands. "Rainer began her experiments with the medium of film under extraordinary circumstances. *Hand Movie* was made in the hospital while she recovered from a life-threatening illness and major surgery in 1966."[8] Considerations about ways of depicting an opened body during plastic surgery with respect and compassion resulted in a concept for a film of five minutes with the same title. In fact, my way of videoing and later on editing is similar to the surgical approach in some respects. A frame of the gaze is prepared (Figure 6.2). First of all, only in my head. Then in the settings that will be recorded, in the operating room, where the hands of the surgeon, the surgical nurses, and the helper will be looked at as movement material. The artistic work is generated later, in the course of cutting the video material and experimenting with light and dark.

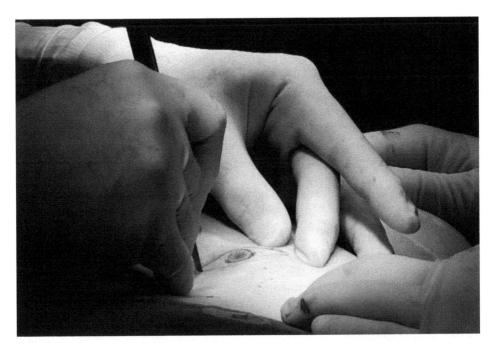

Figure 6.1 Christina Lammer, video still from *Hand Movie I*, 2012. © Christina Lammer.

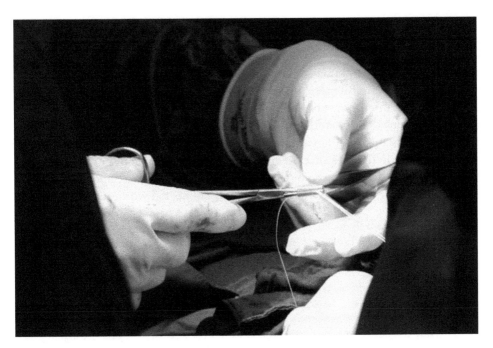

Figure 6.2 Christina Lammer, video still from *Hand Movie II*, 2012. © Christina Lammer.

A gesture of waiting. Folded hands in front of the body. The surgeon's fingers are intertwined. The tips of the thumbs touch each other in a certain rhythm. Wrapped up over the wrist by a soft flexible plastic skin. The dark green of the garments and drapes goes into a deep black space. Light is reflected by the gloves. The hands appear vivid and stand out well against the dark background. Isolated from the body of the surgeon. "The hand belongs to someone…but its attachment to a person seems beside the point."[9] The nature of the clinical setting is emphasized by the artificially produced light dramaturgy in the editing process. The illumination of the operation area, the surgical sphere of activity, designated with sterile cloths, resembles the framing in films.

> I am an operator. But, as a matter of fact, being an operator, in the world in which I live and upon which I live, does not in the least mean operating. I operate nothing.
> This is what I do. I set up my machine on its knock-kneed tripod. One or more stage hands, following my directions, mark out on the carpet or on the stage with a long wand and a blue pencil the limits within which the actors have to move to keep the picture in focus.
> This is called marking out the ground.[10]

In the medical operating theater, a sterile area—an exposed part of the body framed by surgical drapes—is marked out. In this area, the actions of the surgeons take place. Before the operation starts, an image segment is created; within its boundaries lines are drawn, the body is touched and cut, and the surgeon reaches inside.

Painting Surgeons

Walter Benjamin addresses interpersonal distance and closeness when he compares the surgeon or the cinematographer with the magician or the painter. This comparison provides a wonderful prerequisite for an artistic experiment. In order to test this setup, I invited three surgeons and one gastroenterologist to represent with brush and acrylic paint their operations, investigations, and therapeutic interventions by means of endoscopy on a large piece of paper on the wall.[11] The painting actions were premised on the idea that the practices of the surgeon and the cameraman in the present—not least because of the medical use of miniature cameras, which are inserted into the human body—are inextricably connected with each other.

> Here we have to ask the question: what is the difference between the surgeon and the painter? To answer that question an auxiliary construction must be permitted, based on *the* term of the operator, which is known from the field of surgery. The surgeon stands for one pole of the structure, at the other end is the magician…The magician maintains the natural distance between himself and the patient, more precisely, he reduces it—by virtue of his overlaying hand—just a little and increases it very much—by virtue of his authority. The surgeon acts the other way around: he reduces the distance to the patient very much—by penetrating inside of the body—and he increases it only slightly—by the caution with which his hand moves beneath the organs.[12]

Aspects of touch are brought into play (Figure 6.3). The encounters between people in the clinic have become abundantly clear to me during the investigation of patients about to undergo surgery. Drawing is used to explain complex processes and to generate trust. An interventional radiologist, a transplant surgeon, an abdominal surgeon, a plastic surgeon, and a neuro-pediatric surgeon drew for me in front of a video camera the actions of operations that they perform frequently. With the pencil—in most cases, these are simple ballpoint pens—they describe with words and drawing for their patients what is going to happen to them later in the operating theater. The drawing hand of the surgeon anticipates not only the intervention in a living body but also serves the purpose of making an empathetic and unfrightening gesture. The drawing for the person to be operated on is like a gift—a present—and also fulfills the task of depicting abstract and yet simplified on a piece of paper the actions that are difficult to understand and imagine on one's own body.

In fact, the surgeon has an affinity to visual language. Surgery is an act of designing. The movements of the hands of the plastic surgeon Manfred Frey while drawing certain strokes can easily be mistaken for the movements of the cutting scalpel. A very attentive and gentle action of the doctor—any surgical operation is a permitted injury of the patient's body—is reflected in the moments before the actual surgery, during the act of drawing for the ill person. A space opens up in which

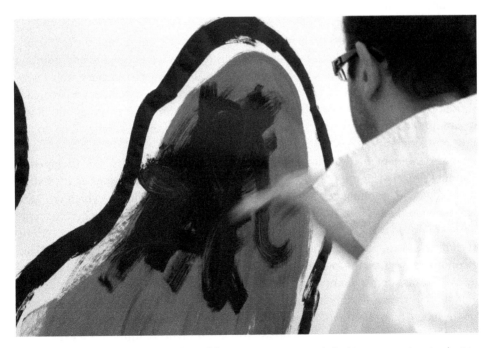

Figure 6.3 Christina Lammer, video still from painting action with the Viennese gastroenterologist Michael Häfner, 2012. © Christina Lammer.

interpersonal intimacy is felt. A form of empathy emerges that I considered as non-existent in the clinical setting. The choreographer and historian Susan Leigh Foster examined in her study *Choreographing Empathy* (2011) the historical development of different concepts of empathy:

> Continuing nineteenth century practices of objective quantification of parts of the social body, empathy became something that could be measured in terms of behaviours associated with sociability among students in the classroom, inmates in prison, nurses in hospitals, and so forth. In other studies, empathy was rated in terms of estimations of generosity, selflessness, or friendliness, again using quantitative schemata for determining amounts of feeling. Many of these studies identified the object of empathy as the "target," a nomenclature that intimates a theory of empathy as projection, but one with a specific and measureable velocity. In both therapeutic and sociological branches of psychology, empathy was pursued as an attribute of the psyche in which there was no element of muscular responsiveness.[13]

In the field of phenomenology, writes Foster, empathy is associated with somatic experiences, feelings, and emotions. The philosopher Maurice Merleau-Ponty identified the experience of bodiliness as "the grounding for all conscious experience."[14] We have arrived now in the era of mirror neurons, which form the physical basis of being able to empathize, to grasp the feelings of others in a particular situation. In my view, empathy is a bodily phenomenon. Empathy, in my opinion, is the human capability to perceive what another person feels in his or her own body, a skill that is connected to his or her own feelings and experiences.

Exemplary of this physical perception of the other's emotions—an act of understanding highly complex processes—are, in my view, the drawing and painting activities of surgeons. In the act of drawing and transferring the image onto a large-size paper during the painting actions, each one of the four invited doctors imagines himself to be in the situation of the other. At the same time, they convey and mediate comprehensible fields of knowledge to people who in their everyday lives do not have much to do with the science of medicine.

In the moment of drawing, the patients become involved in the therapeutic planning process (Figure 6.4). In medical training, drawing functions as mediating knowledge and teaching certain aspects of craftsmanship. "Things, which are hard to understand, are often drawn," says Manfred Frey.[15] He even sketches concepts while communicating with colleagues, to illustrate the complexity of a procedure. Even by means of photography, some structures in the body are difficult to explain. "A photograph does not increase the essential aspects," emphasizes the plastic surgeon.[16] In this surgical compartment, there is a focus on the creation of form.

Now and then the drawing happens—on the day before the surgery—directly on the body of the patient. "Drawing on the body produces an incredible presence."[17] Operations on the female breast are, according to Manfred Frey, exemplary of the designing process that goes along with the body drawing prior to surgery.

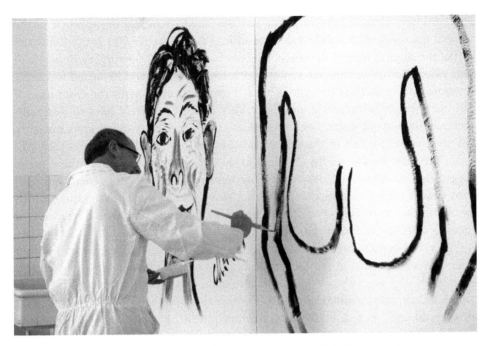

Figure 6.4 Christina Lammer, video still from painting action with the Viennese plastic surgeon Manfred Frey, 2012. © Christina Lammer.

The boundaries of intimacy are regularly significantly exceeded. An allowed injury during an operation is preceded by moments of touching, which lead to a bizarre intimacy between two people. In their everyday lives, both of them, the doctor and the patient, do not have anything to do with one another. They hardly know each other.

Areas of Touch

The cautiousness and carefulness with which a surgeon treats the human body harbors a secretive closeness, which is confined to the duration of the operation. Operating hands as moving images. Movement material for an artistic work. The operating theater as a space remains in the dark. The gaze wanders into depth. Close-up of a variety of surgical actions. Excerpts are shown with wounds on the face and thigh of the operated child, wrapped in robes and cloths. An intimate secret from the inside, which seeks no revelation.

My participation in operations as a video maker is characterized by many prohibitions regarding the closeness. Distance from the sterile field, from the surgeons, surgical nurses, and the tables with the surgical instruments is demanded as a prerequisite for taking part. In addition to these conditions, the responsible nurse checks

whether I have obtained the written consent of the patient and the approval of the hospital management to make video recordings during surgery.[18] I get to know the staff of the surgical team only a short while before or during the surgery. Being there with video and photo cameras sometimes leads to curious and bemused reactions, questions concerning my intentions, what happens later on with the recordings, if they are used or published in any form. Very rarely, however, I have to deal with rejection. By showing respect and acceptance, the aim is to try to integrate my work and presence, to be part of the action and the well-rehearsed procedures that take place. The team looks over my shoulder at the images on the screen of the camera. Suggestions are made and discussed. Questions are asked. Quite often I am confronted with surprised faces, due to the fact that the images of the operation, which are of interest to me, are very different from those pictures that would be made for scientific documentation purposes.

One's own body seems to be strangely dressed in the operating theater. I put on green pants and a shirt in the locker room. I slip on the specially designed surgery shoes made of plastic. On the head, I wear a hood and a mask for the mouth. Since complex operations must take place—the muscle transplantation in the face of a six-year-old child is a difficult surgical procedure, which takes many hours—the team consists of many people who themselves have very little room to work; the conditions for me as a cinematographer are quite a challenge. But, on the other hand, my concept for a *Hand Movie* is nurtured and supported by these difficult circumstances. In this particular situation of videoing—no surgery is like any other—the conditions surgeons have to face in their work are mirrored.

The position that I occupy with the video camera is focused on the sequence of surgical processes. The movement material of the operating hands is similar to a rehearsed choreography, which I follow with my gaze and physically. Two surgeons operate on the left thigh and two others on the face of the boy. The child's body is small and the operators, surgical nurses, and assistants have to share a very narrow space. I watch the sphere of surgical activity while being positioned next to the patient's head. My field of vision is again and again blocked. An arm or a shoulder comes into the picture and moves in front of the lens. The green gowns of the surgeons pucker with every little movement. Individual body parts are barely visible. I'm too close to the action with my camera. Close enough to have the opportunity to film through the extremely tiny opening into the space; able to feel a depth in which the hands gently move.

With a thin hook, the assisting surgeon holds a piece of skin of the face. His left hand rests on the patient's head, which is covered by sterile materials. The surgeon carefully divides structures and fibers from each other with scissors and prepares the child's face for the transplantation. On the inside of the left leg—from the crotch to the knees—the muscle tissue is exposed. In the moving image, eight hands can be seen. Apparently isolated from the people, they give a neutral impression. Dark green cloth, draped very diligently around the body, produces an almost quaint plasticity. A seemingly organic intimacy unfolds in the light of the operating theater.

I would like to thank the physicians, patients and artists for the good work together. Further thanks go to Artur Zmijewski who invited me to participate at the 7th Berlin Biennale 2012.

1. February and March 2012.
2. The video interview took place on February 16, 2012.
3. M. Bakhtin, *Autor und Held in der ästhetischen Tätigkeit* (Frankfurt/Main: Suhrkamp, 2008), 153.
4. Ibid., 116.
5. W. Benjamin, *Das Kunstwerk im Zeitalter seiner technischen Reproduzierbarkeit* (Frankfurt/Main: Suhrkamp, 1977), 31.
6. Ibid., 32.
7. I began my video work in hospitals in 2002 in interventional radiology—a department in which minimally invasive procedures are carried out in order to examine and treat the blood vessels. During these interventions most of the patients are fully conscious and react to breathing commands and respond to questions by the attending radiologist. The patients look at screens with the moving fluoroscopic images of the inside of their bodies.
8. C. Lambert-Beatty, *Being Watched—Yvonne Rainer and the 1960s* (Cambridge, MA: MIT Press, 2008), 178.
9. Ibid., 173.
10. L. Pirandello, *Shoot! The Notebooks of Serafino Gubbio, Cinematograph Operator* (Milton Keynes, UK: dodopress, 2010), 2–3.
11. The painting activities were part of the preparation for an event in the 7th Berlin Biennale and took place on the June 23, 2012 in a lecture hall of the *Charité* in Berlin. Artur Zmijewski, curator of the 7th Berlin Biennale, had developed an artistic concept for *Anatomy Lessons* together with me.
12. Benjamin, *Das Kunstwerk im Zeitalter seiner technischen Reproduzierbarkeit*, 31–32.
13. S. Foster, *Choreographing Empathy, Kinesthesia in Performance* (London: Routledge, 2001), 164.
14. Ibid., 165.
15. Personal notes of a conversation with Manfred Frey, which took place in July 2011.
16. Ibid.
17. Ibid.
18. The artistic-scientific research in the operating theater has (as have all the other projects I have conducted at the hospital) been approved by the Ethics Commission of the Medical University Vienna. The participating patients as well as their relatives have agreed to take part in the project, and I have received written permission to take photographs and video during the operations.

A WORD IS NOT ALWAYS JUST A WORD, SOMETIMES IT IS AN IMAGE: MUSINGS ABOUT THE FILM *YANQUI WALKER AND THE OPTICAL REVOLUTION*

Kathryn Ramey

Yanqui WALKER and the OPTICAL REVOLUTION is an experimental documentary about a now obscure American expansionist and military dictator William Walker, who, through force and coercion, became president of Nicaragua in 1856. The film features various visual motifs including found footage, assemblage, documentary photography, and experimental film techniques such as hand-processing, optical printing, hand-conducted time-lapse, and under-the-camera animation in an effort to *détourné* and derail the various approaches to history-making that have been applied to this story. *Yanqui WALKER* as a contemporary work of film art tells us something not only about history and how it connects to current political, social, and economic situations but also how art and poetry can be a means to subvert and transcend even the most oppressive of narratives.

In an effort to simultaneously recover history and question the ability to objectively report it, *WALKER* blends educational films, personal travelogue, and ethnographic inquiry with various recurring sonorous elements (bells, explosions, contemporary location sound, and melodramatic music from the found materials) alongside first-person narration regarding the events depicted in the film. Found footage is a major component of the film. The use of détourné refers of course to *détournément* as championed by Guy Debord and Isidore Isou. Quoting Debord, "Plagiarism is necessary. Progress implies it. It embraces an author's phrase, makes use of his expressions, erases a false idea, and replaces it with the right idea."[1] *Yanqui WALKER*'s creation literally began with a found object. My husband brought me a gift, a single film can containing an extraordinary cultural object, a Reading Film created at Harvard University in the 1930s as part of a program that was experimenting with students' ability to retain information. The film was a historical text that was to be played at variously increasing speeds to find the threshold between reading speed and adequate comprehension. Not only was its status as a historical, cultural, visual object of interest to me, the story it told about American expansionist William Walker was something I knew nothing about and was instantly

fascinated by. Thus I was compelled to work with the material and the story of this *objet trouvé*.

With the exception of the Reading Film, which was a gift from my husband, all of the unoriginal footage used in this piece was literally found in the trash or purchased on eBay. It is important to distinguish the term *found footage* from the term *archival footage*. The material that is repurposed in this film has not been carefully preserved in an archive—an institution in which a film's representational importance has been catalogued and can be accessed for the purposes of documentarians or others who require evidentiary footage from the past. My found film is media detritus that is being mined not so much for its representational content but for the history behind the image, that which is "discursively embedded within its history of production, circulation and consumption."[2] In other words, found footage is used to critique the ideology behind its manufacturing, causing to the viewer to question the rationales behind educational media and what historical perspectives and power structures these films were made to shore up.

A concern central to the screenwriting for *Yanqui WALKER* was to capture the ways in which educational media from the twentieth century can be reused to subvert its original intent and to reveal the massive social, economic, and historic inequities these materials, in this case films, ignore. A film about banana plantations in Central America is used in *Yanqui WALKER* to accentuate economic colonialism and neocolonialism. There are several excerpts from it, including in the beginning of the film where we are shown a map of Central America without any national boundaries as though it is one massive tabula rasa open for economic, cultural, and agricultural exploitation. This banana film returns toward the end of *WALKER* with workers loading boats bound for America. These historical films are used throughout to make transparent the artifice of objectivity that these "first-world discourses" pretend to have.[3]

Yanqui WALKER is also a film about traveling and looking for history in primary locations. Evidence of interaction with ethnographic subjects in the field is relayed through excerpts from actual interviews. But this information is partial and sometimes veers off course into topics such as the protective habits of butterflies and mythological ancestors. One of the most authoritative statements in the film comes from a taxi driver who says of William Walker, "He was a pirate paid to invade Nicaragua" (see Figure 7.1). There is an inherent mistrust in the veracity of the perspective of the filmmaker as being anything other than subjective. She is there, yes, and trying to find something out, but she is easily distracted, and there are problems with translation and misunderstanding.

Text on screen takes on multiple roles, sometimes translating location audio, sometimes contradicting or augmenting the voiceover or image, and sometimes giving a Spanish translation of English voiceover. Spoken words are also used in contrapuntal ways, creating jarring collisions as well as uncomfortable moments of self-recognition for primarily English-speaking viewers of the intertwining histories of economic, geographical, and linguistic dominance over Spanish-speaking peoples

in the Americas. In this way, language-as-power and the impossibility of complete translation become two conceptual threads in the film.

The film was conceived of and produced during a sociopolitical climate in the United States that has been increasingly anti-immigration and in particular has targeted Spanish-speaking populations for racial profiling. Various local and state governments were pushing statutes or amendments to state constitutions with English-only agendas. At the same time, immigrants from Central and South America endured low-wage labor jobs such as house cleaning, child care, gardening, and some manufacturing in the north without basic protections because of their marginal status as guest workers or illegal immigrants. I wanted to make clear my subject position as a well-meaning Yanqui (a slang expression still in use in Central/South America to refer to Anglo-Americans) who, although capturing what I was seeing and hearing with my various mechanical devices was all too frequently missing quite a lot.

This is made most apparent in a passage narrating the experience of being taken to a pond by our guide on the island of Ometepe. In English voiceover, I say that the guide has told us that if we eat the red fish that swims in the pond, we will never leave Nicaragua. Then I say that another local told us that if we eat the red fish, we will leave Nicaragua and never return. On screen, the text "pescado rojo" flashes (Figure 7.2). This "red herring" is a distraction from the actual problem, a real anthropological conundrum of misunderstanding. There is no clear answer for me so we choose not to eat the fish, too confused by our position as outsiders to know what to do. Of course this incident is dramatized and foregrounded in the film as a humorous device. In actuality, there wasn't really that much concern over the fish during the trip. However, in the movie the sequence is set up as another example of the filmmaker steering the viewer around the story and highlighting my mistrust of cinema as a means to present "reality."

In another strategy used to highlight cultural dissonance, a film meant to teach US high school students Spanish and greater cultural awareness is woven throughout *WALKER*, highlighting the disjuncture between its well-meaning professor/narrator and the reality of the way our southern neighbors have been treated by the United States.[4] Initially, this passage seems fairly innocuous and gets belly laughs as the white male narrator intones over a picture of a (apparently Spanish speaking) mother and child, "The language *these people* speak is not entire foreign to *us*. Look! Colorado is a Spanish word that probably refers to the red colored land of Colorado." The real historical consequences of seeing "these people" as the Other is revealed when the narrator says, "Ya que la casa se quema, calentamonos," with the translation, "Now that the house is burning, let's get warm!" cut in as voiceover while the film relates how in 1856 Walker's retreating forces burned the town of Granada, Nicaragua, to the ground.

Efforts to force active viewership are in use throughout the film. In an early passage, we learn about a museum in Costa Rica built to honor the country's victory over William Walker. The museum is named after Costa Rica's first martyr in the

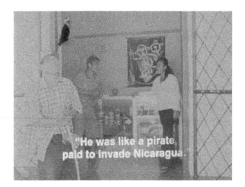

Figure 7.1 Kathryn Ramey, film still from *Yanqui WALKER and the OPTICAL REVOLUTION*: Our taxi driver with the docent and a passerby outside El Ceibo Museo in Altagracia on the island of Ometepe; courtesy of the author.

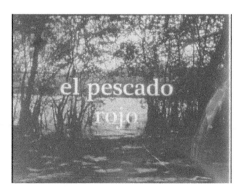

Figure 7.2 Kathryn Ramey, film still from *Yanqui WALKER and the OPTICAL REVOLUTION*: Laguna Verde, where the red fish swims; courtesy of the author.

Figure 7.3 Kathryn Ramey, film still from *Yanqui WALKER and the OPTICAL REVOLUTION*: The Cathedral of Alajuela, Costa Rica. This is not the Museo de Juan Santamaria; courtesy of the author.

Figure 7.4 Kathryn Ramey, film still from *Yanqui WALKER and the OPTICAL REVOLUTION*: Hand processing provides a screen that viewers must see through. In this case, hand processing literally framed a boy ringing a bell in Rivas, Nicaragua; courtesy of the author.

war, Juan Santamaria. As the filmmaker tells about this museum in voiceover, a building is shown. Before we get too comfortable, text on screen states "this is not the museum" (Figure 7.3), and later as we hear parts of an interview with the curator of Museo de Juan Santamaria, text on screen states, "This is the church across from the museum." Finally, as a bird lifts off the tower of the church in slow motion and the beautiful audio that has accompanied the voiceover swells to complete the scene, the text on screen reads "this is what it sounds like inside."

This pushing and pulling of the viewer by the filmmaker is a conscious redirection back to the audience members' own habits of viewership. How do you ever know if an image that is being shown to you has any relationship to what the narrator is saying? And what about beauty and just appreciating that which you cannot know as something beautiful nonetheless? This is one of the many passages

in which the audience is reminded that this is a representation by the filmmaker, who is consciously resisting her desires to simply share some of the sensuous beauty of her experience. While the filmmaker cannot help but bask in the sensuous experience of her travels, she does not want the viewers to be seduced into passivity, washed over by beauty so that they forget that they are watching a representation.[5]

A major textural element of *Yanqui WALKER* is that all of the original travelogue footage has been hand-processed to create significant artifacts on the surface of the film. Still, as unstable as the hand-processed images are, it is impossible to ignore the luscious beauty of what is being photographed. It struggles through the cracks and rips in the emulsion much like the landscape and people themselves have survived despite over 500 years of cultural and economic imperialism. The experimental techniques do not destroy the beauty of the original people or landscape. Instead they create a screen between the viewer and the filmic image, forcing viewers to see through text, through the distressed surface of the emulsion, through whatever other overlays are present. The function of this screen is not only to distance the viewer but also to reinforce what film theorist Peter Gidal calls the "dialectic interaction" between the moviegoer and the film itself. Filmgoers are reminded of their subject position as voyeur/viewer and the power inequities therein. Here is an image of a boy ringing a bell. When the film was processed, it stuck together so that some film did not get developed. This created a framing of the boy's face. In the film, this footage is used twice, once at regular speed so that the framing zips by without much attention. A moment later, it is repeated slowly so that the viewer really sees the frame within the frame. These kinds of isolation of image parts through optical printing, the rephotographing of film at various frame rates, are another formal device in the film to emphasize moments that might otherwise escape unnoticed (Figure 7.4).

As a final conceptual element, films of vision and the discourses of visuality are employed to underscore the cinematic and anthropological enterprises of image making with/by/about the Latin American Other. This preoccupation with occularcentrism or insistence of privileging vision is brought to the forefront with the very title of the film itself. The *OPTICAL REVOLUTION* isn't just, as the narrator intones, when various scientists (including Augustin Fresnel—inventor of the Fresnel lens) argued over whether light was composed of particles or rays. In the film, it is also the way sight has become privileged as a way of knowing things. Optical illusions are investigated with tricking of the eyes, serving as a corollary to the way the audience might be misled by moving images. This theme of how our vision is seen as a primary way of knowing things is explored throughout the film. Toward the end, in a piece of found footage, a newborn human infant is being tested to see how its eye reacts to a beam of light as the narrator says, "Even a newborn infant can follow a beam of light!" In Western culture, we are called forth as seeing subjects from the moment we are born, with eyesight being some sort of a testament to our ability to learn and to know. After all, as they say, "Seeing is believing." Unfortunately, all too often what someone sees is what she or he already believes.[6]

Table 7.1 Extract from Script for *Yanqui WALKER and the OPTICAL REVOLUTION*, Kathryn Ramey.

Run Time	Original Voices	Found and Détourned Image/V.O	Original Image/Sound
0:00:00	AUTHOR: In the 1930's Harvard researchers thought they could increase reading speed and comprehension by putting books on film.	IMAGE: Instructors' manual for Harvard Reading Film IMAGE: Selections for Improving Speed of Comprehension IMAGE: (title card) Harvard University Reading Course Reading Films Second Series	SOUND: Silence on a 16 mm optical soundtrack
0:00:15		IMAGE: (text on screen) Americans like to think that dictators grow only in foreign countries. Our history books often overlook the potential dictators who have appeared on the American scene from time to time. One of these potential dictators was an obscure person named William Walker, a short little man who…	
0:00:54	AUTHOR: On the island of Ometepe in the middle of Lake Nicaragua, farmers tie sticks to the heads of cattle to prevent them from getting into their neighbors' fields.	IMAGE/SOUND: A solar flare from an educational film on light with the sound slowed down so that it sounds somewhere between an explosion and the roar of a giant lion. (audio cross fade to) (image cut to) SOUND: "traditional" marimba music taken from an educational film on Central America. (cross fade to v.o below)	SOUND: Nocturnal recordings from the jungles of Ometepe, Nicaragua. Birds sound like crying children. IMAGE: Hand-processed footage of a cow with a stick tied to its head walking along a road. IMAGE (title sequence) medium close-up of a cow with a stick tied to its head behind a barbed wire fence chewing grass. (superimpose title—separate cards)
0:01:17			Yanqui WALKER (fade to) IMAGE: (title continues over détourned image) and the OPTICAL REVOLUTION
		IMAGE: Zoom in on a map of the Western Hemisphere with Canada, the United States, Mexico, and South America label	
0:01:30		SOUND: (voiceover from educational film) Lying southeast of Mexico is a narrow strip of land connecting the North and South American continents.	

Yanqui WALKER and the OPTICAL REVOLUTION confronts the relationship between what we see, what we believe, and how we came to know what it is we think we know. It is an essay film, in the style of a travelogue told by a curious stranger. My voice, which begins with a cool third-person detachment, gradually becomes first person. My person, originally with at least a valence of objectivity, gradually succumbs to my own experience, and I finally confess, "As cliché as it may sound, butterflies and flowers are two of this filmmaker's favorite things to photograph." I made this film on instinct, wanting to tell a story both historical and contemporary from within the geographical location central to the narrative but deeply mistrusting of conventions of realist documentary to which most anthropologically informed moving images subscribe. As an experimental filmmaker whose work mostly circulates in art house cinemas, museums, and festivals, there is no pressure on me to conform to documentary conventions or anthropological standards for legibility or veracity. Thus I was free to invent ways of writing, filming, and editing that acknowledge and foreground the dissonance created between words, images, and text. What follows is a small excerpt from the original script. Its format demonstrates the way in which, as a filmmaker, I am very conscious of the multiple ways image and sound can play against each other to create a productive dissonance, jarring, disruptive, and even conflicting interpretations of events, forcing the viewer to become an active interpreter confronting their own experiences and expectations.[7]

Notes

1. Guy Debord, *Society of the Spectacle* (Detroit: Black & Red Press, 1983), 207.
2. Michael Zryd, "Found Footage as Discursive Metahistory," *The Moving Image* 3, no. 2 (2003): 42.
3. This film is *Central America: Geography of the Americas* (Chicago: Coronet Films, 1955, 16mm). The Reading Film is *William Walker*, Reading Films Series (Cambridge, MA: Harvard University Press, production date unknown; somewhere between 1936–42, 16mm). The other educational film on the region is *America Finding New Ways*, 2nd ed. (Dir. Hector J. Lemieux, Toronto; Released in United States by Encyclopedia Britannica, 1974, 16mm). In order to contextualize the U.S. program of manifest destiny in the mid-1800s that rationalized expansion into what is now Canada, the Caribbean, Mexico, Central America, and the western part of what is now the United States, films on this historical period were used. These films were *The Civil War: Background Issues: 1820–1860* (Deerfield, IL: Coronet Films, 1963, 16mm); and *The New Equation: Annexationism and Reciprocity 1840–1860*, Part 5, Struggle for a Border, Canada's Relations with the United States series (Dir. Ronald S. Dick, Ottawa National Film Board of Canada, 1969).
4. *Spanish Language Film* (fragment—actual title unknown) (Coronet Films, production date unknown).
5. The formal techniques of hand-processing that produces significant artifacts on the surface of the film that must be "read" through as well as the disjunctive editing of both sound and images and

the text on screen are all devices to distance the viewer. In his introductory essay "Theory and Definition of Structural/Materialist Film," in *Structural Film Anthology,* Peter Gidal states, "Through the attempted non-hierarchical, cool, separate unfolding a distance(ing) is sought. This distance reinforces (rather than denies) the dialectic interaction of viewer with each film moment, which is necessary if it is not to pass into passiveness and needlessness"; see Peter Gidal, *Structural Film Anthology* (London: British Film Institute, 1978), 9.

6. These films are *Perception of Life* (London: Nuffield Foundation Unit for the History of Ideas, 1964, 16mm) and *More than Meets the Eye* (New York: Time-Life Multimedia, 1971, 16mm).

7. In an article by Penny Lane, she quotes the filmmaker as saying, "Clearly, given the tools that I took with me—not a synchronous camera in the bunch, let alone video!—I did not intend to do much standard documentary-type stuff…I am not a historian, or an authority on Central American history or politics. There was no way that I could take a position of authority vis-à-vis this story other than that of an artist and maybe a traveler. Both of these roles involve humility—recognizing all you don't know, and foregrounding your own experience as a way of getting at some aspect of the story"; see Penny Lane, *Psychogeographies: Four Films about Place and Time,* http://www.p-lane.com/psychogeographies.html (accessed February 2, 2012).

OUT OF HAND: REFLECTIONS ON ELSEWHERENESS

Robert Willim

How do you make an account of a place you have never visited? This question is the point of departure for the Elsewhereness series. The series is an Internet-based art project consisting of a still growing number of experimental films, each film imagining a different city never visited by the creators.

I initiated Elsewhereness in 2008 together with video artist Anders Weberg. It can be seen as a meditation on questions about site-specificity and the ends of ethnography. Here I will reflect on the role of the work as an art probe and discuss some aspects of chance in artistic and ethnographic practice.

Out of Place

I have been working together with Weberg since 2003, creating works with concepts derived from my practices as a cultural analyst and ethnographer. The audiovisual arrangements of Elsewhereness, as well as our other common works, are based on Weberg's dreamlike, organically fragmented video art combined with my sound compositions. The basic idea behind Elsewhereness is to form an imaginary geography based on films associated with cities that we have never visited. The parts of the series are made solely from audio and video material found on the Web, material that emanates from a specific city. The audiovisual pieces are manipulated and composed into a surreal journey through an estranged landscape, based entirely on the culturally bound and stereotypical preconceptions we have about the actual location. Parts of the series have been shown at exhibitions or screenings in the respective cities they are about, and the films are also available for download.[1]

Elsewhereness can be seen as a surreal account of fieldwork practices, juxtaposing ideas about site-specificity with technological mediation and appropriation.[2] Elsewhereness can also be seen as an alternative way to approach the boundary-work going on when fields and places are called forth through ethnography.[3] However, it

Figure 8.1 Anders Weberg and Robert Willim, still from Elsewhereness: New Orleans, commissioned by Ethnographic Terminalia, 2010; courtesy of the artists.

Figure 8.2 Anders Weberg and Robert Willim, still from Elsewhereness: New Orleans, commissioned by Ethnographic Terminalia, 2010; courtesy of the artists.

Figure 8.3 Anders Weberg and Robert Willim, still from Elsewhereness: Utrecht, commissioned by Impakt Festival, 2010; courtesy of the artists.

Figure 8.4 Anders Weberg and Robert Willim, still from Elsewhereness: Utrecht, commissioned by Impakt Festival, 2010; courtesy of the artists.

is not an attempt to epistemologically or methodologically pinpoint the practices of ethnography or anthropology. Instead, Elsewhereness is a probe drifting around in a more aimless manner.

Art Probes

The concepts behind my artworks have often emanated from research questions or thoughts that have come up in my academic practice. But the artworks are not integral to specific research projects; instead they have often been aimed at various art spaces outside academia.[4]

I would like to see Elsewhereness as an art probe. Art probes do not gather data with any precision; they do not measure. They evoke and provoke. Art probes probably have more in common with the verbal probes used by Marshall McLuhan than with scientific instruments.[5] There are also some resemblances between the way I use art probes and the concept of cultural probes. The latter can be small packages including artifacts and instructions that are handed out to people in order to get inspirational feedback for a design issue. William W. Gaver et al. write about cultural probes and their design-led approach: "Probes are collections of evocative tasks meant to elicit inspirational responses from people—not comprehensive information about them, but fragmentary clues about their lives and thoughts."[6] The authors are critical to ways in which their approach has been overrationalized by other users, ways that according to them have taken away the potential of the probes. They stress the importance of uncertainty and epistemological limits:

> The Probes embodied an approach to design that recognizes and embraces the notion that knowledge has limits. It's an approach that values uncertainty, play, exploration, and subjective interpretation as ways of dealing with those limits.[7]

This approach is in line with the way I consider art probes. The probes are used to convey inspiration, to provoke questions, and to simultaneously and paradoxically instill framings and evoke new associations. They provoke me to continuously search for patterns as well as gaps and aporias. Sometimes, what I find out from the probes can pollinate my research practices. At other times the art probes are academically "useless."[8] The point has been to create works that do not have any clear-cut intention to be used in a foreseeable way in a specific research project.

Chance

As a researcher, you seldom state that your research might be out of control. But all creative practices, including art and anthropology, are to some degree excursions into the unknown. The question is instead to what degree you articulate your lack of control or frame uncertainties.[9] When it comes to art practices, the room for the intractable is a bit wider. It might, however, be fruitful to leave some vents open between art and anthropology when it comes to questions about chance, uncertainty, and control.

In advocating nonrepresentational theory, Nigel Thrift stresses the importance of surprising events and the experimental as part of social science. He promotes "wild ideas" as a counterpole to a practical, policy-oriented social science that is "fetishizing the values of methodological rigour."[10] He emphasizes that "this is a world that we can only partly understand" and goes on by promoting a "poetics of the spaces of dreams and improvisations" and a

> wild conceptuality which is attuned to the moment but always goes beyond it, which always works against cultural gravity, so to speak. This improvisatory virtuality provides an opportunity for an unsettled politics of advocacy which watch(es) the world, listening for what escapes explanation by science, law and other established discourses.[11]

I sympathize with Thrift's fuzzy approach, especially while I'm making art that is lingering in the interzone next to ethnography, to cultural and social science. As an artist, I find it stimulating to jumble ideas of intentionality, serendipity, and control.

The interplay between chance and control has of course been a central theme for artists for a long time. Gaps between intentions and execution, between methodological work and the open-ended have been characterizing the creative processes of several artists since at least early modernism. Even the notion of failure has been utilized in a way that makes these practices different from the discourses of science.

> Failure, by definition, takes us beyond assumptions and what we think we know. Artists have long turned their attention to the unrealizability of the quest for

perfection, or the open-endedness of experiment, using both dissatisfaction and error as means to rethink how we understand our place in the world.[12]

In my work, I consciously strive to keep artistic practices semidetached, or at arm's length, from my research. Elsewhereness is no pedagogical account of the ways cities can be represented, no straightforward suggestion of how to use digital media in order to approach ethnographic fieldwork. It is an open-ended set of evocations, initiated with the outright feeling of not knowing where the project should end. The question is of course, how can this kind of open-ended work be ended? Even if I as initiator decide to stop feeding the series with new parts, previous entities or probes might keep on circling around, spinning away like viruses or space debris. Elsewhereness engenders chance, the provisional, even the fragmentary.[13] This is one thing that characterizes works that utilize networked digital media.

Meanwhile, that some advocate the interzone between art and scientific practices as a space of mind opening potential, reifications of the same space are promoted. Patricia Leavy deals with arts-based research practice in her book *Method Meets Art*.[14] She addresses important questions, and the book is an attempt to among other things give an epistemological and theoretical outline of the relation between arts and qualitative methods. But in order to give art practices academic credibility, she is stressing the importance of assessment strategies and validity checks in ways that might be limiting to the potentials of art.[15] She suggests that by having postviewing dialogue with audiences, researchers can "gauge how well appropriate emotions were evoked."[16] And by working with professionals outside the researcher's disciplines, they can "maximize the aesthetic qualities and authenticity of the work. Moreover, the more effective the artistic aspects are, the more likely the research is to affect audiences in their intended ways."[17]

When advocating arts-based research or practice and the uses of art in connection to social and cultural research, there is a prevalent risk of using simplified notions of intentionality and control in attempts to frame the practices as methodologically stringent. Mieke Bal points out that works of art work across time: "The artist is involved only part of the way. He disappears, gives his work over to a public he will not know. What happens after the work has been made is not determinable by artistic will."[18]

Elsewhere

There is always an interplay between chance and control in art as well as in research.

When developing the conceptual framework for Elsewhereness, I wanted chance and serendipity to be integral to the workflow. We started by discussing the city we were about to approach. Then isolated from each other, we collected images and sounds. Anders Weberg composed the images, while I composed the sound. We also

made the first sketches of image and sound detached from each other. Some time into the project we had the wedding moment, when image for the first time met sound. In this way, we tried to surprise ourselves. We used the material of this process as the basis for the final composition, which was conceived as a kind of close dialogue. Before deciding to close the chapter, we tried to keep as much as possible from the first detached part of the process. This process accentuates the interplay between distance and proximity, alienation and intimacy.

From the day the first part of Elsewhereness was sent away to the Dislocate 08 festival in Yokohama and published on the Web, it was in a sense out of control.[19] We had contact with curators through e-mail, and we gave some overall suggestions on how to screen or exhibit the works. But we also kept a distance. We weren't concretely involved in any of the spatial, technological, and aesthetic considerations that took place in the various art spaces and venues where the works were shown. We were elsewhere. It became an intentional stance to include a certain level of abandon in Elsewhereness.

Sometimes we visited the openings of exhibitions or took part in the screenings. At other times, like with the introductory film evoking Yokohama, we were not present. I can only imagine venues, audiences, and the events that took place elsewhere.[20] We got some brief reports from these occasions and have thence gotten some reactions, comments, and reflections on various websites. We can see some traffic and download statistics from websites where the films are available, but the reception and uses of Elsewhereness are at the present to a large degree unknown to us, out of control.

This unfinished series of films embraces the provisional, the irregular, the incomplete. The pieces of Elsewhereness live on as art probes that might return at some point to make a difference in my practices as a cultural analyst. But the work might just as well drift out into the void.

Notes

1. See www.elsewhereness.com.
2. See James Clifford, "On Ethnographic Surrealism," *Comparative Studies in Society and History* 23 (1981): 539–64; Arnd Schneider, "On 'Appropriation.' A Critical Reappraisal of the Concept and Its Application in Global Art Practices," *Social Anthropology* 11 (2003): 215–29; Linda M. Steer, "Photographic Appropriation, Ethnography, and the Surrealist Other," *Comparatist* 32 (2008): 63–81. One might also associate earlier works, such as the suggestive compositions of Raymond Roussel's "estranged site-specificity" in his *Impressions of Africa* (2011 [1910]). Through the work with the series, discussions and accounts of site-specific and environmental art has also been important; see, for example, Miwon Kwon, *One Place after Another: Site-Specific Art and Locational Identity* (Cambridge, MA: MIT Press, 2004); and Jeffrey Kastner, ed. *Land and Environmental Art* (London: Phaidon Press, 1998). It might also be fruitful to juxtapose notions of the field and the ethnographic with artistic concepts such as, for example, Robert Smithson's site and nonsite.

3. See George E. Marcus, "Affinities: Fieldwork in Anthropology Today and the Ethnographic in Artwork," in *Between Art and Anthropology: Contemporary Ethnographic Practice*, ed. Arnd Schneider and Christopher Wright (Oxford: Berg, 2010), 83–94.

4. The works have been either commissioned by an organization, or we have submitted a proposal to make a work for a festival or exhibition. The first part of the series was commissioned by the festival Dislocate 08 in Yokohama, followed by parts being made for events in cities such as Cape Town, New Orleans, and Utrecht. Some parts of Elsewhereness have been made for festivals geared toward new media, such as Dislocate 08 in Yokohama (see http://dis-locate.net/dislocate08press1.pdf); Futureeverything 2010 in Manchester (see http://2010.futureeverything.org/festival2010/elsewhereness); and Impakt Online 2010 in Utrecht (see http://www.impakt.nl/index.php/online/city_as_interface). Other contexts have been exhibitions in the borderland between art and academia such as Ethnographic Terminalia in New Orleans 2010 (see http://ethnographicterminalia.org/2010-new-orleans); see Maria Brodine, Craig Campbell, Kate Hennessy, Fiona P. McDonald, Trudi Lynn Smith, and Stephanie Takaragawa, "Ethnographic Terminalia: An Introduction," *Visual Anthropology Review* 27 (2011): 49–51, for an introduction to the exhibition and the Ethnographic Terminalia concept.

5. McLuhan used the word *probes* to describe his short statements or evocative and often puzzling phrases, which were meant to tease or disturb people. The statements/probes were used as part of McLuhan's explorations. Some of the most famous are his wordplays between message/massage in "The media is the massage" or "The most human thing about us is our technology." See Marshall McLuhan and David Carson, *The Book of Probes* (Berkeley: Gingko Press GmbH, 2003).

6. William Gaver, Andy Boucher, Sarah Pennington, and Brendan Walker, "Cultural Probes and the Value of Uncertainty," *Interactions—Funology* 11 (2004): 53.

7. Ibid.

8. See Pavel Büchler, "Making Nothing Happen: Notes for a Seminar," in *Visualizing Anthropology*, ed. Anna Grimshaw and Amanda Ravetz (Bristol: Intellect Books, 2005), for a discussion on art and utility. See Ulf Hannerz, "Studying Down, up, Sideways, through, Backwards, Forwards, Away and at Home: Reflections on the Field Worries of an Expansive Discipline," in *Locating the Field. Space, Place and Context in Anthropology*, ed. Simon Coleman and Peter Collins (Oxford: Berg, 2006), 31f, for a discussion about serendipity and anthropology. See also Billy Ehn and Orvar Löfgren, *The Secret World of Doing Nothing* (Berkeley: University of California Press, 2010), 217ff; and Richard Wilk, "Reflections on Orderly and Disorderly Ethnography," *Ethnologia Europaea* 41, no. 1 (2011): 15–25. Since the Elsewhereness series was initiated, I started working in a research project (together with Tom O'Dell) at Lund University dealing with the transformations of ethnography. The aim of the project was to create knowledge about methodology by looking at the ways ethnography is used and understood in contexts outside the academic world, mainly in business and the arts. Within the project, I used experiences from my practices as an artist to reflect on ethnographic and cultural analytic practices; see, for examples, Tom O'Dell and Robert Willim, eds., "Irregular Ethnographies," special issue of *Ethnologia Europaea* 41, no. 1 (2011).

9. John Wynne, "Hearing Faces, Seeing Voices: Sound Art, Experimentalism and the Ethnographic Gaze," in *Between Art and Anthropology: Contemporary Ethnographic Practice*, ed. Arnd Schneider and Christopher Wright (Oxford: Berg, 2010), 52.

10. Nigel Thrift, *Non-Representational Theory: Space, Politics, Affect* (London: Routledge, 2007), 18.

11. Ibid., 19f.

12. Lisa Le Feuvre, "Introduction // Strive to Fail," in *Failure*, ed. Lisa Le Feuvre (Cambridge, MA: MIT Press, 2010), 12. The relation between failure, error, malfunction, and noise has been pivotal for

some developments of creative practices within digital culture during the last decades; see Peter Krapp, *Noise Channels. Glitch and Error in Digital Culture* (Minneapolis: University of Minnesota Press, 2011); and Caleb Kelly, *Cracked Media. The Sound of Malfunction* (Cambridge, MA: MIT Press, 2009).

13. Arnd Schneider and Christopher Wright, "Between Art and Anthropology," in *Between Art and Anthropology: Contemporary Ethnographic Practice,* ed. Arnd Schneider and Christopher Wright (Oxford: Berg, 2010), 20.

14. Patricia Leavy, ed. *Method Meets Art: Arts-Based Research Practice* (New York: Guilford Press, 2008). Leavy's book is one among many that discuss the heterogeneous field that takes form when art meets science; see Michael Biggs and Henrik Karlsson, eds. *The Routledge Companion to Research in the Arts* (London: Routledge, 2010); also see Billy Ehn, "Between Contemporary Art and Cultural Analysis: Alternative Methods for Knowledge Production," *InFormation. Nordic Journal of Art and Research* 1, no. 1 (2012): 4–18, for an account from a Swedish cultural analytic perspective.

15. Leavy, *Method Meets Art,* 18.

16. Ibid.

17. Ibid.

18. Mieke Bal, *Travelling Concepts in the Humanities: A Rough Guide* (Toronto: University of Toronto Press, 2002), 255.

19. The lack of control over the ways in which works are screened and used is part of a larger discussion on digital media, reuse, and appropriation, having to do with both aesthetic and ethical dimensions (see Sarah Pink, "Digital Visual Anthropology: Potentials and Challenges," in *Made to Be Seen: Perspectives on the History of Visual Anthropology,* ed. Marcus Banks and Jay Ruby [Chicago: University of Chicago Press, 2011], 211). The question of how films are framed in various settings and situation is also something that has been extensively discussed when it comes to experimental as well as ethnographic film; see Kathryn Ramey, "Productive Dissonance and Sensuous Image-Making: Visual Anthropology and Experimental Film," in *Made to Be Seen: Perspectives on the History of Visual Anthropology,* ed. Marcus Banks and Jay Ruby (Chicago: University of Chicago Press, 2011), 271f.

20. Part two of the series, the one made for Cape Town and the video art show City Breath, was incorporated in a series of works touring to venues under the package name City Breath. At the time of writing, I am sometimes still getting notices about Elsewhereness: Cape Town being screened in different places.

ON COLLECTIONS AND COLLECTIVITY:
A CONVERSATION BETWEEN BRAD BUTLER, KAREN MIRZA, AND CHRIS WRIGHT

Brad Butler and Karen Mirza

Since 1998, Karen Mirza and Brad Butler have been creating a body of work that is centered upon collaboration, dialogue, and the social, and their early works emerged from their interest in seminal avant-garde film. In 2004, they formed no.w.here, an artist-run center that combines film production and critical dialogue on contemporary image making.

Since 2007, they have pursued a strain of practice entitled The Museum of Non Participation. For the duo, the term *non participation* is a useful device for questioning and challenging current conditions of political involvement and resistance. How does one participate in or withdraw from political realities individually and collectively? How can one make withdrawal visible, our non participation active and critical? What social spaces support or deter from such actions? And how can art represent, facilitate, or intervene in this process? Made up of film, sound, text, and performed actions, The Museum of Non Participation serves as the conceptual platform from which to address these questions.

Chris Wright (C)—Contemporary artists can use words like *anthropology* and *ethnography* without necessarily considering the relationship between the two, and I would like to start by asking what it is you mean by using those terms? Your work has been described as ethnographic, but perhaps you don't see it in that way, and what is it's relation to the anthropological? Where do you see the difference between the two?

Brad Butler (B)—I find that one of the more useful anthropological texts for this particular question is *The Ethnographer's Eye* by Anna Grimshaw.[1] In this book, Grimshaw links the evolution of anthropology as a discipline with the birth of cinema, and this greatly influenced our film *The Exception and the Rule*. By arguing that there is an ocular-centric bias at the heart of anthropology, which is encapsulated by the commitment of modern ethnographers to "go see for themselves," Grimshaw is

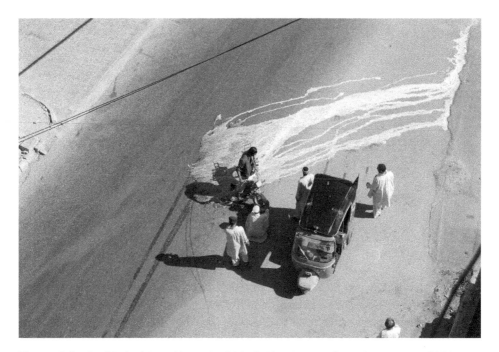

Figure 9.1 Brad Butler/Karen Mirza, Act 00010, The Museum of Non Participation, 2008; courtesy of Galeri NON (Istanbul) and waterside contemporary (London). This image is part of an archive within the collection of the Museum of Non Participation, a museum of gesture and action, the relation of collections and collectivity. The image of the spilt milk articulates a set of conditions, a set of social relations, a gathering of people around the action. As The Museum of Non Participation travels, it is produced by and produces, collecting through disruption the places of the non—violence, fatigue, silence, deletion, absence, dissemblance.

arguing that the fieldworkers of the twentieth century reaffirmed the association of vision and knowledge. She then goes on to articulate that anthropology is characterized by "its different ways of seeing."

Karen Mirza (K)—This is a structure we pick up in our film *The Exception and the Rule*, which I consider as a lexicon that indexes ideas and positions of the image and the event. Broadly speaking, in the first half of *The Exception and the Rule* we move through three main strategies: the camera as an interlocutor for events evidenced in frame [news], as an apparatus that changes the pattern of events by its presence [social/intervention], and as a translator of events that would not happen had a camera not been present [choreography for the camera]. Each of these strategies we situate within very everyday situations, and we often talked about them in terms of whether we could filmically reproduce the feeling of conducting ethnographic fieldwork. What develops is an interrogation of the different modalities of camera, subject, and object—an exposition of these complex relationships. This then sets up a radical departure that includes an intermission sequence filmed at the Wagah border between India and Pakistan, followed by film montage with a sonic score

made from the phrase "Images I wish I had filmed but couldn't." This part of the film speaks much more to the body and to what might exist between images.

B—Eventually what came out of this process was this idea of non participation, which we can perhaps talk more about later. But through thinking about vision as a strategy or a technique, and as a way of knowing the world, we also began thinking about power, exclusion, and the frame, and we began to talk of the said, the unsaid, and the unsayable.

K—So in terms of anthropology and ethnography, we hold anthropology as a way of seeing; this not only includes an interrogation of vision, but it is also the reflexive use of such insights to expose ways that people engage in the world, including non participation as a way to think about withdrawal. Experimental ethnography is a methodology within this dynamic, though in our practice we like to push this even further by thinking through images and objects as sets of social relations.

C—I think anthropologists sometimes use the word *ethnographic* in relation to art-works in a dismissive way—"It's very ethnographic but"—and there's always a "but." Your work is anthropological in the way it interrogates images in terms of ethics, and it is not only concerned with adopting a method—your work does both.

K—We do interrogate what it means to produce an ethical image. And this also im-pacts wider in how we are using the term *non participation* as a frame in which we site our images. Because we do not view this non as a negation but as a threshold—a political plastic—that expands and contracts, is unstable and malleable. One aspect of non participation is to acknowledge that it is a life condition in which we are all embedded. It is both consciously and unconsciously exercised in each of our lives. For example, internationally it exists in the continued excess of one's own society gained at the expense of another's nameless plight elsewhere. Locally it is recogniz-able when, for example, a person encounters an issue, or even a social practice, that is agreed is necessary or even a necessity and in that simultaneous moment, they ignore it or reject it. We feel this is much more complicated than just apathy. It needs processes of unlearning, deschooling, the decolonization of knowledge and an awareness of the forcible frames that direct what can be seen, read, said, and heard. So we frame the non as a lack of connections, as well as new connections to be made between power and its interests that might otherwise stay unseen. So The Museum of Non Participation in its title refers to an embedded institutional critique, but it is released from being an actual museum, and with its ability to travel as a place, a site, a slogan, a banner, a performance, a newspaper, a film, an intervention, an occupa-tion, this also allows for this museum to act. Thus we aspire to make each image, artwork, event, or constituency of The Museum of Non Participation as agent, so it becomes animated often beyond our intentions, more so because neither we nor the museum possesses sole authorship of our work or processes. Instead, The Museum of Non Participation assembles multiplicity and a multiplicity of readings, a multi-plicity of authors, a multiplicity of voices.

Figure 9.2 Brad Butler/Karen Mirza, Act 00157, 9-minute DVD, The Museum of Non Participation, 2011; courtesy of Galeri NON (Istanbul) and waterside contemporary (London). Conceived across three monitors, these (speech) acts perform utterances from the voice to the body, the body to voice as an exposition of voice, silence, gesture, and authority. Each performer is cast in relation to his or her personal and political circumstances. The acts include Khalid Abdalla, a Hollywood actor and cofounder of the collective Mosireen, a nonprofit media center in downtown Cairo born out of the explosion of citizen journalism and cultural activism in Egypt during the revolution. Khalid Abdalla stands in downtown Cairo just a few weeks prior to the revolution, speaking about the propaganda drive of Western cinema in its depiction of the Arab body. Act of State is an interpretation and translation of Act of State: A Photographed History of Occupation, an exhibition curated by Ariella Azoulay created from photographs by Palestinians about their struggle, which Azoulay argues is a "citizen contract" in the absence of legitimized legal citizenry. Last is artist Nabil Ahmed speaking on contemporary labor and migration issues intertwined with his heritage and knowledge of the language movement from Bangladesh and his desire to protest against precarity in the UK. While each work is a speech act that is self-contained, the accumulation of the voices speak to each other and the exhibition as a whole through the spatiotemporal strategies of adjacency and (off)setting of timing. A choreography of images and temporalities collect a collective practice. Act, act(s), act(ion), act(ivist), act(uality), speech(act).

B—So The Museum of Non Participation aligns itself with the legacy of the dematerialized art object working with systems of distribution, strategies of intervention, overlapping in various registers traversing urban geographies and media contexts appropriating text as image, image as text, text as action. We do not completely disavow the object of art, but we are driven to dislodge its centralizing position within the field of art; our concerns are taken up by placing our importance on processes of viewing these objects within a set of social relations, objects, and sets of social affinities—collections and collectivity.

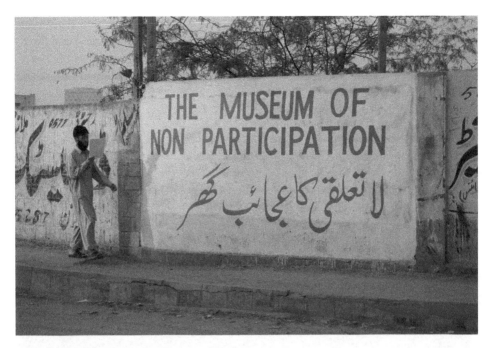

Figure 9.3 Brad Butler/Karen Mirza, Act 00171, The Museum of Non Participation, 2008–13; courtesy of Galeri NON (Istanbul) and waterside contemporary (London).

C—Often in terms of actual practice, you don't think about things like the relation between ethnography and anthropology, but when it comes to distribution it is a concern.

K—Our first ever work made, in 1999, was *Non-Places*—influenced by the text by anthropologist Marc Augé—which we showed in all categories, as fiction, as experimental, as nonfiction, in galleries, in cinemas. It was one of those rare works that wasn't defined by categories.

C—The opposite of having to fit it into a space.

K—Our new film is also a good example; it is going to be shown on a public screen in Canary Wharf tube station, and it is called *Hold Your Ground*, and although the content of the work is incredibly relevant, the art—as a contemporary practitioner—is also in negotiating the work into that space—that is, the work of art. All these forces that come to bear on the work of art, the commission, the site, the social and economic forces, the regulations are all bound up within it.

B—In *Hold Your Ground*, the central character is trying to do two things I feel a lot of empathy with: she's addressing you directly, attempting to teach a language of protest whilst simultaneously she also struggles to speak. But this work also highlights wider political conditions of inserting a work of art into a public space because, at that time, the corporation of Canary Wharf enforced an indefinite

injunction against protest following their fears that the Occupy London movement would target the most symbolically powerful site of banking deregulation and financial crisis in the UK. So there is a tension between the legal authority of the space, the iconography of the architecture, and its position in relationship to one of the most privatized areas of the city of London.

K—Addressing the city workers in Canary Wharf.

B—Most of what is being said is phonetic; a few sparse words are completely formed in Egyptian Arabic dialect ["hold your ground," "strike," "enough," "homeland"]; one does not have to be an Arabic speaker to understand the sentiment, but access to the meaning does add depth for some of the workers in Canary Wharf who are able to translate it.

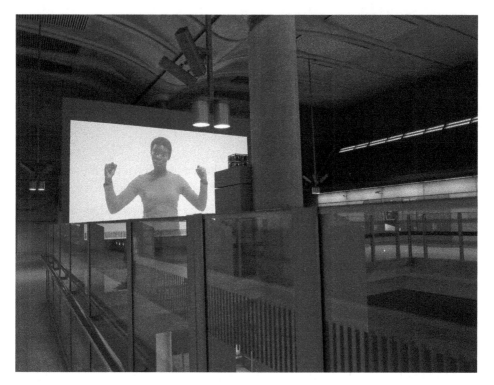

Figure 9.4 Brad Butler/Karen Mirza, Act 00009, *Hold Your Ground*, 9-minute HD film, The Museum of Non Participation, 2012; commissioned by Film and Video Umbrella; courtesy of Galeri NON (Istanbul) and waterside contemporary (London). *Hold Your Ground* is a companion piece to a larger film work by Karen Mirza and Brad Butler, scripted in conjunction with the author China Miéville. Inspired by the events of the Arab Spring, and triggered by a pamphlet of instructions for pro-democracy demonstrators, called "How to Protest Intelligently," the piece dissects the "semantics" of the crowd, and the resulting performative "speech act." Conceived for the site at Canary Wharf, this work calls forth the struggle to turn "fugitive sounds" into speech, addressing an audience predominantly in transit.

C—Yes, it's about the courses you run, the kind of space you operate here that are both part of your work. You run a space that transcends certain kinds of boundaries between disciplines like art and anthropology that are often kept more separate.

K—Sometimes you have to produce the space in order to have a platform from which to speak. We always wanted our collaborative practice to be within a certain context and community, and if that's not there, then you have to create it. So no.w.here (www.no-w-here.org.uk) has been integral to our practice—it's hard to separate the two; they give air to each other.[2]

C—Your work also opens up questions about collaboration; artists use that word quite a lot, but I wonder what it actually means in practice?

B—My relationship to the word *participation* and *collaboration* comes from anthropology, and personally it was a real relief to create a museum of non participation; it allowed imagination and possibility into a word which had ceased, for me, to be about social transformation. The non allowed us to take up a position where we could speak about issues that are very tangible and real but that also allowed for subversion, imagination, and insurrection. There is a reflexivity in understanding our processes of implication, and the crucial question becomes, how do we actively participate and withdraw at the same time?

C—Yes, the discussion around participation seems to be only in positive terms.

K—The ameliorative discourse on participation masks for me the violence of participation; as an anguished optimist I think of how violence, fatigue, silence, deletion, absence, dissemblance all assemble. Our use of the term *non participation* is an entry point into thinking about zones of conflict that connect us, a performative utterance of folded contested spaces, a political plastic that expands and contracts, is unstable and malleable.

C—Using the word *participation* is often a way of getting rid of any actual negotiation.

B—The Museum of Non Participation allows us to look at some of that—at those microshifts of power.

C—One of the elements of your part of the exhibition at the Arnolfini, within their overall frame of the Museum Show, was the concrete—you are dealing with the sayable and the unsayable, and then there are these huge blocks of concrete which address you in a very different way. The combination of words and that bodily form of address is very powerful.

K—The concepts of intervention and collaboration are integral to everything we do, and for this exhibition we specifically wanted to interrogate the relations of display, art object, institution, and movement of bodies in the exhibition space. So very early on, we decided we wanted to invite Pavilion [Sophie Yetton and Gabriel Birch] to intervene in our museum of non participation—our discussions focused on the visual language and texture of the social and political fabric of the city of Karachi and of how to reframe the space of exhibition with interventions that call into question

the relationships between viewer, art work, and gallery architecture. The concrete forms [which we call "lost objects"] borrow from a language of order, oppression, and organization of the city. Karachi has amongst many of its features a series of large-scale signal-free concrete corridors [motorways] that cut right through communities which brutally destroy access to neighborhoods. The only way for local people to gain access was to remove or cut into the concrete corridors to facilitate the movement of pedestrians. The concrete has those resonances of barricades, of roadblocks—it's a very strong architectural form, bringing the outside inside.

C—It's that relationship between the languages—on the wall and on the screen—and the effect that concrete has on you; it's physical. The words are connected to the concrete.

K—One of our desires is to return objects to their original etymology; the word *object* comes from the Latin *Obicere*, meaning to present, oppose, cast, or throw in the way of, to bring forward in opposition. In April 2013, our exhibition at the Walker Arts Center will be titled The Museum of Non Participation: The New Deal for two reasons. Firstly, it refers to both the history of Roosevelt's Works Projects Administration—relief, recovery, and reform. That was, relief for the unemployed and poor; recovery of the economy to normal levels; and reform of the financial system from which the Walker grew from its origin as a community center. Secondly, it refers to a work we are making for the Walker based on four UN resolutions on Iraq dated 1990 [there were two that year], one 2002, and one 2003. From these legal documents, we track the actual consequences that resulted from the occupation, a process of self-education on the scale, desolation, and vast level of corruption engaged by the author, authorities of this sociocide, the U.S., and UK. In particular, we will focus on Bremer's 100 orders, an unfettered vision of neoconservative free market principles. This is the contemporary New Deal—private security firms with full immunity from Iraq's laws; no unions; privatization of Iraq's 200 state-owned enterprises; 100 percent foreign ownership of Iraqi businesses; no preferences for local over foreign businesses; unrestricted, tax-free remittance of all profits and other funds; and forty-year ownership licenses. A contemporary vision of U.S. imperial neocolonial economy. For us art and anthropology must oppose, cast, throw itself in the way of—or bring forward itself in opposition to—such crimes.

Notes

1. Anna Grimshaw, *The Ethnographer's Eye: Ways of Seeing in Anthropology* (Cambridge: Cambridge University Press, 2001).
2. See www.no-w-here.org.uk.

10

IMMERSIONS: RAUL ORTEGA AYALA
IN CONVERSATION WITH CHRIS WRIGHT

Raul Ortega Ayala

Chris Wright (CW)—When did you first encounter anthropology as a discipline?

Raul Ortega Ayala (ROA)—I first seriously considered anthropology as a discipline to work with when I began the An Ethnography on Gardening series in London around 2004. There are several hypotheses about when and how anthropology originated, but they all seem to share a concern with understanding the other or otherness. My work shares this fundamental focus with anthropology, and at a practical level I've been influenced by the ethnographic method of participant observation.

CW—You make a distinction between the closeness of how you worked on your gardening and food projects, and later works, which are more concerned with distance. Can you tell me a bit about the processes involved in making the An Ethnography on Gardening works and their precursors, and also the role of embodied knowledge and how you transmit knowledge, as that's such a key area for anthropologists.

ROA—In an earlier series, titled Bureaucratic Sonata, I had been unknowingly working ethnographically as I did an immersion in the office world by working in one for over a year, unaware of anthropological research methods. Instead for the gardening project I consciously set out to do an ethnography, reading about anthropology and ethnographic methods before I started. I explicitly wanted to be a part of the context to make my work—I wanted to do the same job as others. So I got a job with a gardening company and started to learn, as I wanted to really get to know this context in an embodied way, rather than just using all the new materials I was encountering as aesthetic supports for my work. I wanted to know more, and by inserting myself into this context, I also started to learn about the behavior and the ways of thinking of the group of people I was working with—the jargon and everything that you can't really learn from books. I immersed myself in the extensive world of gardening in the UK and began to learn about a world that is different from the world I occupied as an artist. I then made use of my subsequent learning—what I had embodied from doing the work myself. During that

Figure 10.1 Raul Ortega Ayala, *Calf Roping* from the Bureaucratic Sonata series, video 10:11, film still, 2003; courtesy of the artist.

process I learned new techniques, techniques that I could then think about using artistically in making my own work.

I often refer to my works as souvenirs to emphasize that they are intrinsically linked to an experience or sourced from a specific context or line of research. They operate as a sort of cumulative record of testimonies or sets of reactions to each immersion. The clusters of souvenirs, in combination with the field notes I collect during each immersion produce, I believe, something anthropological. But they differ from academic anthropological study in terms of the aesthetic format in which the result is presented, and also in the sense that each project is constructed horizontally as opposed to vertically. That is, I don't build upon existing anthropological theories, nor do I try to prove any particular one; instead I propose my own intake of each context. I can say that my work is the direct result of combining anthropological and aesthetic processes to produce something that offers anthropological insight through aesthetic experience.

CW—Did your initial intentions about doing an ethnography have to shift at any point? It's a common anthropological experience that you start a project with a set of intentions, but as you become part of a group and learn more of the context you have to shift those initial ideas—there's an openness to being changed by the experience. You develop a set of responsibilities from having immersed yourself in a context, rather than working on something at a distance and, because you are in various kinds of relationships with these people, the knowledge that gets produced requires different decisions to be made about it. Differences about how you can use that knowledge and how you can represent them.

ROA—This is exactly what happened through my process of immersions. I wanted to immerse myself in a context without any a priori ideas—or as few as possible—about what the outcome would look like. I deliberately wanted to involve myself in a context that I did not know much about—a different world for me. It was and is important for me to involve myself in contexts that at the outset don't yet mean much to me—that I don't start with a preconceived knowledge of them. I might have a couple of vague ideas, but as soon as the process starts the assumptions dissipate and the whole research changes. You need to be able to slowly allow yourself to transform and change—to allow yourself to learn new ways of thinking and new ways of using materials. An office wasn't a context in which one could easily think about making art. I needed to work for a living, and I thought I should make use of my environment to make my artwork. I wanted to challenge that opposition in my own thinking—how can I make art here? I sought to merge my working life with my artistic life and I found a way to blend them and to explore my interest in otherness through mixing anthropological methods with aesthetics. I began as an artist working in painting, but I couldn't use that skill to respond to each context. I needed to start each project without a métier and learn the appropriate craftsmanship of each environment I was immersing myself in—that's why the process of making Bureaucratic Sonata felt very comfortable, and I wanted to continue working in that way. So the move towards an ethnographic approach felt very natural. I decided to attempt seriously what I had previously done unknowingly: undertaking immersions in an anthropological way. Finding a way to embody knowledge is a real concern for me—that's why the immersive process is so important.

CW—The anthropologist Loïc Wacquant[1] studied boxing through becoming a boxer—that was his way of studying. Embodied learning and practice changes you as a person—there's an openness to having yourself changed; you're not just extracting something. I think that the term *immersion* is very important, as are the specific qualities of that process and how it actually works out on the ground. You could see Wacquant's project as a performance artwork—immersion is certainly a necessary method—and there is a similarity between what some artists do in terms of immersion and anthropological approaches to it. But although the types of sociality involved and the processes may share a lot in common, the relative status of the final product seems different. What kinds of actual works did you produce during the process of the gardening and food projects?

ROA—In making work responding to these immersions, I did several things: I tried to speak about the new embodied knowledge I had gained using materials and techniques that I had taken from each world. I wrote my own field notes, took photographs and produced what I call "intervened field notes," and then used these three sources to make something else—an artwork. All of these function as a kind of souvenir linked to each immersion—and they have strong relationships between them. So, for example, for An Ethnography on Gardening I produced an actual hybrid plant with the obtained knowledge of grafting and in Food for Thought

Look for an Fit into place Settle in
entry point

Figure 10.2 Raul Ortega Ayala, *Intervened field note 02 24 08–4* from the series An Ethnography on Gardening, pen and typewriter on paper, 21.6 x 13.9 cm, 2008; courtesy of the artist.

Figure 10.3 Raul Ortega Ayala, *Last Supper* from the Food for Thought series, video and photographic documentation of a performance 2003–10; courtesy of the artist. Photo: Thierry Bal.

I used my learned cooking skills to make several performances that involve shared meals and their remains. But it's important to say that I stop an immersion when I feel I am becoming the thing I'm studying—my interest is art, and at some point I need to step back to make the actual work.

CW—This obviously involves an interplay between proximity and distance, but there are also issues of responsibility at work here. What about your ongoing project with the Mexican town that is at threat from being submerged under water with the building of a new dam? It would seem there are larger responsibilities at work in that project, and lots of artists are concerned in a negative way by the inclusion of those kinds of ethics.

ROA—After spending some ten years assuming a participant-observer role in many of my projects, I began wondering what would happen if I somehow inverted this methodology. I wanted to see what the consequences would be in my own work if I distanced myself from the subject matter, as opposed to being a participant-observer. This shift naturally connected me with history (i.e., the construction of history) and with archaeology—disciplines that deal with absent contexts. I came across a note in a Mexican newspaper about a sixteenth-century town called Temacapulin, which is in danger of disappearing because a private company backed by the Mexican government is building a dam for a major city nearby (León, in the state of Guanajuato), and the town is right in the middle of what is likely to become a large lake. I became really interested in this story as it is history in the making: if the town loses its battle against the government and is flooded I will be able to witness the birth of a "trace."[2]

So I went to Temacapulin and interviewed the people who are part of the struggle to save their hometown, and I realized that I wasn't only going to be able to see this as a phenomenon, that is, I wasn't going to be able to emotionally detach myself from it. But nor was I practically going to be able to immerse myself enough to be a participant-observer. So I began working with some people from the town in the form of a collaboration rather than attempting to experience everything myself. The methods I've used so far in my practice entail different degrees of emotional and physical involvement and different degrees of trust. As a participant-observer, in immersions you obtain all your information empirically, and you are able to learn firsthand the craftsmanship and embody the knowledge of a particular context. In a collaborative model, you build your understanding of a context through others' experience or expertise, and in a sense you borrow this craftsmanship and their knowledge for the production of your own work. You could see it as two different ways of traveling: arriving somewhere without a tour guide and with no preconception of the place to find your own way around by trusting your instincts, or arriving somewhere with a tour guide to be taken to specific places to discover the stories embedded within the context through a third person. The experience and the kinds of works generated by these two methods are always going to be different.

Figure 10.4 Raul Ortega Ayala, *Temacapulin* from the series From the Pit of Et Cetera, film in progress, film still 2012–13; courtesy of the artist.

Using a new methodology also made me aware of the differences between being a participant-observer by choice, or by force. When I learned about what Temaca-pulin is facing, I felt compelled to do something. The circumstances—mine and theirs—do not allow me to become a participant-observer and immerse myself in the same way as I did with the gardening project, for instance. Instead, I have to deal with this context from a distance. My own role is also more complicated than it has previously been: it is a world I do know something of as I am Mexican and I know how these injustices occur. So this project called for a different approach—I'm try-ing to deal with distance as a productive element, working with collaborators and using their expertise and their experience to develop this project. The work will end up taking the form of a documentary with many anthropological overtones, but my own role in the research is different this time. It will be an observational documen-tary, but directed by their knowledge.

CW—Observational filmmaking seems to be a very popular approach in contempo-rary art at the moment. It does involve a particular kind of immersion in a situation, and your collaboration in this instance seems very anthropological. It seems also to be about different kinds of bearing witness?

ROA—It's not dealing with embodied knowledge in the same direct way as the gardening or food projects. I feel I can do more to help politically by making some-thing more observational. I have my beliefs in terms of the politics involved, but in this case I don't need to pursue them using the same immersive process but instead by making something that addresses those beliefs through collaboration. Because of the subject matter (a town that will disappear), I somehow have to deal with contexts that are not there—so I have become interested in the approaches taken by archaeologists and historians as well as anthropologists. I'm interested in how history is made and the politics behind this process.

I'm trying to make work that has both anthropological and aesthetic aspects, and I'm thinking about different ways to present it. If I show the work in a gallery or art museum the anthropological aspects might be overlooked. I think the art world needs to catch up with artists in terms of exhibiting and supporting hybrid work—work that shares content and values with other disciplines and that needs to be considered from several points of view. I also think there is a problem with commercializing this kind of work, and I don't seek to exploit the whole array of materials I gather through my research process. For example, I don't sell any of the field material I produce as I don't feel it is necessarily mine in the same way. There are issues of authorship and output that I am constantly struggling with. For example, I would like to show this work on Temacapulin in Mexico City's Tamayo Contemporary Art Museum, which has been recently refurbished and extended. A lot of the finance for this has come from the same people who are financing the building of the dam. I don't think the people in the museum are aware of that, and I think that showing the work there would be an interesting way of framing it. Then I would film the documentary on Temacapulin being viewed within the museum and make that footage part of the work itself. It would say something about how these institutions don't always check or care where their money has come from and would draw attention to the way institutions work.

CW—The use of documentary now spreads across filmmaking, anthropology, and art, but we are stuck with different kinds of exhibition spaces that then define that documentary in various different ways. What drew me to your work was the focus on process. Maybe some of the documentary work made by artists is diminished in some way by being shown in a gallery and not elsewhere—maybe it needs to go outside the gallery to engage with wider social contexts?

ROA—It is precisely this kind of work that deals with anthropological and not just aesthetic values that needs to be seen and judged from a wider perspective. It doesn't always fit within the perspective of art because it's not entirely of that domain or concerned with addressing only that domain.

Notes

1. Loïc Wacquant, *Body & Soul: Notebooks of an Apprentice Boxer* (Oxford: Oxford University Press, 2004).
2. I use the term *trace* here as Derrida did: "The trace is not a presence but is rather the simulacrum of a presence that dislocates, displaces and refers beyond itself. The trace has, properly speaking, no place, for effacement belongs to the very structure of the trace. Effacement must always be able to overtake the trace"; see Jacques Derrida, *Writing and Difference*, 2nd ed. (London: Routledge, 2001), 156.

IN-BETWEEN

Jennifer Deger

Miyarrka Media formed in 2009 to create a new kind of shared art practice. In the beginning we were four: two senior Yolngu performers, a video artist, and an anthropologist. Drawing on contemporary Aboriginal aesthetic and social values, we experimented in the spaces between ritual, visual art, and ethnography.

In December 2011, we curated our first exhibition, Christmas Birrimbirr (Christmas Spirit)[1]. For those close to the project, this show held a particular poignancy. Earlier in the year, one of Miyarrka's cofounders, Fiona Yangathu, had died almost without warning. In our grief, we considered canceling the exhibition. But eventually Yangathu's husband and our project director, Paul Gurrumuruwuy, decided otherwise. "It will be hard," he said. "But it's the right time."

And so Yangathu's death became the final galvanizing theme in a project concerned precisely with enlivening the relationships between the living and the dead at Christmas.

For Yolngu, Christmas preparations start in October when the first *wulma* thunder clouds form, heralding the approach of the wet season and the impending birth of Christ. As distant rumbling triggers memories of lost loved ones, quiet tears start to flow. So begins a ritual that embraces—and participates in—circuits of life, death, and rebirth. With songs such as "Christmas without You" and "Joy to the World" playing on high rotation, Yolngu families in remote Arnhem Land settlements use tinsel, lights, and photographs to highlight the absence of lost loved ones. Longing and luminosity comingle; homes and graves become sites of attraction for both the living and the dead. Drawn together through this work of feeling, families reunite in Christmas spirit.

The Christmas Birrimbirr (Christmas Spirit) installation experiments with generating this field of sensation and sentiment in a gallery space. Intended for both Yolngu and non-Aboriginal audiences, the installation uses video, photography, and painted sculptural elements to "share feelings," as Gurrumuruwuy put it, via the

Figure 11.1 Miyarrka Media, Christmas Birrimbirr, 2011, production still.

animating power of digital technologies. Radically humanist in its intentions, it seeks to offer the possibility of meaningful connection for all viewers—both Aboriginal and non-Aboriginal—while simultaneously insisting on the enduring cultural differences between Yolngu and mainstream Australian culture.

A 39-minute, three-channel video provides the installation's central focus. Symbolically structured around the graves of three Dhalwangu clan leaders, it opens with full-frame images of the massing of *wulma* clouds. Projected images on three stand-alone screens build from the slow and melancholic labor of clearing and decorating family graves, through the candlelit singing of Christmas Eve and a Christmas Day *bungul* (ceremony) conceived and performed especially for the project. In the center of an adjoining gallery stands a Christmas tree sculpture surrounded by a forest of slender tree trunks painted in figurative clan designs. Together with a series of photographs and smaller video works, these elements claim the art gallery as a ceremonial space—a space of repetition, amplified sensation, associative meaning, and palpable co-presence. In a smaller side gallery, video segments narrated by Gurrumuruwuy and subtitled into English provide a description of events from a Yolngu point of view.[2]

I think I can speak for each of the members of Miyarrka Media when saying the first installation of Christmas Birrimbirr proved deeply satisfying. Together we have created a work that we each find moving, beautiful, and resonant. Our willingness

to work with the back-and-forth processes of co-creation has resulted in an exhibition that not only coheres on its own terms but far exceeds what we might have envisaged individually.

Nonetheless, in many ways Christmas Birrimbirr means very different things to each of us.[3]

This is surely both inevitable and entirely apt. It speaks to the unruly truths of images; to the ways art can encompass contradiction and ambiguity, even as it engenders connection and identification. The language of explanation, in comparison, wrenches things apart. Or, at least it can. Particularly perhaps in this case where our differences have been so constitutively defining of how and why we came to the project—and what we will potentially take from it in terms of our own career trajectories. As in any collaboration, a complex, intermeshing web of ambition, inspiration, and goodwill has held us together and propelled us forward. But perhaps more than most, this collaboration has been energized by the risks and the potentialities of the in-between. This is a work that pivots on the power of resonance; it affirms relationships rather than individual subjectivities; it invokes forces that draw disparate things, people, ideas, and even maybe cultures together. But equally it claims differences that will not—cannot? need not?—give ground. Even as we lean toward each other.[4]

In the text below, recorded fragments of conversations have been cut and pasted in an effort to sidestep the rupturing potential of difference laid bare. In the spirit of the project itself, the text is arranged as assemblage rather than conventional critical analysis.

Paul Gurrumuruwuy (PG)—No project can be made by one single person. But when you've got three or four or five people that work together, talking and planning, over time, we've got a team…Balang [David], you and me and *ngarndi* [my mother, his wife, Fiona Yangathu]. We share one *mulkurr* [mind]. Our minds talk to each other, our hearts speak back and forth, we share a sense of purpose.

It's *djal*. I don't know how to say that in English…For Yolngu there is djal everywhere. I don't know how to explain it for *balanda* [non-Aboriginal people]. What word to use? Want, maybe? [Jennifer Deger (JD): Or desire?] Desire, yes. But it's more than that, too. For example, someone might say, "I just want to have a sleep…you're just wasting my time [with all these demands]." That's djal speaking. It can take people away from each other. But our djal is like a magnet. One djal, the four of us. Because your *djama* [work] gets me going. That's djal.

Figure 11.2 Miyarrka Media, Christmas Birrimbirr, 2011, video still.

We don't push one person over the other. For example myself, my job is different to yours, and yours to mine and balang [Mackenzie], different again. But everyone brings it into one. Like a nest and nursery, we've been nursing the plan. And that plan will grow into a *yindi* [big] strong project. That's how I see it from a Yolngu point of view.

With my mind, through the Yolngu side, I drift or carry it with the water, through the river. Not rough but lovely smooth water. I move with it. And work with it. We just followed on the current, follow on the water to carry our plan.

And it worked. What me made is true. It's not made up.

Jennifer Deger (JD)—The original idea for this project came out of my long-term relationships with Yolngu and certain ideas I'd developed about media aesthetics. I'd been researching indigenous media in Gapuwiyak for more than fifteen years but had never really made—much less claimed—a creative intervention of my own. Having shifted from an anthropology department to a research position at a college of fine arts, I felt emboldened. I began to see both the creative and curatorial possibilities of my own work beyond the "black hands on cameras" policies that had shaped my earlier participatory practice as trainer/producer. I felt strongly too that there were other directions that ethnographic filmmaking should be pushing beyond the often slightly cold detachments of the observational. I was drawn to exploring certain nonverbal modes of engagement and response, interested in sensation and affect as constitutive of certain kinds of knowledges and relationships; concerned with the links between seeing, feeling, and knowing, and with creative practice as a new direction for anthropology.

At the same time, I felt that there was a certain lip service being paid to ethnographic orientations in the art world. It seemed to me that despite an avowed interest in alternative aesthetic schema, curators and commentators were still extremely limited in their capacity to recognize and respond to Aboriginal culture on anything resembling its own terms—or at least the terms that I recognized from my fieldwork.

I'd spent several Christmases in Gapuwiyak and found it incredibly moving, especially in comparison to the consumerist rites my own family struggle through each year. Inspired by this, I made a short little film. It tried to use video to convey—and recreate—the performative aesthetic of color and music and sentiment that I saw to be at the heart of Christmas in Gapuwiyak.[5]

When I showed this to Paul and Fiona they responded very enthusiastically. Straightaway they saw how this idea could become something far more substantial—both thematically and structurally. Paul had toured the world as a performer and director of a local dance troupe…together they had expertise and energy to take the work to another level. As we talked and our vision for the project developed, I became concerned about how we were going to move forward because I knew that none of us had the camera skills to do justice to the large-scale ambitions of what we were planning.

Then one day, apparently quite by chance, I met David in the Gapuwiyak store. After that, things really began to take shape.

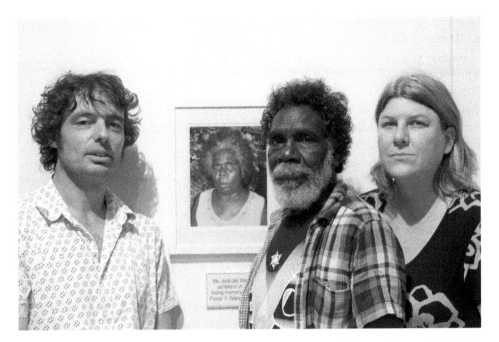

Figure 11.3 *Members of Miyarrka Media; left to right: David Mackenzie, Fiona Yangathu, Paul Gurrumuruwuy, Jennifer Deger, 2011.*

David Mackenzie (DM)—I came to north Australia and Arnhem Land with certain ideas about how to work collaboratively with indigenous people, but I wasn't sure how to approach that. In my own practice as a video artist, I had been thinking for a long time about how I could do that. It's almost like I was looking for this project. And when I found myself in Gapuwiyak on a totally unrelated project with the northern territory open education center, working with Yolngu in schools on video production, I ran into you and that was the spark that started a larger project.

I was particularly interested in the space that video created, that working with video created for me and how indigenous people could translate their own belief systems into the space of video. And I think what really drew me to start thinking in this way was a conference I went to in Canberra where Francis Kelly [a Warlpiri man from Central Australia] showed a video that he'd done with Eric Michaels back in the 1980s where they'd planned a trip back to country with a couple of the old people and some of the young people, and Eric Michaels…I can't remember how it went, but he couldn't go, and so he gave the camera, this big old super VHS video camera, to Francis and said, "Document the trip."[6] And that tape sat in a drawer for twenty years, deteriorating, and they brought it out to this conference and showed it. And I was so moved by it.

And so drawn to what the tape held and the possibilities the tape held, and that's what started me to think, why can't this kind of footage work as a piece of art in a

gallery? And what's involved in the coming together of me as an artist and Francis as a Warlpiri man?

At that point I was very much caught up in the politics of it. In the politics of representation and coming from Sydney art school and having my supervisor say, "Oh well, Blackfellas tell Blackfella stories, and we tell our stories." I couldn't accept that. So I wanted to find a way to bring a work like that into a gallery, to an installation where because I knew…because video to me was all about feeling—about the sense of things, color, light, and movement.

While all this was happening, I was trying to finish my master's, and I was grappling with the concepts and divisions between all those things—between art and ethnology and film. They're categories that I was trying to pick apart, exactly to find the spaces in-between. [I wanted to make a video] where someone would go and watch the work in the end and ask themselves these questions: is this art? Is this a video installation? Is this ethnographic film? And that's what I wanted to be testing as well. Because I find it a very natural way to work. But I find it an unnatural process to try to categorize it afterward.

PG—I know you're an anthropologist, Balang [David] is an artist, and I just fit in as the leader in Yolngu *rom* [culture, law]. Like that we fit together well. Before, we were *barku wetj* [far apart], each alone. I don't know how it came about that we fit in so well, but someone knows.

We bring different angles to it. We're all different corners, and all those corners just fit in to make a table perfectly. Firm. I don't know how it happened, but we're the right people, right *mulkurr* [mind], *ngayangu* [heart], and *djal* [motivation, desire]. And we made it happen.

But in another way *gathu* [daughter], if you look at it in a Yolngu way, this project is coming from somewhere else. Really, this project has always been there. We just brought it out. We made it real. The way we look at it, the project has come from those graves, from those *birrimbirr* [spirits]. That's where the power and what you would call vision for this project comes from—from those photographs we filmed, from the land itself. That's where this art comes from. That's where this project is really coming from.

Even though the camera can't see it, if you're clever enough, you can see it.

DM—I knew right away that the project wasn't about me or what I wanted or what I saw. It was about how we would all work together to translate it into something else. And that it could never have been the project it was without our collective ideas coming together. And so really for me, it was all about sitting and listening and then starting to contribute what I could of my own ideas and direction. And it unfolded that way, day by day, as we collectively built and directed the project. So in that way, we all had to work very closely together, and I had to develop a rapport with Paul to try not to second guess but to be on a similar level of vision and seeing things.

The very interesting thing for me was the way that worked so seamlessly—that a scenario or a scene would be set up, whether it was decorating the houses or raking the ground around the graves, and people would just come together and start doing

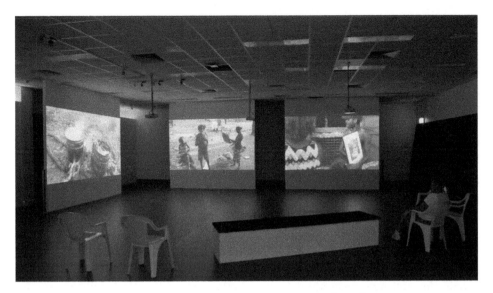

Figure 11.4 Miyarrka Media, *Christmas Birrimbirr*, 2011, view of installation.

that. And suddenly I'd have to film it. And so what do you film? How do you film it? And that's where in a way Paul really trusted me to follow that action and that vision, and that's, I think, the beautiful thing for me—the way that I work was that I'm instantly drawn to things, whether it's the movement of a flag in the wind, and its interesting all those things I was drawn to and concentrated on were the things of significance and power in the project—and meaning. And then I'd always look at Paul, and he'd wink or nod; he never really said anything. And in there is the beauty of that collaboration.

There's a place that you go to when you're behind the camera which is in a sense very alone. The time and the space that I enter behind the camera is very much an individual one, and if we put aside technique and style and the basic operations of the camera, you're still essentially very isolated, even though I knew that every-one was there and that we'd all had a shared vision. But what makes you come to the decision that you won't just set it up on a tripod and let it unfold in front of the camera? Or you follow something and you go into a place that you're drawn to as well?

Even though you're surrounded by others—and I know that you're there, and I know Paul is there, and I can actually feel you both watching me. So then there's already established this invisible connection between the three of us, and a trust.

So that style and that way of filming is shared as well.

JD to DM—Paul makes explicit in the documentary we've just made about this project that ultimately the vision is coming from the old people. He's making a claim about knowledge and truth that is of a really different order.

DM—Yes, but that's all he can do because that's who he is and what he knows. I don't claim to know the ancestral force that he's referring to, but I do claim to feel it. And I think that's enough. So Paul doesn't have an understanding of cinematic structure the way I might or the way you might, but that doesn't matter because we found a common ground where all the elements can work together. And they will, with different audiences, have different meanings.

Because part of me wants to claim this as…not as mine, but I want to hold onto the vision at the same time as letting it go and sharing it. And that's the only way I think it can work.

PG—David's art looks really perfect, clear. This is why I like working with him. People can just look at his video and get the feeling straightaway. And that's because of David's art. David's eye can touch the eye of the audience, and their heart. It's so clear.

But really, especially for Yolngu [audiences], it's the rom that entices. The rom is coming from us actively. It came alive in that gallery. The video, the photos, the people, the audience—everything is alive. So those birrimbirr, they walk amongst us in that room; we can feel them walking amongst us.

That's the secret thing, gathu. The reality. Making the *manikay* [songs] alive, *ringgitj* [sacred places and connections between clans] alive, the photos alive, the paintings alive, and the people, the audience, alive. So they [the spirits, birrimbirr] walk amongst us in that room; we can feel them walking amongst us or sitting amongst us, watching.

That gallery was full of riches. Riches, feelings, energy. And we did that.

JD—In many ways this project has been as much about creating shared discourse as creating shared art.[7] Given the experimental dimensions of the work—this was very new for all of us in different ways—we've needed to find ways to conceptualize and explain the project both to ourselves and to others. Over the past several years in preproduction, editing, and installation, and also in grant applications, press releases, and catalogue texts and press interviews, we have shaped, rehearsed, and refined the narrative for the project. Each version carefully calibrated to context, which has mostly meant downplaying the ethnographic element due to what I detect as certain prejudices in the art world.

But for me this project comes out of exactly the things that matter to me about ethnographic engagement—namely, taking people seriously on their own terms. In this case, for me, it has involved learning what it means to look, feel, and relate in a particularly Yolngu way.

DM—Paul talks a lot about feeling, and I think essentially that's what guided this project. He says it doesn't matter if you're Yolngu or Balanda, it sits above everything and guides everything. It's bigger than any of us. That power, that feeling.

PG—Balanda can feel it. And they can feel that power in their own lives—through their own families and through their own sorrows. We're all human. We all have

feelings. It's up to them. It's up to them to open their hearts and feel it—to understand that this is true and real and that there is something special hidden here.

[We made this exhibition] not like Balanda who just put pictures, pictures, pictures everywhere. That's nothing really, the way I see it. But in that gallery, the way we made it—and Yolngu looked at it—in a different way, from Yolngu culture, from Dhalwangu clan culture and Marrangu clan [the ritual managers for this work]. It's coming from there really. Underneath, they looked.

Because Yolngu have never seen an exhibition like this before, it's the first time in our lives that they can see where it's coming from—from rom.

When they came to our opening, they looked and they said, "What's this? Is it real? True? But you've only got a small name. You're nothing. And look what you're doing now. You're only an outsider, an ordinary Yolngu."

They got that shock because they don't know how. And that's the secret. Yeah. "Anybody can do that," I told them. "Anybody." "No, too hard for me" [they said]. But if you've got a team, working together, planning together, one ngayangu—it can happen. At that big opening, lots of Yolngu were asking, "How can he do that?" There's no such people who can do that. Only if you concentrate on djama, *ga ngayangu* [and heart, emotions, inner force], ga djal together.

And those other Yolngu, they reckon…ah…now you've got windows. You've got lots of doors and windows like in Balanda rom. You've got doors everywhere now. It doesn't matter if you stay at an outstation…[Through this work] you've got doors and you can walk out to the world, to another world.

Notes

1. Christmas Birrimbirr (Christmas Spirit), Chan Contemporary Art Space, Darwin, December 8–18, 2011.

2. The project gave rise to forms of ritual elaboration in the community which meant that in fact the Christmas that was performed for the camera and re-created in the gallery space was unlike any previous Christmas. And indeed, unlike subsequent ones. This performative dimension of the project underscores again that this is not social documentary but a form of participatory cultural creation that in both its particularity and innovative imperatives actually accords with other forms of contemporary Yolngu ritual performance.

3. This is not the place to assess the project's success in other people's eyes, although arguably the relationship between the viewer and the work is the collaboration that matters most of all in this most participatory of projects.

4. As Gurrumuruwuy says in the documentary version of the project, "Yolngu and Balanda, we have very different cultures. But through feelings we can be connected."

5. *Christmas with Wawa*, Dir. Jennifer Deger with Susan Marrawakamirr Marrawungu (Gapuwiyak Media Project, 2008, DVCAM).

6. See Eric Michaels, *Bad Aboriginal Art: Tradition, Media and Technological Horizons* (Minneapolis: University of Minnesota Press, 1994).

7. The category of art deserves more of a critical shake up than I have the space to do here.

—————————— 12 ——————————

AN IMAGINARY LINE: *ACTIVE PASS TO IR9*

Kate Hennessy

Active Pass to IR9

Active Pass to IR9 is a video-based collaboration between artist Richard Wilson, a member of the Hwlitsum First Nation, and me, an anthropologist of European descent. At the core of our video is an exploration of a series of relationships: between Richard and me; between landscape and narrative; and as we discovered in the process of production, between the place-based politics of European colonialism and the ongoing defense of Aboriginal rights and recognition. We use video as a mediating tool for the documentation and communication of our first collective encounter with a place that we both consider home.

Richard and I grew up together on Galiano Island on the west coast of British Columbia, Canada. While we had attended school together, we had only started a friendship later in life based largely around our shared interest in digital media production and our involvement in the activities of the Gulf Islands Film and Television School, a radical media training institution built in a former logging camp.[1] In the summer of 2008, we were invited to co-curate an exhibition for Vancouver's New Forms Media Arts Festival.[2] Festival director Malcolm Levy commissioned us to bring together a selection of contemporary Aboriginal digital media projects as an interactive gallery installation at the VIVO Media Arts Centre.[3] Our starting point was the selection and study of six online projects—*UsMob*;[4] *Digital Dynamics Across Cultures*;[5] *Isuma TV*;[6] *FirstVoices*;[7] *The Whale Hunt*;[8] and *Dane Wajich—Dane-zaa Stories and Songs: Dreamers and the Land*[9]—which would be displayed on individual monitors in the gallery space.

We curated these multimedia works from Canada, Australia, and the United States because of the innovative ways in which they all, taking different approaches and forms, represented spaces and relationships online and on the ground. *UsMob*, for example, presents video narratives drawn from the life of young members of an Aboriginal community close to Alice Springs, Australia, inviting online visitors

to acquire a permit to visit their reserve, drawing attention to legacies of colonial administration and persistence in the face of isolation and discrimination. The site allows online visitors to better understand a cultural and political space that would otherwise be far out of reach. Another project, *First Voices*, provides Web-based tools and support services for Aboriginal peoples in Canada who choose to use digital technologies for language archiving, teaching, and revitalization. *First Voices* virtually connects remote Aboriginal communities in their shared efforts to record and revitalize languages that in many cases were historically violently suppressed by the Canadian government. It also facilitates the interaction of youth and elders within their communities as they work together to record and upload their language, reinforcing social relations and strengthening personal relationships. A third project—also shaping Web-based media to support the transmission of local cultural knowledge—Kimberly Christen and Chris Cooney's *Digital Dynamics Across Cultures* (2006), introduces viewers to the knowledge and access protocols of the central Australian Aboriginal Warumungu community and countries. The site teaches about local Warumungu protocols for knowledge circulation, production, and interaction, deliberately intervening in common expectations that the Internet should be used to share and distribute, rather than restrict and protect, forms of knowledge. The website's interface demonstrates the proper circulation of cultural knowledge in Warumungu social space.

The issues raised in these projects informed the development of our video *Active Pass to IR9*. Richard and I saw in these Internet-based projects a suggestion that cultural and historical knowledge, and the forging of social relationships, could be generated in virtual spaces in ways they cannot be on the ground. Physical bodies, separated by geographical and social distance, or by legacies of colonialism and trauma, were finding new opportunities for communication in hypermediated environments. At the same time, we saw that representations of indigeneity online are initiating discussion about the capacity of the Internet and digital technologies to share knowledge more widely than ever before, potentially an extension of the colonial project, rather than a technologically mediated solution to real social problems in and between local Aboriginal and settler communities.

The video *Active Pass to IR9* was originally initiated to contextualize and situate the selected Aboriginal media works as products of social relations and colonial histories that were creating meaning in new virtual environments. The video was first projected in the exhibit space at VIVO Media Arts Centre as a curatorial statement and placed online in a website documenting the exhibition, implicating our newly created video in broader relations of sharing, circulation, and remix. However, the process of producing the video work became for me and Richard a more personal project, one in which our own histories and understanding of our shared colonial relationship came into contact for the first time. Our curatorial project became an opportunity to put themes raised in our exhibit into a more personal practice that could be shared with visitors to our installation and with a virtual audience online. We decided to experiment with the production of a video work that would reflect

our own emerging relationship and in which broader social and cultural meaning would be generated through our collaboration. In the way that Aboriginal media works selected for the New Forms Festival exhibit were seen to create virtual social spaces for interaction and dialogue across real and virtual communities, we wondered if we could create our own space of social relations and exchange.

In some respects, our approach echoes Nicolas Bourriaud's explorations of relational art, which takes "as its theoretical horizon the realm of human interactions and its social context, rather than the assertion of an independent and *private* symbolic space."[10] We used a relational context—our shared experience of the island, cut through by a locally underexplored colonial history—to define the production principles for our video work (which I explain below). Richard and I were inspired to reconsider our personal relationship and to document the face-to-face process with video, in response to questions raised in our exhibition about the qualities of social relationships that are virtually mediated. At the same time, our project was less an exploration of the theory and application of relational aesthetics, one that has been critiqued for its micro-utopian emphasis on togetherness,[11] than experimentation with video as a medium for the articulation of what Claire Bishop has called relational antagonism.[12] Drawing on Ernesto Laclau and Chantal Mouffe's explorations of hegemony, Bishop describes antagonism as central to the function of a democratic public sphere in which "relations of conflict are sustained, not erased."[13] Beyond Bourriaud's assertions of relational art as that which produces human relations, Bishop calls for a more particular investment in the types of relations being produced, for whom they are produced, and why. The goal should not merely be the cheerful unification of people in a social space, such as in many of the works of artists celebrated in Bourriaud's writing; indeed, relational antagonism is "predicated not on social harmony but on exposing that which is repressed in sustaining the semblance of this harmony. It would thereby provide a more concrete and polemical grounds for rethinking our relationship to the world and one another."[14] Relational antagonism more closely describes the intent of *Active Pass to IR9*, which in its exploratory, dialogic nature evokes narratives of colonial encounter and resistance that while often invisible, profoundly shape the subjectivities and social relations of Aboriginal and non-Aboriginal peoples of British Columbia.

An Imaginary Line

On a rainy morning in July 2008, Richard and I met at the Sturdies Bay Ferry Terminal at the south end of Galiano Island. The terminal is situated at one end of Active Pass, a highly trafficked, narrow body of water that churns with whirlpools and standing waves with the changing tide. The Active Pass lighthouse flashes from its post on Mayne Island, and ferries traveling from Vancouver to Victoria pass on the hour. Ferries land at Sturdies Bay twice a day from both Vancouver and Victoria, bringing residents and visitors to the island. Everyone travels along a single road

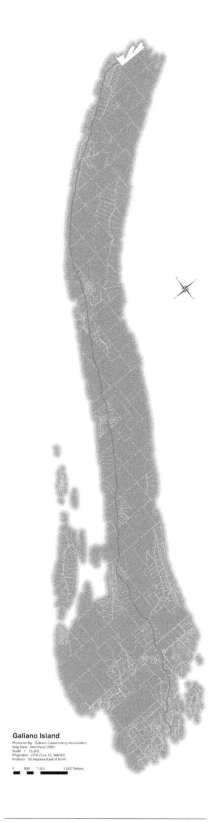

Figure 12.1 Map of Galiano Island, British Columbia. Courtesy: Galiano Conservancy Association; produced by Galiano Conservancy Association; map date: November 2009; scale 1:15,000; projection: UTM Zone 10, NAD83; rotation: 50 degrees East of North.

Galiano Island
Produced By: Galiano Conservancy Association
Map Date: November 2009
Scale: 1: 15,000
Projection: UTM Zone 10, NAD83
Rotation: 50 degrees East of North.

0 500 1,000 2,000 Meters

from the ferry terminal to an intersection that leads either to the south or north end of the island. The drive from ferry to home constitutes a common experience for all residents and visitors. From the road, the island appears relatively uninhabited; however, every inch is divided up into private properties, Crown-owned forest lots and tree farms, and parkland (Figure 12.1).

At the terminus of the northern road, called Porlier Pass Road, is Indian Reserve #9 (IR9), which belongs to the Penelakut First Nation (see Figure 12.1, marked in white). The Penelakut represent approximately 13 percent of Hul'qumi'num people on the Northwest Coast. Today, other Penelakut reserves are also on Kuper Island, Tent Island, and on the lower end of the Chemainus River on Vancouver Island.[15]

Richard and I had decided that we would choose a day to drive together, for the first time, from the ferry terminal at Active Pass to the Penelakut Indian Reserve #9. We would mount a video camera so that it would film the road in front of us—the road so familiar to residents and visitors alike—but also record our conversation as we drove. We would film a single, long take. After we had completed the route, we would transcribe our conversation and augment the video with the text generated during the drive. The text would represent the dialogue generated in the social space that we created; it would be experienced by the viewer as an element of the shifting landscape and the result of our encounter. We didn't know how the conversation would unfold but planned to talk about issues that we had never had the opportunity to address with one another before.

In the final version of the video, text representing both sides of our conversation scrolls down the left and right sides of the frame, moving slowly across the

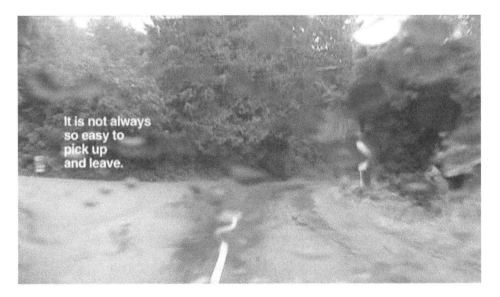

Figure 12.2 Kate Hennessy and Richard Wilson, *Active Pass to IR9*, video still, 2008.

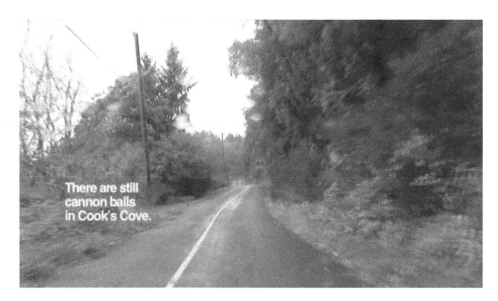

Figure 12.3 Kate Hennessy and Richard Wilson, *Active Pass to IR9*, video still, 2008.

rain-soaked road and green landscape. In the center of the frame, the road's yellow dividing line is distorted by raindrops and the sheen of headlights from oncoming cars; the line weaves and twists against the gray concrete as we talk. In between the trailing lines of our dialogue are deeper histories and complexities; the conversation generated in the car as we drove and recorded was a starting point for making visible the social relations that for both of us had remained opaque and often difficult to comprehend. As we drive north along Porlier Pass Road, glimmers of larger stories of colonial domination, administration, and violence—as well as Aboriginal resistance to it—emerge in our shared space of conversation.

We leave the ferry terminal at Active Pass discussing our families: mine, who left Washington, D.C., in the early 1970s, bought a piece of land, planted gardens, kept goats and chickens; Richard's, who came from the Vancouver mainland and Mayne Island, on the other side of Active Pass, and eventually settled mid-island on Galiano. Contrary to my assumption, I quickly learn that Richard's family had never lived on IR9.

> Kate: "Was your Grandmother Penelakut?"
> Richard: "We're not Penelakut."
> Kate: "I always thought you were!"
> Richard: "We just started trying to figure it out a few years ago."

I later came to understand through this conversation that while related, Richard's family maintains a distinct cultural identity, one that continues to differentiate them from the Penelakut First Nation (Figure 12.2).[16] When Richard and

I were growing up, several Penelakut families lived full time on the small reserve, with relations living on the Kuper Island Reserve and on Vancouver Island. IR9, which occupies a small northern tip of Galiano, continues to be used seasonally by band members, although the community there has largely moved to join their relatives on Kuper and Vancouver Islands. Other families, like Richard's, continue to live closer to the south end of the island. Neither of us had understood why (Figure 12.3). Richard tells me:

> A long time ago, there were these sailors, no, government people...My family ended up killing two of them, maybe they were defending themselves, I am not sure, but then they ran, and then they ended up on Kuper, at Lemalchi Bay, and there was a big fight.
> There are still cannonballs in Cook's Cove.

Chris Arnett (1999) has described how, between 1850 and 1854, the Hudson's Bay Company negotiated a series of land sale agreements with First Nations on Vancouver Island, which guaranteed Aboriginal people "the undisturbed use of their lands and resources in exchange for allowing white settlement within their territories."[17] As the colony attempted to expand further on Vancouver Island and into the Gulf Islands, Aboriginal willingness to negotiate decreased. Arnett tells how a frustrated colonial government began to illegally survey and sell desired land, which provoked militant opposition from Lamalchi and Penelakut warriors. Lamalchi warriors, accused of murdering two white settlers, were pursued by military authorities to Lamalchi Bay on Kuper Island. The village was shelled by the military, and Lamalchi people responded with rifle fire. Eventually, two Lamalchi suspects were seized by authorities and held responsible for the murders. In a widely regarded travesty of justice, the two warriors were publicly executed in Victoria, British Columbia.[18] According to Arnett,

> The war against the Kuper Island warriors was small compared to those raging elsewhere in North America. While Napoleon III laid waste to Central Mexico, the American Civil War entering its third year of bloodshed, dominating the Victoria and New Westminster newspapers with descriptions of the battlefields piled high with unburied dead. But this short-lived, almost forgotten war, waged by the British colony of Vancouver's Island against the Lamalcha of Kuper Island, was significant in the history of British Columbia.
> The war marked the first time that military force was used to eliminate hwulmuhw [Aboriginal] opposition to hwunitum ["the hungry ones"] settlement. The defeat of the Lamalcha and Penelekut warriors removed the most strident opposition to hwunitum expansion and paved the way, without mutual agreement, for the alienation of hwulmuhw land on eastern Vancouver Island and the Gulf Islands.[19]

The cannonballs left on the shore of Kuper Island after this colonial attack would continue to do damage far into the next century. The Hwlitsum people, including Richard's family, are the descendants the Lamalchis; like many Indigenous peoples

121

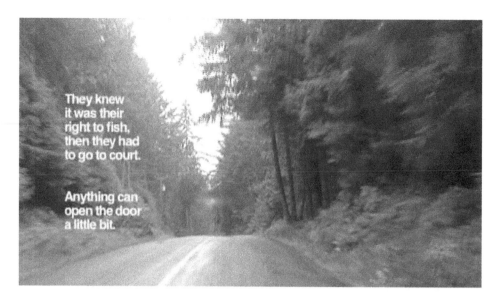

Figure 12.4 Kate Hennessy and Richard Wilson, *Active Pass to IR9*, video still, 2008.

around the world, the Hwlitsum have been engaged in an ongoing struggle for federal recognition as Aboriginal peoples. According to anthropologist Bruce Miller, the Hwlitsum band is composed of several hundred members living in the area of Ladner, British Columbia, south of Vancouver (while some, like Richard's family, are still living in the Gulf Islands). After the attack on the village at Lamalchi Bay and execution of the tribe's members, Hwlitsum members fled to Lummi tribal lands in Washington territory for safety. When they returned, their land and their interests had been assigned to the Penelakut band.[20] Miller describes how in the 1870s, canneries were built in key Hwlitsum fishing areas, which were essential to band life and the Hwlitsums, "as a consequence of white antipathy, the loss of land, and the administrative merger of their band with another group, were not assigned their own reserve and did not achieve recognition under the Indian Act."[21]

In the video, rain obscures our vision through the windshield and then is cleared away. Trees hang over the road, obscuring the houses and summer cottages that populate the landscape. Richard tells me, as we drive along the road toward IR9 (Figure 12.4):

> I couldn't understand why my family was trying so hard to get the right to food fish. But then I realized when they got it that it set off a chain reaction of rights and recognition.
>
> Anything can open the door a little bit. They knew it was their right to fish, then they had to go to court.
>
> We have food rights, but we are not recognized as a band. They don't want us to open it up, there are 500 or 700 of us who have food fishing rights but no formal band status. We don't have a land base.

I learn from Richard that as the Hwlitsum First Nation had been administratively dispossessed in British Columbia, they had both endured and negotiated colonial assimilationist policies. This included forced attendance at the Kuper Island residential school, as well as the exercising of agency in keeping children away from the school.

> Richard: My grandfather was left at the residential school on Kuper Island. He went for a boat ride with his parents, got off on the beach, and when he turned around his parents were gone.
> Kate: I guess a lot of parents at that time felt like they didn't have a choice.
> Richard: Some members of my family didn't do it, they didn't take the kids.

Enduring the effects of colonial administration and systemic racism also entailed creative negotiation of identity. Richard tells me how his family shifted their self-representation in order to make a living:

> Richard: My family started to call themselves Portuguese because it was easier than being Native. They could pass as Portuguese, so they could just work and get on with their lives. They split up from other people, they didn't deal with the government. They went under the radar.
> Kate: Instead of being administered by the state.

Video was a productive tool for us in representing local narratives of colonial encounter, which were elicited in the social space that we created for the project. *Active Pass to IR9* activates narratives of conflict that are largely erased from the everyday spaces of island community relationships, politics, and commerce. Evoking relational antagonism through dialogue, production, exhibition, and circulation is not about creating conflict; rather, it challenges our common desire for the illusion of social harmony, seeking instead to make visible the hegemonic relationships that continue to shape the experience of Aboriginal and settler communities on Galiano Island and beyond.

We approach the end of the road, making a sweeping turn before climbing up over a small hill. Abruptly, the yellow line in the center of the road disappears. The road into the reserve is not paved. We have arrived at IR9, and we stop the car in front of the old sign advising that "THIS IS AN INDIAN RESERVE." We watch it, distorted by raindrops on the windshield. Richard tells me, "My uncle says, only a white man will trip over an imaginary line."

Our collaborative exercise in digital cultural production suggests possibilities in the fields of visual and media anthropology for experimentation with method, medium, and exhibition that are in keeping with broader movements toward collaboration and negotiation of research-borne relations of power in the ever-shifting field. *Active Pass to IR9* is perhaps closer in genre to what Shelly Errington calls "Digital/Intermedia Anthropology," which involves the exploration of "new forms of representation, intervention, and subjectivity";[22] our project came into being within an emerging space at the intersection of digital media, anthropological theory, and

artistic practice in which boundaries between disciplines and their methods—the lines we may formerly have taken for granted as fixed or immutable—have become flexible, productive places of their own.

Notes

1. Gulf Islands Film and Television School, http://www.giftsfilms.com/ (accessed May 1, 2012).
2. New Forms Festival, 2008, http://2008.newformsfestival.com/ (accessed May 1, 2012).
3. The VIVO Media Arts Centre, http://vivomediaarts.com/ (accessed May 1, 2012).
4. *UsMob*, http://www.abc.net.au/usmob/ (accessed May 1, 2012).
5. Kimberly Christen and Chris Cooney, *Digital Dynamics Across Cultures*, 2008, http://www.vectorsjournal.org/issues/3/digitaldynamics/ (accessed May 1, 2012).
6. *Isuma TV*, http://www.isuma.tv/ (accessed May 1, 2012).
7. First People's Cultural Foundation, *First Voices*, http://www.firstvoices.ca/ (accessed May 1, 2012).
8. Jonathan Harris, *The Whale Hunt*, 2007, http://thewhalehunt.org/ (accessed May 1, 2012).
9. Doig River First Nation, *Dane Wajich—Dane-zaa Stories and Songs: Dreamers and the Land*, 2007, http://www.museevirtuel-virtualmuseum.ca/sgc-cms/expositions-exhibitions/danewajich/english/index.html (accessed May 1, 2012).
10. Nicolas Bourriaud, *Relational Aesthetics* (France: Les Presses du Reel, 2002), 14.
11. Claire Bishop, "Antagonism and Relational Aesthetics," *October* 110 (2004): 51–79.
12. Ibid.
13. Ibid, 66.
14. Ibid, 79.
15. Hul'qumi'um Treaty Group, http://www.hulquminum.bc.ca/hulquminum_people/penelakut (accessed May 1, 2012).
16. Bruce Granville Miller, *Invisible Indigenes: The Politics of Nonrecognition* (Lincoln: University of Nebraska Press, 2003).
17. Chris Arnett, *The Terror of the Coast: Land Alienation and Colonial War on Vancouver Island and the Gulf Islands, 1849–1863* (Vancouver: Talon Books, 1999), 11.
18. Ibid., 12; Hul'qumi'um Treaty Group, http://www.hulquminum.bc.ca/hulquminum_people/penelakut (accessed May 5, 2012).
19. Arnett, *The Terror of the Coast,* 13.
20. Miller, *Invisible Indigenes,* 152.
21. Ibid., 153.
22. Shelly Errington, "Ethnographic Terminalia: 2009–10–11," *American Anthropologist* 114, no. 3 (2012): 538–42.

DANCING IN THE ABYSS[1]: LIVING WITH LIMINALITY

Ruth Jones

Sophia arrived twelve weeks early in Singleton hospital, Swansea, on February 25, 2012. Feeling helpless and unable to influence the course of our baby's progress, we sit beside her incubator trying to make sense of the flashing numbers on the ventilator that breathes for her. A consultant chooses his words carefully, talking only of today, never tomorrow or next week. Reassurance comes in the form of a young nurse named Stephanie, who performs her ritual cares with presence and love. The clock indicates that hours have slipped by, but we experience time differently, as though suspended, punctuated only by the need to eat, drink, sleep.

"Death stalks the room," my partner observes grimly about the intensive care unit where Sophia lives with five other babies. Having spent the last twenty years engaged with creative arts of various sorts as an artist, curator, and writer, most of what I have produced or experienced in the name of art seems utterly inadequate when faced with a life-or-death situation such as this, but it also brings into sharp relief the events I have witnessed or participated in and the artists I have engaged with over the years whose works remain meaningful in spite of, or perhaps because of, my current situation. The projects I am going to reflect on here, some my own and some by other artists, all address directly or obliquely those great and unavoidable human transition of birth and death.

Walking a fine line between art and anthropology, my practice has focused on liminality and ritual creativity based on the premise that it is possible for artists to draw audiences into an experience of liminality through ritual patterns, sometimes with profound and surprising effects. Since the 1960s, the term *liminal* has been appropriated from its anthropological origins by cultural theorists to describe a vast number of creative activities often without reference to its ritual context, and then it becomes a very slippery term indeed, often confused with transgressive, unquantifiable, or marginal. But I use it strictly to describe an experience during which the normal, linear, and day-to-day experiences of time and space are suspended, a different state of consciousness is achieved, and the possibility of transformation, however small, arises. Why is it important to experience liminality? And why

might art be an appropriate vehicle for this? Victor Turner perceived that ritual is in decline in modern societies, having shifted from a collective, often obligatory activity to fragmented practices on the periphery of the social process. Turner proposes that ritual is a response to the division, alienation, and exploitation that are associated with everyday social structure. By suspending these structures through liminal space, ritual may create direct and egalitarian exchanges and invite experimentation with alternative relations. Turner uses the term *communitas* to refer to "a quality of human interrelatedness that can 'emerge' from or 'descend' upon two or more human beings" during the liminal phase of a ritual action.[2] Communitas unmasks the arbitrary distinctions inherent to social structure and allows humans to interact with one another, "not as role players but as 'human totals,' integral beings who share the same humanity."[3] It also represents "the desire for a total unmediated relationship between person and person…in the very act of realizing their commonness."[4] It is not an expression of a type of herd instinct but of humans "in their wholeness wholly attending."[5] Turner does not deny the need for structure within society but believes that our need for communitas is just as great.

Contemporary art practice that employs ritual patterns could be identified with Turner's concept of the liminoid—that is, liminal activities carried out in Western cultures that are not connected to the hegemonic social structures of politics or religion but provide opportunities to let go of structural commitments, if only briefly. "Ritual, like art, is a child of the imagination," says Ronald Grimes.[6] In its independence from organized religion, art provides a space to play (albeit seriously) and to test out in a material and embodied way ideas that do not conform to the dominant culture. Performative arts in particular lend themselves to ritual experimentation because they can meet some of ritual's essential requirements; for example, ritual is understood as action, not just thought, and it is performed. Classic twentieth-century examples include the Ulay/Abramovic performance collaborations of the 1970s and 1980s and Joseph Beuys's *I Like America and America Likes Me* (1974), a five-day performance/ritualization with a coyote.[7] Art, like ritual, is associated with the cultural realm of ideas, symbols, and aesthetics; both have a social and a collective dimension and take place in the subjunctive mood, a realm of pure possibility in which experiences generated could introduce innovations into the social structure.

Two questions have motivated me in recent years: could ritual enactment through art practice draw audiences/participants into liminal space? And could this create the potential for transformation? In attempting to find practical approaches to these questions, I have been mostly feeling about in the dark and occasionally stumbling upon something that works. For each project that has achieved some success, there have been one or two others that have fallen short. I have paid increasing attention to the responses of audiences/participants in order to seek tangible evidence that people have been genuinely affected by artworks rather than simply entertained.

The project *sleepers* was originally developed in Belfast in 2003 when I was asked to create an exhibition in a gallery that had once been the site of the public

unwrapping of an Egyptian mummy, now housed in the Ulster Museum. Disturbed by the disrespect this event seemed to show for the different cultural values and beliefs of the inhabitant of the body, I wanted to create a situation where the mummy could be retrieved from the position of a passive object of curiosity. This was also informed by my research into the sleeper in esoteric Western folklore, who is depicted as an active agent full of potential, dreaming the world into being.[8] I invited people to sleep in the park beside the museum on blankets at dusk. A few years later, when I had moved to Pembrokeshire, I visited Ty Canol woods and felt that this magical ancient oak woodland would be an ideal setting for another version of sleepers. This time, I advertised more widely and invited people to "become a communal dreamer." Over seventy people from all sorts of backgrounds took part, ranging from the ages of 3 to 83. On a bright April afternoon, everyone found a place to slumber, and the event was documented with stills and moving image (Figure 13.1). Here are responses from two of the participants:

> Ty Canol always has a special embracing atmosphere, but in spite of so many people gathered the lack of human noise seemed to make one aware of the sounds of other stimuli around us... It was a good experience to be with so many people and to experience the silence and stillness together.

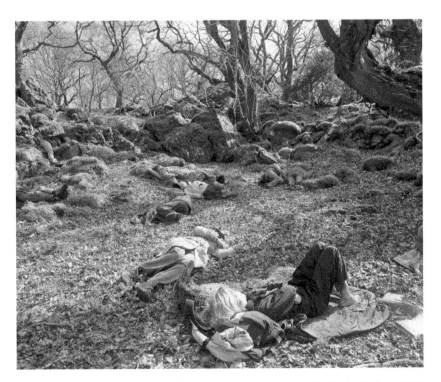

Figure 13.1 Ruth Jones, *sleepers*, public art event in Ty Canol woods, Pembrokeshire, 2006. Photo: Phillip Clarke. © Ruth Jones.

...great humor as each person was there for their own reasons in their own way and although dozens together resting, all alone in the rest in the quiet... We were all changed when we moved again to leave the different nests and perches we had chosen or had chosen us. I was moved by the grace of people letting go, being, suspended in time, out of time. I felt such affection for us as we rose, crumpled, altered. The experience felt like a powerful act.

Later we ate stew, drank wine, and danced to a céilidh band in the nearby village hall, and it felt as though a bond had formed between these strangers that perhaps was akin to Turner's communitas.

The film that was created from sleepers was arguably less successful than the event. I learnt that a film that draws audiences into liminal space must also echo ritual in its structure and flow. In 2008, while expecting my first child, I created a video installation called *Vigil*, which attempted to do just that. Places that have drawn me to them again and again are often the starting point for a new project. *Vigil* explores the presence that Strumble Head lighthouse has on the surrounding landscape in North Pembrokeshire. Strumble Head was built in 1908, and its rotating beam can be seen for thirty miles in all directions. Every lighthouse has its own distinctive character, recognized by a pattern and duration of flashes—in this case, one flash every two seconds four times followed by seven seconds of darkness. *Vigil* suggests that this rhythm has permeated the land for over a hundred years, seeping into the psyche of its inhabitants, both human and nonhuman.

The installation also portrays the lighthouse as a threshold place, situated between land and sea, day and night, and human and animal kingdoms, born and unborn. The 5.1 surround sound immerses the audience in the work, which uses Strumble's regulated light pattern as a guide for editing both picture and sound, inviting quiet contemplation of the internal and external rhythms that influence our daily experiences, rituals, and memories (see Figure 13.2).[9]

Flashes of light zip along telegraph wires. A horse munches grass in the twilight. A heavily pregnant woman sitting by a window in the dark is illuminated rhythmically by beams of light. A new rhythm is set by an in utero heartbeat and a distant barking dog. Submerging underwater, the heartbeat quickens; a seal approaches and glides past. Above water, the howling of baby seals from the bays below the lighthouse sound just like a crying infant.

Audience Responses

very alive, I felt a part of the video
so moving and evocative, almost indescribable.
a very powerful and stirring piece
sound elemental vision archetypal resonance primal

Another strand of my practice has been to work in a curatorial role with other artists. In 2008, I coordinated Holy Hiatus, a series of public art events in the market

Figure 13.2 Ruth Jones, *Vigil,* video installation, Tregwynt Manor House, Pembrokeshire 2009. ©
Ruth Jones.

town of Cardigan, West Wales. In meditation and spiritual practices that involve rit-
ual pattern making, holy hiatus refers to the crossing of the boundary between inner
and outer consciousness. The purpose of such practices is to allow inner processes
to manifest as outer forms—a method that has strong analogies with art-making.
The project focused on social ritual, community and public places to examine the
ways that artists can draw audiences into different, often unexpected, experiences
of place through ritual. Alastair MacLennan worked on the footbridge over the
River Teifi for twelve hours, tying ribbon, greenery, and paper boats to the railings.
When asked what he was doing, he replied that he was "celebrating a birth." I later
found out that it was for my daughter Ffion, who was born three weeks later. One
witness described it as "temporary, very subtle and jubilant within Cardigan, that
kind of lifted people." Another said:

> As we approached the bridge, we saw a man in a black hat doing something
> with purpose and rhythm, which was calming, and we saw the white ribbons on
> the bridge. By the time we reached him, I felt calmer. I was surprised because he
> looked up and said hello but without shifting from what he was doing, which made
> you feel part of it. It was like watching someone knitting or sewing, the rhythm and
> repetition draws you in; it separates you from your head, and you're in the rhythm.

like when you listen to music and you're in the melody. It was a very profound place to be—in his ritual.

Maura Hazelden collaborated with acoustic singer Lou Laurens to create a six-hour performance in the Small World Theatre that explored ritual and prayer (see Figure 13.3). Maura performed a cycle of simple movements, while from the balcony above Lou sang the thirteenth-century Anglo-Saxon *Worldes Blis*:

> Worldes blis ne last no throwe;
> it went and wit awey anon.
> Worldly bliss lasts but a moment
> It is here then it disappears.

The work provoked powerful responses from many who witnessed it. One woman described it as "quite amazing…it got you thinking about humanity as it is and was and what we're doing or not doing. There was a lot of thinking to be done after it." Other responses included:

> Well, it affected me because it was the first time we'd been in that particular theatre…and then when Maura started, I was fascinated by simply watching her feet. Although she used the whole of her body, I just focused on that…We simply sat, completely silent, and it was as though we were meditating, and the mantra was her movements.

Figure 13.3 Holy Hiatus, *Untitled*, durational performance by Maura Hazelden in collaboration with Lou Laurens, 2008. Photo: Noelle Pollington. © Ruth Jones.

> It was like seeing something very beautiful or like experiencing nature in a way; a kind of quietness came over you, and you sort of took it in, the same reverence you might have for a kind of quality of really paying attention.

Since the original 2008 Holy Hiatus event, Maura and Lou have recreated the work every year in the same venue on the same day. In 2012 it was the fifth version of the ritual. Each year, the audio recordings are replayed in the space from the previous year and new life elements are introduced. Lou wrote, "Holy Hiatus feels more and more part of the year to Maura and me—a kind of marker in our lives."

One of the audience members for Holy Hiatus described how in her experience there was no clear division between the artworks and the everyday experiences of the place and community:

> When I was down on the quayside...it was about to really pour with rain so I went into the Grovenor Pub to shelter, and there were people in there. I think there'd been a funeral; well, there were people dressed in black ties so I presumed that was what was going on, and that experience was as much part of whatever was going on outside. So to be in that pub with people and sheltering from the rain and a bit of interaction with people coming through the door, and you were part of something...There it was in front of your eyes, and I'll remember that with fondness...I suppose because I'm from Cardigan as well, so what I liked was going somewhere really familiar, and there was something strange happening on the bridge...some public art happening, but everybody was sheltering in this pub, looking through the door...and somebody had died, but there we were.

The responses to the 2008 Holy Hiatus events indicated that there was a desire for more exploration of the relationships between art, liminality, and ritual and that there was potential for dialogue across disciplines within the arts and humanities including anthropology, ethnography, ritual studies, cultural geography, and religious studies. In 2010, I curated a two-day symposium; a mixture of talks, film screenings, performances, and a workshop by ritual theorist and practitioner Ron Grimes. When I invited him to lead a workshop, Ron had hesitated, concerned that a disparate group of strangers from diverse backgrounds might not feel comfortable enough with each other to benefit from the experience. Around thirty-five people participated in the workshop, which took place in the main circular vaulted room of the Small World Theatre, in which had been placed various objects such as cloth, sticks, buckets, and a coracle boat (see Figure 13.4). We were invited to spontaneously enact, without discussion, a funerary ritual for a stuffed figure, vaguely human in shape, using the objects at our disposal. Many of us hung back to begin with, unsure how to contribute or looking for validation for our tentative interactions, but gradually we became absorbed in the task, which slowly built in energy and confidence and came to its own natural conclusion. Afterward, as we sat animated and surprised by our own actions, we talked about the experience. One woman described movingly how the ritual had extended and connected to a funeral she had attended that morning of an old friend. Another participant invited us all to orchestrate his funeral, should the need arise. Later, other members described

Figure 13.4 Ruth Jones, Holy Hiatus symposium, Ron Grimes workshop, 2010. Photo © Rob Irving.

the workshop as "a powerful and bonding experience" where "we became a group rather than individuals." On the symposium in general, another wrote to say that he found the event to be "an integrating experience." Other comments suggested that Turner's communitas could be a tangible reality and not just an idealized fantasy:

> We performed, we formed and . . . a sense of a mutually shared interests was present in the community of the symposium.

Two years on from the last Holy Hiatus event, I am still reflecting on its impact and potential and considering where to go next. Ritualization contributes to the vital dynamic flow between life experience and creative practice, and for this reason it deserves our attention. My own experiences have reminded me that in modern societies we often struggle to find the tools to create meaningful rituals that guide us through both painful and celebratory occasions when the need arises. Books and theories are useful, but as Grimes says, the "only option is to enter the fray."[10] We labor on, adapting, inventing, creating. Fear of failure must be balanced with the risk of losing touch with the fundamental rhythms of human existence. Grimes warns, "If we do not birth and die ritually, we will do so technologically, inscribing technocratic values into our very bones."[11] Studying the responses of participants of Holy Hiatus events and workshops has led me to believe that people from disciplines across the arts and humanities crave more opportunities to experience ritual liminality in direct

and embodied ways, even if this is also challenging at times. Possibilities are arising to turn Holy Hiatus into a formal organization enabling more events throughout the year. As for my artistic practice, I see greater confluence emerging between that and Holy Hiatus; I am currently collaborating with Lou Laurens to translate CTG[12] trace of a labor and birth into a score for eight voices which will be performed live at the Small World Theater in September 2013.

For Sophia as she makes her way through life; for all mothers who brush with death in childbirth; and for baby Tomos who didn't make it this time.

Notes

1. See Ronald L. Grimes, *Deeply into the Bone* (Berkeley: University of California Press, 2000), 4: "I dance into the abyss that comfortably separates the spiritual from the social scientific, the personal from the scholarly, and the narrative from the analytical."
2. Victor Turner in Bobby C. Alexander, *Victor Turner Revisited: Ritual as Social Change* (Atlanta: Georgia Scholars Press, 1991), 35.
3. Ibid., 18.
4. Ibid., 36.
5. Ibid., 36.
6. Grimes, *Deeply into the Bone*, 4.
7. See Victoria Walters, "The Artist as Shaman: The Work of Joseph Beuys and Marcus Coates," in *Between Art and Anthropology*, ed. Arnd Schneider and Chris Wright (Oxford: Berg, 2010), 35–47, for a full discussion of the potential benefits and possible ethical pitfalls associated with the appropriation of shamanic methods by artists.
8. See R. J. Stewart, *Power within the Land—The Roots of Celtic and Underworld Traditions Awakening the Sleepers and Regenerating the Earth* (Lake Toxaway, NC: Mercury, 1993), 86–111, for Western esoteric interpretations of fairytales such as Sleeping Beauty and Snow White. Here, the sleeper is portrayed as a powerful figure, full of potential, deeply connected to the land, who we can encounter in altered states of consciousness. Sleep and dreaming have also been ongoing subjects of interest to artists. This project was influenced by the Cornelia Parker and Tilda Swinton collaboration *The Maybe* in the Serpentine Gallery in 1995. Other artists projects exploring sleep and dreaming include Susan Hiller's *Dream Mapping* (1974); see Denise Robinson, "Encounters with the Work of Susan Hiller," in *Contemporary Art and Anthropology*, ed. Arnd Schneider and Christopher Wright (Oxford: Berg, 2006), 71–83, and Luke Jerram, *The Dream Director* (Bristol: Watershed Media Centre, 2007), www.lukejerram.com/projects/dream_director (accessed April 11, 2012).
9. The term "5.1" refers to six-channel surround sound multichannel audio systems commonly used in cinemas and home theaters. All 5.1 systems use the same speaker channels and configuration, having front left and right channels, a center channel, two surround channels, and a subwoofer.
10. Grimes, *Deeply into the Bone*, 5.
11. Ibid., 13.
12. In obstetrics, cardiotocography (CTG) is a technical means of recording the fetal heartbeat and the uterine contractions.

YVETTE BRACKMAN DISCUSSES HER PROJECT, COMMON KNOWLEDGE. INTERVIEWED BY HELENE LUNDBYE PETERSEN

Yvette Brackman

Helene Lundbye Petersen (HP)—Common Knowledge is a project of independent artworks that you have been working on since 2006. It includes performances, sculptures, videos, installations, publications, websites, and even a tea set. How did it all start?

Yvette Brackman (YB)—In 2005, I was invited to a summer residency in the town of Lovozero because of my work with the Nenets people in the project Land in 2001. Lovozero is located in the center of the Kola Peninsula in Russia; it is the headquarters for reindeer herding on the Kola Peninsula and home to a community of Eastern Sami. The region's historical name is Sapmi, and it covers the whole northern part of the Barents region, but the Eastern Sami live mostly within Russia.

HP—The Eastern Sami are among the most culturally threatened of the whole Sami population. Did you decide to do a project about them because their way of life is being challenged?

YB—Yes, but Lovozero also interested me because it has several other indigenous communities living in the area together with the Eastern Sami. The Sami are the largest group, and I was fascinated by the fact that they have mingled with these other indigenous groups for over 200 years, influencing one another's traditions. A central piece in the Common Knowledge project is *The Catalyst*—a play, a series of performances, and, finally, a book, all of which are recording a specific set of events. I wanted to explore my continuing interest in engaging a community and in what it means to use a group of people as artistic material. For the initial residency, I found myself in a remote, economically challenged community consisting partly of Russians who had been relocated there to excavate natural resources. Many Sami and other indigenous communities had been displaced to Lovozero from areas around the region, and their rights are being challenged to this day. Their traditional way of life is being restricted by constant government legislation and control. There is little economic growth and most survive by bartering services and goods. I wanted to make a project that directly addressed these issues.

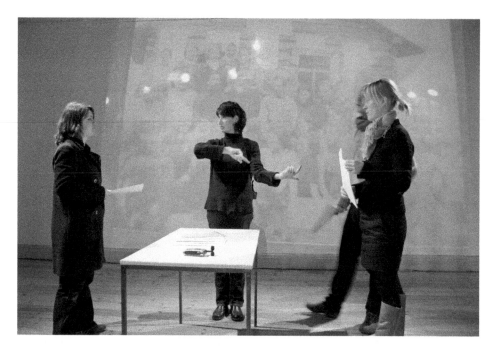

Figure 14.1 Yvette Brackman, *Catalyst II,* 2007, performance still.

HP—How did you come up with the idea of pairing the local artisans and a global design company?

YB—To explore these questions, I decided to do a workshop linking the global enterprise with the local culture and document the collaboration in all its stages. This allowed for sharing various points of view thereby representing antagonistic roles within society. Originally I wanted to make an adaptation of Bertolt Brecht's learning play from 1930 called *The Decision,* which is about organizing workers. I found its historical context and the message pertinent in relation to this context. Instead of doing Brecht's play, I decided to use the discussions and negotiations that took place during the collaboration to make the play, *The Catalyst,* which was performed between 2007 and 2010 in thirteen variations.

HP—In what way were the thirteen performances variations?

YB—The first six versions were written while the actual events were taking place and evolving. Each time *The Catalyst* was performed, it would change in terms of the development of the negotiations, the feedback from the performers and the audience, and my own reflections.

HP—Why is it called *The Catalyst?*

YB—A catalyst is something that causes a transformation. A catalyst can be an event, a person, an object, or another element that brings about change, and that is what I

wanted to do. Not to be presumptuous, thinking I could really change something, it was more the change within myself while thinking about these issues, about ethics and aesthetics, and how and if one can use an art practice to explore these themes.

HP—What are the roles in the play?

YB—There are six roles in the play, and they reflect the perspectives I witnessed during the negotiations. "The Advocate" is myself, "The Specialist" is the designer from Camper, and "The Native" is the representative of the indigenous community. "The Inhabitant" is someone who is not indigenous but has adapted to the local way of life. "The Resident" is an administrator, a worker, or a soldier who has no real attachment to the place and doesn't care about it. "The Insurgent" is the radical, or the student, the person coming from outside, questioning and challenging what is going on. Finally, "The Chorus" is an additional voice that is the collective conscience of the community. "The Chorus" functions in the same way as in Greek drama—as commentators.

HP—Was Bertolt Brecht's epic theater an inspiration for *The Catalyst*? Part of his concept was to make the audience aware that it is watching a play and prevent it from being seduced by illusion.

YB—I was particularly interested in Brecht's *Lehrstücke*, the learning plays, which would welcome comments and participation from the audience. Gradually the play

Figure 14.2 Yvette Brackman, *Catalyst IX*, 2009, performance still.

137

shed the boundary between audience and performer until everyone was a participant. For *The Catalyst*, I tried to do something similar. I dissolved the roles, so there were no longer characters; instead they were numbered points of view.

When the performance begins, everyone in the audience is handed numbered cards that correspond to lines in the play. The lines would slowly scroll down a screen, and the spectators spoke when their numbers came up. The audience members didn't know what roles they were to recite until their lines appeared on the screen, so they didn't have a choice of whom they would play. The experience for the audience was playful on one hand but also created a kind of collective schizophrenia.

HP—Your role as an advocate but also as the mediator during the real negotiations and as director of the play must have been challenging at times, given the diverse positions and interests involved on all three sides, including your own.

YB—I wanted to understand certain aspects of globalization and its impact on indigenous people. I saw a paradox in the meeting of these two realities. The indigenous population needs to engage in trade and development to survive, yet the terms of engagement are defined by global business structures and the local government's support of tourism, which undermines their traditional way of life by restricting hunting and gathering areas and only allowing for touristy forms of cultural expression. My goal was to investigate the potential gains and losses for the community when collaborating in such projects, including my own.

HP—Did you side with certain roles in *The Catalyst*?

YB—I'm interested in collective experience and how every interaction is composed of an interrelationship between self and other. That is why the audience performs the final version of *The Catalyst*. At the same time, there is an interaction that alters the communal experience. If someone misses a line or reads too slowly, the others all feel a responsibility to make the performance work. That became another important layer to the work. It is about the relations that are happening in the room among the performing audience that reflect back to the events in the story itself.

HP—Why is participation important? Is it about taking communal responsibility?

YB—In order to draw attention to communal responsibility, I wanted to revisit and experiment with agitational techniques of engagement that were developed in Soviet Russia in the 1920s during the period of revolution. One such method is the Living Newspaper, a theatrical form presenting factual information on current events by using experimental techniques of agitprop theater, including the extensive use of multimedia. It is interesting to see how Occupy Wall Street has been using similar techniques.

HP—Even though you use agitational language, the play does not have a clear hero or villain; instead, the story evolves allowing for multiple points of view.

YB—The last version of *The Catalyst* involved fifty people, and suddenly the whole room would say, "We are the crafts people; you may think us passive and naïve, but we know that work and innovation are of utmost importance." It is intense to hear a large group say this in unison—the language is accusative, and it becomes confrontational. The eleventh version of *The Catalyst* took place in Lovozero with several of the people who participated in the original workshop. For me, this was the most profound performance, after four years of traveling, having misunderstandings with the community, then coming back and reading the play together and hearing their reactions. Sometimes they were taking [the lines] very literally: "No, this is wrong, I didn't say that"—and the other one patting her friend on the back, saying, "It's a play. It's fiction. You don't have to argue with it."

HP—The book *The Catalyst* only contains the final version.

YB—Yes. It is a small publication that presents the play in three languages—Eastern Sami, Russian, and English. There are only 400 people left in the world who still speak Eastern or Kildin Sami.

HP—When the collaboration with Camper ended, you didn't want to collaborate with another company but instead decided to develop LUJA as a collective enterprise. Did you change from "Advocate" to "Specialist"—shifting roles like in *The Catalyst* performance?

YB—[Laughter] If only life was that simple. After discussion and agreement with the artisans, we eventually decided to stop pursuing the Camper collaboration and started the design collective LUJA. Common Knowledge is a platform to question how globalization and commerce affect our sense of identity. On this platform, LUJA is a sculpture about commerce; its elements are marketing, merchandise, and contracts. Each of these elements targets our perception. Treating them as forms

Figure 14.3 Yvette Brackman, *Company*, 2010, video still.

and altering their context and therefore their reception allows us to examine their role and their potential impact on our lives. I maintain my role as "The Advocate" and take on the role of "The Specialist" by defining them within two spheres. One is the idea of an enterprise as a sculpture, and that is my work Common Knowledge. The other is the product development and distribution company that is a collective enterprise in collaboration with Norwegian curator Hilde Methi, the group of artisans from Lovozero, and myself.

HP—You produced sculptures in porcelain called The Cast. They are abstract forms with names written from the play on them—for example, *The Insurgent*. What part do they have in the overall project?

YB—I wanted to make abstract but heroic representations of all the roles in *The Catalyst* play. That's how The Cast evolved, six sets of six figures, all individually painted, with text and photos prints on them. I was thinking about the Russian nesting dolls, the *matryoshkas*, and the lingam sculptures that I had seen in India. I wanted something that was abstract and primordial. During the early 1920s constructivist period, many artists worked in the Lomonosov State Porcelain Factory making platters, tea sets, and figurines. I was referencing that tradition of commemorative porcelain.

HP—Is The Cast related to another porcelain artwork called *Service?*

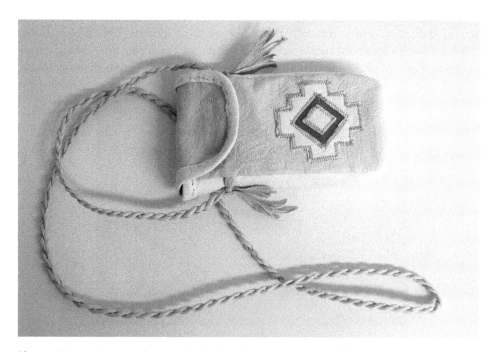

Figure 14.4 Yvette Brackman, Ludmilla Timoshjenko's mobile bag, 2010. Photo: Vigdig Hautrø.

YB—*Service* also refers to the commemorative tea set, which I just mentioned, but it was also inspired by my visits with reindeer herders on the Yamal peninsula who carry a tea service with them in a suitcase. *Service* is connected to the LUJA shop, where you are served tea. I liked this idea that the tea and the social situation created by the tea service would encourage a social exchange in terms of negotiations, trading, or conversations.

HP—Your video called *Company* documents the workshop that led to *The Catalyst*. Moving images alternate with black-and-white text that narrates the story of how the community produced boots and cell-phone bags.

YB—*Company* is a silent film using the documentary footage from the workshop and from my visits to the artisans and to the reindeer-processing factory in Lovozero. The text borrows Russian newsreel film techniques from the 1920s. The narrative starts with the collaboration with Camper and evolves into the establishment of LUJA, the collective. It's not quite a documentary, as I use the roles from the play. In this interview here I mention Camper, but in the play, I don't. There Camper is called "The Specialist." It is easy to call them the bad guy—global design companies are evil, exploiting the innocent, helpless indigenous community. But with that angle we were not going to get anywhere. The whole process of talking about these interactions and the things that happened gave a much more nuanced picture of the issues. For me it's not so much about good or bad but about being able to understand and communicate the essential issues that people aren't willing to move on.

HP—Is it possible to say that there are things here that have nothing to do with economy but with cultural survival?

YB—Commerce, globalization, and industrialization are going to go on no matter what because that is the world we live in. But first we have to recognize what should be common knowledge and then protect what needs to be protected.

Note

"Interview #5" was first published in *Yvette Brackman—Systems and Scenarios* (Zurich: JRP|Ringier, 2012). Reprinted here by kind permission of the publisher and the artist.

WITH(IN) EACH OTHER: SENSORIAL STRATEGIES IN RECENT AUDIOVISUAL WORK

Laurent Van Lancker

As a filmmaker and anthropologist, I have always been interested in the relationship between lived experience and audiovisual media; I want to give the viewer a taste of other cultures, rather than explain the menu. My aim is to convey cultural encounters as experience and situate my practice in the grey area between art, anthropology, and cinema. I want to find a dialogue between poetics and politics, ethics and aesthetics, form and content, theory and practice.

My own audiovisual works embrace a set of practical approaches: filmmaking as a performative act; considering sound at least as important as image; articulating a creative dialogue between sound and image; introducing different types of materiality of image and sound; using decontextualisation; drawing on cinematic imagination; developing new narrative forms; and stimulating creative collaborations. This use of sensorial, narrative, and collaborative strategies[1] allows me to create documentary cinema. I believe that the more we allow cinematic practices to infuse documentary and anthropology, the more we might be able to experience it in a sensory and sense-making way.

The term *sensorial* or *sensory* is used here from an audiovisual and synaesthetic perspective and has only an indirect link with the anthropology of the senses.[2] The sensorial approach[3] calls not for descriptions of, or films about, something or someone but proposes experiencing either a moment of the life of another person or an imaginary dimension of a person or culture. It is also concerned with producing knowledge via experiences. Hence, performing knowledge and learning from performances and shared experiences. Creating a sensorial documentary is not just about making haptic images and sounds but also about putting into play specific documentary strategies: asynchronicity, decontextualisation, and cinematic imagination. I will consider some of these strategies through two of my recent single-screen works: *Surya*[4] (2006) and *disorient* (2010), although my recent collaborative Web project, Diwans.org, is also relevant.

The feature-length documentary *Surya* is an experiment in making a film *as* storytelling, and in its making and its reception, it created an intercultural dialogue based on imagination through collaborating with storytellers from different cultures. I consider *Surya* more of a contemporary collaborative art project[5] than a film. If Jean Rouch called for a shared anthropology, I regard *Surya* as an example that calls for "shared-authorship." *Disorient* is a film proposing a transcultural polyphony of voices of returnees (migrants returning home), not following one or two specific portrait stories but mingling them into one storyline.

Asynchronicity is a strategy for making sensorial documentary. It refers to the articulation of—often unexpected—creative links between sound and image in order to promote an experience or sensorial knowledge through cinema. Asynchronicity signals the artistic possibilities of sound and image when, in one respect, they are liberated from each other. But they should not be seen as independent entities but rather the creative possibilities of their dialogical articulation, combination, juxtaposition should be explored without a necessary relationship between them

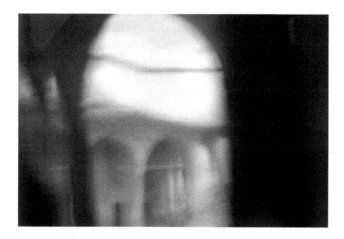

Figure 15.1 Laurent Van Lancker, *Surya*, 2006, video still.

Figure 15.2 Laurent Van Lancker, *disorient*, 2010, video still.

being adhered to.[6] Asynchronicity questions how the interplay of sound and image can induce a more synaesthetic sense production, more corporeal experiences, and a more poetical knowledge. Asynchronicity creates an excess in meaning and knowledge that is specific to cinema.

In *Surya* I make use of different asynchronous practices. Half of the film is composed of asynchronous images and sounds, which in an impressionistic way evoke the journey of the filmmaker, to give a taste of the different cultures. The other half of the film is composed of synchronic sounds and performances from the storytellers. One of the challenges of the film was to be able to transmit the lived experience, the direct contact involved in oral performances by audiovisual means to an audience sitting in front of a screen. To achieve this, I decided to film the performances using different filming techniques and asked the storytellers/performers to look into the camera in order to address the spectator directly. But the biggest challenge was how to add images and sounds to these performances without destroying the connection with the spectator. To achieve this I used poetic evocation. The idea was that I would first listen to the story invented by the storyteller of each culture and then try to find an image and/or sound that related to some elements of this story in the everyday life of this culture. The relation between what I filmed and the words of the storytellers should not be directly illustrative. It should be somehow asynchronic but also not random, not just any kind of sound or image. For instance, the episode told in Iran was about a son throwing his mother in a bread-oven. So, I decided not to film a bread-oven or someone pushing someone or a mother and a son but rather focused on the element of fire and of veiled women in relation to fire to create a poetic evocation of the story. Two or three weeks after the recording of this story, I bumped into a street scene—a veiled woman next to a brazier—that evoked for me the sentiment and sensation conveyed in the story. This poetic evocation was not a straightforward description but still related enough to the story so that the spectator would not depart from the sensory qualities of the film. Documentary cinema can involve an oscillation between everyday life and imagination that is quite unique.

In *disorient* we wanted to radically experiment with the idea of asynchronicity in documentary. We decided to record only voices, life-histories, and not film conversations or talking heads. We wanted to not only separate sound from image but additionally to ask what the added value is of seeing someone talk—using the lack of image to activate the spectator's imagination and in a sense to allow for a greater sound-image dialogue. For us, the absence of an image of the speaking person in the film *disorient* was a way of creating a corporeal link between the spectator and the protagonists without the need of visualization. In *disorient* you hear many people speak, but you never see them physically; the characters are interwoven in such a way that together they create somehow one narrative, one storyline composed out of a polyphony of voices. The invisibilty of the protagonists is both an artistic and a political strategy here. It evokes the fact that the migrants are often relegated to an invisible position in our society. It also calls for a reconsideration of anthropological practice. Classically, anthropologists are asked to map and identify their research

Figure 15.3 Laurent Van Lancker, *Surya*, 2006, video still.

group, which is often supposed to have a common cultural background, identity, or context; *disorient* not only proposes a transcultural voice but also chooses its protagonists not because of a shared culture, context, or language but because of a shared lived experience.

Materiality is another important feature of my sensorial strategy. Engaging with materiality in documentary cinema is a way of escaping the rules imposed by semiotic readings of the film. I use a mixture of DV video, super 8 film, and digital photographs together (in *disorient* this was also supplemented with 16mm and 35mm film) in a manner similar to a painter. To approach filmmaking as a painter requires considering sound and image in all their sensory and synaesthetic possibilities—different materials become the palette at my disposal, to use to convey sensations, impressions, and intentions. Many films use a change in materiality to signal a change in point of view—for instance, using super 8 to invoke childhood or memory. I do not adopt the same strategy; in *Surya* I mix super 8, photography, and DV video to play both with material appearances (texture, grain, colors) and the different feelings associated with them. This promotes a more sensorial, corporeal experience of the film than a solely illustrative reading of it allows. Using a mix of different film formats allows me to activate different memories of senses.

Another important aspect of using different formats while filmmaking is that they also entail different techniques of filmmaking—different corporeal approaches to producing images. I like to use small, handheld digital cameras for the performative and corporeal dimension they allow. Having a heavy camera on the shoulder doesn't allow the same kind of exploration or searching for an image. These are two different ways of filmmaking and involve a different corporeal relation between the subject and object. Both the material and corporeal dimensions involved are ways of making the same reality make sense very differently and produce different kinds of knowledge.

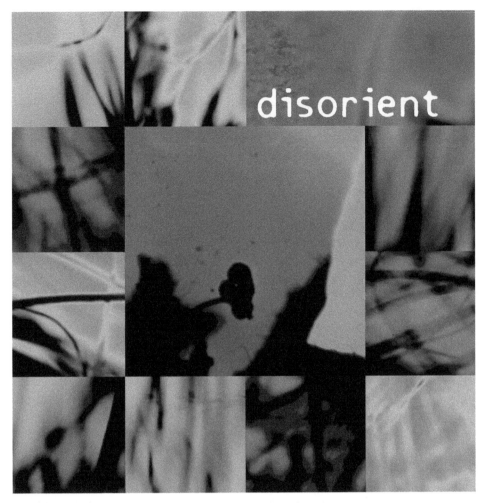

Figure 15.4 Laurent Van Lancker, *disorient*, 2010, composite collage of video stills.

In *disorient*, I used a mix of formats for a different reason—to convey the trans-cultural experience of returnees and a feeling of in-betweeness. This film was an experiment in what has been called haptic effect[7]—creating images that the specta-tor cannot grasp immediately means that the spectator must search the images in a different way to make sense of them and embark on an active journey.

For the *disorient* project, we wanted to make an evocative film with few images (some photographs of material culture and some super 8 images). But when we looked at the first edited version—where 80 percent of the film was black (i.e., no video signal)—we felt something was not right. The hypnotic[8] sensation we wanted to convey worked very well, but the black signaled the absence of an image. The spectator was not triggered to look at the screen through this absence of signal but did not know what to look at. So we decided to give this absence a soul, to add

some materiality to these black passages, while still keeping an abstract, sensorial approach. This resulted in the creation of film images that are still close to black but that give the impression of traces of life, rather then absences. These evoke, metaphorically and visually, the traces left by the migrants in their memories and their host countries. Our experiments on 16mm and 35mm film include the following: direct scratching, chemical manipulation, Rayogrammes[9] (direct/contact development of objects), underexposed footage, reshooting projected photographs on super 16mm; all allowed an articulation of materiality to be part of this documentary. We adopted a strategy calling for "an aesthetic of sensation, where the material dimension of a cinematic work is initially given precedence over its expository and mimetic/realistic functions."[10] So during a second editing period, we inserted all these experiments into the black video gaps so that no part of the film would be without filmic presence/materiality. The fact of having a minimal image allows the spectator to create a lot of imaginary images of the lives they are listening to, and it promotes a focus on interior feeling rather than on exterior representation.

Decontextualisation is a strategy proposing an alternative to the dominant principle—found in almost any television documentary or ethnographic film—that states that in order to present a culture it is always necessary to start with a mapping of the place of research or filming. This idea of signposting finds an echo in the anthropological tradition of seeing the world as a surface or fixed entity and of placing context above experience. A film relying on decontextualisation is one where the spectator is "denied the distancing effect of explanatory introductions and establishing shots, (and) is left to experience the powerful, perplexing affect of the imagery."[11] This immersive and experiential approach to understanding has been considered by Christopher Wright[12] as a fruitful addition to a solely contextual mapping. For Wright, the combination of both approaches could put a halt to the traditional antagonism between art and anthropology.

In *Surya* I used a topographic approach in contrast to a geographic approach. Such a decontextualising approach does not name or locate the filmmaking within a regime of information. As in oral traditions or storytelling, it situates the actions in imaginary worlds and in sensory evocations of cultures. It enabled us to locate the storytelling practices in a culturally specific setting rather than a nation-state, since the specific oral art encountered during the making of the film could not become representative of a nation-state in general. This topographic strategy of decontextualisation suggests that we do not need to leave the context (or atmosphere) of the recording out of the film—quite the reverse. Instead, this strategy advocates that since this context is implied in sounds, images, and sensorial memories, we do not need to map or name the context, nor take the spectator by the hand but simply leave him to live the experience—to be lost and then find his way in a different kind of space.

In the film *disorient* none of the migrants was named or clearly situated. When a name or location was mentioned, it happened naturally, as part of the action and not as an exterior intervention. This does nothing to impede our intimacy with the protagonists; quite the contrary. Since the migrants are not named or signposted,

they are more human, closer to us, than if they are signaled as examples. They are not just names and places; they are lived experiences. In *disorient* almost no direct, referential images are used, so we could only rely on sound—soundscapes and voices—to evoke the different contexts. Decontextualisation facilitated the interaction between spectator and filmed subject.

A dialogue—the combination and juxtaposition of meaning and being, of senses, and of points of view—could result in documentary practices that are not about or even near others but are with and within cultural experiences. The use of a sensorial strategy is not only a method of becoming engaged with the filmed subject in a performative way, but also with the audience. An audience that is activated in this manner will search for knowledge, will seek to make sense of their world and other cultures through their senses, but only if new audiovisual strategies (asynchronicity, materiality, decontextualisation) are in place to help them make that sense, as an added value within an anthropological endeavor. In other words, there must be a clear form/content relation, which makes sense and is sense-giving, not merely as a game, a way of using other cultures as mere objects for artistic projects. By this I mean intentions that address the audience and the filmed subjects in their relational qualities, and not just as resources; intentions that are not only motivated to create sensations in the body of the spectator, but to induce knowledge through an experience.

Films

Laurent Van Lancker, *Surya*, 2006, 76 min., 35 mm. Produced by Polymorfilms.be. Distributed by Dafilms.com.

Laurent Van Lancker and Florence Aigner, *disorient*, 2010, 36 min., 35mm, 16mm, super 8 transferred to video. Produced by Polymorfilms.be.

Notes

1. These three strategies have been extensively discussed in my PhD thesis, "Experiencing Cultures: Sensory, Narrative and Collaborative Strategies in Documentary Cinema" (University of Ghent, 2012).
2. A discipline that is often preoccupied with labeling cultures according to their sensorium.
3. A sensorial mode draws on performative modes of representation and is relatively close to, but not the same as, a "cinema of sensations," as proposed by M. Beugnet, *Cinema and Sensation: French Film and Art of Transgression* (Carbondale, IL: SIU Press, 2007); a transcendental documentary, as imagined by E. Knudsen, "Transcendental Realism in Documentary," in *Rethinking Documentary*, ed. W. De Jong and T. Austin (London: Open University Press, 2008), 108–20; or a "body of cinema," as projected by R. Bellour, *Le corps du cinéma. Hypnoses, émotions, animalités* (Paris: P.O.L., 2010).
4. It is possible to see *Surya* online for a small fee, via the following link: http://dafilms.com/film/7195-surya/.
5. For this project, collaboration is not only the vehicle for creating original content but the very foundation of the formal approach. The basic principle of Surya was to ask storytellers from different countries to continue an imaginary story initiated by others before them. For me, 90 percent of

the film is made out of the creative gifts the storytellers gave us. If collaboration had failed at any stage, the project would have been entirely unsuccessful.

6. Daniel Deshays has explained that sound is not only an "additive" to an image or an "added value" (as stated by M. Chion, *Un art sonore, le cinéma* [Paris: Edition du Cahiers du cinéma, 2004], 191), but has its own specificities, its own plasticity, which continues to live next to the image, creating additional meanings and sensations; see D. Deshays, *Pour une écriture du son*, (Paris: Klincksieck, 2006), 23.

7. See Laura U. Marks, *The Skin of the Film: Intercultural Cinema, Embodiment, and the Senses* (Durham, NC: Duke University Press, 2000).

8. See Bellour, *Le corps du cinéma*, for his argument that cinema is more like hypnosis than dream.

9. The name comes from Man Ray, who was the first to use this technique.

10. Beugnet, *Cinema and Sensation*, 14.

11. Ibid., 8.

12. C. Wright, "In the Thick of It: Notes on Observation and Context," in *Between Art and Anthropology, Contemporary Ethnographic Practice*, ed. A. Schneider and C. Wright (Oxford: Berg, 2010), 67–74.

IN PRAISE OF SLOW MOTION

Caterina Pasqualino

At the end of the nineteenth century, photographers such as Eadweard Muybridge and Etienne-Jules Marey conceived processes for the fragmentation of time. The techniques of these two photographers diverged appreciably. While Marey exploited chronophotography for scientific ends, Muybridge—"the Fred Astaire of the nude," as Eric de Kuyper called him—conceived his series of depicting men, women, and animals as an artistic expression.[1] Throughout the twentieth century, other experimenters, sculptors, painters, and filmmakers wanted to shake off a stereotyped perception of time. Among those in the historic avant-garde, we can cite the futurists and their decomposition of movement, the surrealist filmmaker Cocteau, and, later, the experimental filmmakers, all of whom made extensive use of slow motion.

The spectator's identification with an image is made possible by a manipulation of time. The suspension of time allows emotion to crystallize, leading the filmmaker to work on the shots' duration and the rhythm of images flowing into one another. Filmmakers thus began relying on slow motion to capture the types of fleeting expressions that are ordinarily difficult to portray.

Initiated by filmmakers, research on time manipulation was then continued by video artists. Having studied expressions of emotion throughout the history of art, Bill Viola created *Dolorosa* (2000) and *Observance* (2002), for example, in which he attempts to convey the power and complexity of emotion by representing the models' faces and bodies in slow motion.[2] For his part, Douglas Gordon appropriated aspects of cinematic masterpieces in order to subvert them. In *24-Hour Psycho*, he slowed down Hitchcock's classic so that the entire motion picture lasts twenty-four hours, freeing the filmic image from the constraints of traditional narrative. By experimenting along these lines with time stretched to the utmost, he invites the spectator to confront questions of perception, memory, and time. The ways in which each of these two artists employ slow motion open up heuristic fields relevant to the social sciences.

This mode of filmic restitution is ideal for deciphering ritual actions whose emotional complexity eludes narrative commentary. In interpreting ethnographic research by Henry Wassen and Nils Homer on the stylized procedures of a ritual Cuna Indian chant used to facilitate difficult births, Claude Lévi-Strauss compared the many repetitions of actions with slow-motion film sequences.[3]

This kind of vision—so often experienced by other observers but without their awareness or cognizance of its full impact—plays on the rather paradoxical effect of simultaneous flashback. It seems as if the brain, while mechanically recording a sequence of actions on a wholly perceptual plane in real time, concurrently interprets time in a mode comparable to filmed slow motion, in order to allow a more scrupulously detailed interpretation. A principal of enhanced perception is established in addition to decoding reality in a visual, wholly perceptual manner, insofar that consciousness interacts with reality.

Gypsy Song and Dance

If slow-motion effects provide a simulacrum that approaches the way in which the brain functions to unravel situations of great complexity, they also offer anthropologists a method for analyzing ritual aspects that go beyond conventional narrative description. A particularly relevant terrain is that of the Andalusian Gypsies in Spain.[4] This community has long puzzled anthropologists due to its lack of institutional organization. Its ties, which acknowledge neither social hierarchy nor a kinship system, are based on the very special bonds that develop between individuals at family gatherings (*juergas*). This group lends itself particularly well to analysis of a performative type.[5] Despite the seeming confusion, juergas are punctuated by chanting and dancing sessions in which prosody, voice, and gesture are fundamental units of meaning for reinforcing the common identity.

During each performance, that which establishes the community is reactivated by a succession of metaphorical postures expressing a shared attitude. By recording performances on film in slow motion, one can reveal a sequence of microevents that would ordinarily escape observation. The body may be stretched out, head held high and arms extended to express a sense of pride in the struggle against adversity. But the body can also be slackened, withdrawn, as if giving up, an expression of physical decline mingled with a feeling of moral superiority signifying the woes suffered by the community.

When interviewed, the protagonists are unable to express their painful feelings. They are loath to speak of them, unquestionably out of modesty but also because the nature of shared emotion is fundamentally inexpressible. In film footage, however, the feelings become palpable.

Concerning flamenco dance, Georges Didi-Huberman asserts that Israel Galvan's performances are a "rhythmic protest, between virtuosity and motionlessness, between whirlwind and stasis, rupture, excess and the compass [rhythm],

the pauses of *rematar* and the grace of *templar*."[6] This exceptional dancer continues to decompose and recompose his body. The rhythm is born as if in the "revolt of the singular body against the obliged step of the social body."[7] This interpretation of flamenco dance is in the same vein as research I conducted in Andalusia on singing and dancing.

Intentional negligence of the end of an action is also apparent in various actions in daily living and is claimed as an expression of Gypsy identity. In comparison with the *Payos* (non-Gypsy) artists, who strive to execute their dances perfectly and to enunciate their song lyrics distinctly, Gypsies seem to flaunt their indifference. During a performance, whether public or private, they appear to take pleasure in leaving the public wanting, by unexpectedly interrupting a dance as if sabotaging it or by disturbing the understanding of a song's lyrics by introducing a timbre of a rasping voice. In addition to revealing an anticonformist attitude and indicating their desire to differentiate themselves from the Payos, this attitude also signifies a deeper intention: to refuse the overly explicit quality of the Payos—an excessive rationality that becomes synonymous with alienation.

In their songs, Gypsy performers at times disrupt the meaning of the spoken lyrics and sing only in *lalies*, a series of meaningless sounds, indicating rejection of literal, formed lyrics. An incomplete text or silence introduced spontaneously during a song as well as an intentional interruption in the lyrics' meaning through babbling and insignificant sounds, express the desire to exist beyond rationality. In this way, the singers seek to place themselves at the edge of a minimal existence, to a near nonexistence.[8] To borrow expressions from Vladimir Jankélévitch, they strive for the *presque-rien*, "almost nothing," for the "pure and simple non-being."[9]

Filming Emotion

How can one restore the essence of flamenco performances that establish the identity of the Gypsies without betraying it? In one of my films, *Bastian and Lorie, Notes on Gypsy flamenco songs and dance* (*Bastian et Lorie. Notes sur le chant et la danse flamenco*, 2009), I tried to capture the range of facial and body expressions that occur repeatedly during a song and dance performance (see Figures 16.1 through 16.4).[10]

The film's protagonist is Bastian Blanco, a Gypsy singer native of Jerez de la Frontera in Andalusia. Lorie, a dancer, responds with gestures. I chose to film their performance under powerful lights against a solid black background so as to distinguish gestures and facial expressions as sharply as possible. During the session, Bastian performed a sequence of typical Gypsy songs: *bulerias* (songs for celebration) and *soléas* and *syguirillas* (slower, sadder songs). The emotional crescendo respected the normal course of a flamenco gathering, swinging from a collective, festive, and noisy mood—usually, the audience participates joyously by clapping in rhythm (*palmas*)—to an intimate atmosphere in which the public was more restrained, their clapping silent and less frequent.

Figure 16.1 Caterina Pasqualino, *Bastian and Lorie, Notes on Gypsy flamenco songs and dance (Bastian et Lorie: Notes sur le chant et la danse flamenco)*, 2009; courtesy of the author.

Figure 16.2 Caterina Pasqualino, *Bastian and Lorie, Notes on Gypsy flamenco songs and dance (Bastian et Lorie: Notes sur le chant et la danse flamenco)*, 2009; courtesy of the author.

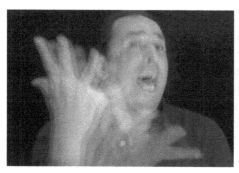

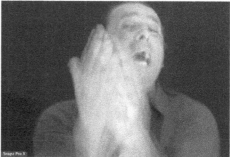

Figure 16.3 Caterina Pasqualino, *Bastian and Lorie, Notes on Gypsy flamenco songs and dance (Bastian et Lorie: Notes sur le chant et la danse flamenco)*, 2009; courtesy of the author.

Figure 16.4 Caterina Pasqualino, *Bastian and Lorie, Notes on Gypsy flamenco songs and dance (Bastian et Lorie: Notes sur le chant et la danse flamenco)*, 2009; courtesy of the author.

Initially, Bastian was nervous and proved to be a poor performer. In the presence of the camera but without an audience, he tried clumsily to find his bearings. Crew members were just as uncomfortable. Taking advantage of a time-out, I proposed to gather everyone around a table. A glass of whiskey in hand, Bastian forgot about the film shoot and began chatting about "the essence of flamenco." The cameraman continued filming while Bastian defined what *ole* and *duende*, two concepts designating moments of communion between a singer, a dancer, and an audience, meant to him. To explain the difficulty performing the songs, he evoked both the image of a little girl picking up a shoe—a gesture of grace and innocence—and the acrobatics of a trapeze artist whose life is literally hanging by a thread.

When he started to perform again, the atmosphere had relaxed. On camera, Bastian appeared at ease. Off camera, Lorie was staring at him. From beneath the

spotlights, Bastian was seducing her, drawing her in. Futile as this may seem, the event made me aware of an error. While in my book *Dire le chant. Les Gitans flamencos d'Andalousie*, I insisted that duende results from the osmosis between the singer, musicians, dancers, and the audience, I had taken the risk, during the film shoot, of placing the singer in an abstract situation alien to the practice of flamenco. I suddenly realized that Bastian and Lorie were trying to recreate the connection, the conditions that made duende possible. So I decided to record them in close-up, focusing on the imperceptible movements of their eyes and mouths.

Passion under the Microscope

In this film, I tried to observe emotions as if under a microscope by restoring a perception of the disconnected world as in weightlessness, trying to build a slow gaze. The images begin in silence with close-ups in black-and-white. The singer's ear appears; an outstretched hand performs a rotating movement; finally a mouth appears, open and grimacing. The film then shifts into color. The dancer's face is revealed in close-up and the frame is enlarged, moving into a medium three-quarters shot. After watching Bastian intently, Lorie begins to dance. After a moment of silence, we hear his voice once again, guiding her dance. My shots remain close-ups in slow motion. While this would theoretically imply a decrease in the amount of information perceived, closing down paradoxically provides access to a more profound observation of their emotions. The close-up framing of their facial expressions hinders narrative interpretation, which has the effect of directing our attention to phenomena of microexpressiveness. Reality appears to be slightly veiled and mysterious; slow motion produces a perceptual shift that encourages a sense of introspection and contemplation in the viewer. With the performances observed as if under the microscope, microactions are better perceived. Slow motion reveals the smallest trembling in the performers' faces, in their mouths and eyes. It allows one to perceive that distortion of the voice is extended through the slight distortion of the body, that grimacing facial expressions are accompanied by an increased mobility of the gaze and by corresponding movements of the arms and hands.

When the film returns to real time, the slow motion that preceded it seems to persist in the form of an afterglow. The scene seems to have been lived deliberately; the performers' density enhanced. The unhurried pace, blurring, and, alternatively, the images' precision provoke the spectator's empathy. In contrast to a distracted, diagonal reading or zapping—modes of rapid, superficial decoding to which we have become accustomed in the contemporary world—the viewer accesses expressive forms that are unique, complex, and irreducible. If they want to be capable of clarifying emotions that have thus far eluded them, anthropologists should break with types of explanations that are too rigid and take up processes such as slow motion used by filmmakers and video artists.

Notes

1. Eric De Kuyper, "Muybridge, le Fred Astaire du nu," *Cinémathèque* no. 13 (1998): 101–11.
2. See also C. Pasqualino, "Filming Émotion: The Place of Video in Anthropology," *Visual Anthropology Review* 23, no. 1 (2007): 84–91.
3. C. Lévi-Strauss, "L'efficacité symbolique," in *Anthropologie structurelle* (Paris: Plon, 1958).
4. C. Pasqualino, *Flamenco gitan* (Paris: CNRS éditions, 2008); see also C. Pasqualino, "Quand les yeux servent de langue. Le statut du regard chez les Gitans d'Andalousie," *Terrain* 30 (1998): 23–34; C. Pasqualino, "The Cock and the Hen. Metaphors of Sex and Fertility at Gitano Flamenco Fiestas," *Journal of the Gypsy Lore Society* 2 (1996): 73–87; C. Pasqualino, "La voix, le souffle. Une séance de chant flamenco chez les Gitans de Jerez de la Frontera," *Études Tsiganes* 40, no. 2 (1994): 83–104.
5. C. Pasqualino, "Hors la loi. Les Tsiganes face aux institutions," *Ethnologie Française* (December 1999): 617–26.
6. G. Didi-Huberman, *Le danseur des solitudes* (Paris: Editions de Minuit, 2006).
7. Ibid., 166.
8. C. Pasqualino, "Ecorchés vif. Pour une anthropologie des affects," *Systèmes de pensée en Afrique noire* no.17 (2005): 51–69.
9. V. Jankélévitch, *Le je-ne-sais-quoi et le presque-rien* (Paris: Seuil, 1981).
10. C. Pasqualino, *Bastian et Lorie. Notes sur le chant et la danse flamencos,* film (Paris: CNRS, 20', 2009). Film selected for the Festival Jean Rouch, in the section "Narrativités singulières" (Singular Narratives), Le Cube, Paris, November 14, 2011.

SKYLARKS: AN EXPLORATION OF A COLLABORATION BETWEEN ART, ANTHROPOLOGY, AND SCIENCE

Rupert Cox and Angus Carlyle

The project we describe below is a collaboration between art, anthropology, and science. It provides an insight into the ways that decisions and outcomes emerge as responses to challenges and opportunities inherent in the materials and therefore evolve in the process of making art work. This has critical consequences for the way that the value of such projects may be read as research. Rather than research value being a tracking back or deconstruction of processes into a trajectory defined by disciplinary norms and standards, the example of this project suggests the necessity of acknowledging the productivity of thinking forward, through the making of things into a variety of outcomes that may not cohere simply or singularly around familiar disciplinary narratives or conventions of written academic assessment.

Our project, titled Air Pressure, was conceived and supported through the art-science framework of the United Kingdom's largest independent medical research organization, the Wellcome Trust, and directed toward the public understanding of scientific questions about the relationship of noise and human health. The primary members of the project were anthropologist Rupert Cox, sound artist Angus Carlyle, acoustic scientists Kozo Hiramatsu and Toshihito Matsui, and project manager Naoki Hayashi. Working together we used acoustic data, sound recordings, on-site, and archive film to represent the sonic experiences of a family living and working on a small organic farm located at the end of one of the main runways of Narita airport, Japan. The site is well known in Japan as part of the neighborhood community of Sanrizuka—starting in 1971, Japanese national and commercial interests in the construction and operation of the Narita international airport were repeatedly opposed by this community's inhabitants. Today only two farms remain. One of these is the farm where we worked, belonging to the Shimamura family and part of the small district of the Toho shrine. The farm almost directly abuts runway B, is surrounded by a steel-and-reinforced-glass wall around which planes constantly taxi on their way to the terminal building, is observed by security guards in a watchtower, and is accessible to the outside world only by specially constructed road tunnels. The airspace

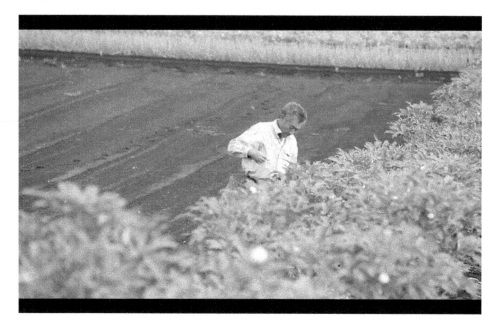

Figure 17.1 Rupert Cox/Angus Carlyle, Air Pressure, 2012, video still.

around the farm and airport is constantly monitored by surveillance and sound measuring mechanisms located at approximately 104 different locations around the airport. This mass of acoustic data is subjected to a formula of calculation, Weighted, Equivalent, Continuous, Perceived, Noise, Level (WECPNL), so as to show the effect of noise on human health. The work of Professor Hiramatsu at various Japanese airports has contested the basis and overreliance on this formula in Japan, reflecting a wider debate about the physical and psychological dimensions of aircraft noise impact. His argument, which was the foundation of our project and collaboration, is that the physical effects of exposure to noise are not a straightforward function of sound-measuring techniques. His work has showed that aircraft sound is heard by those who live in its audible domain as part of a complex, changing, and historically deep acoustic ecology. It is through these soundscapes that personal and communal perceptions are formed, with consequences for health and habitus. Hiramatsu's approach to aircraft sound was uniquely informed by an anthropological commitment to site-specificity and embedded fieldwork and to creative expositions of the results so as to engage a broad public.

We conceived of the project in terms of three sorts of material, all of which would be recorded on the site. The first, comprising for the most part sound recordings, would show the inner life and physical structure of aircraft sound. The second type of material would be mostly film and photographs, shot using a high-definition, still camera that would provide detail, color, and scale to the sounds as they resonated in the exterior world of the farm and the airport. The third type of material

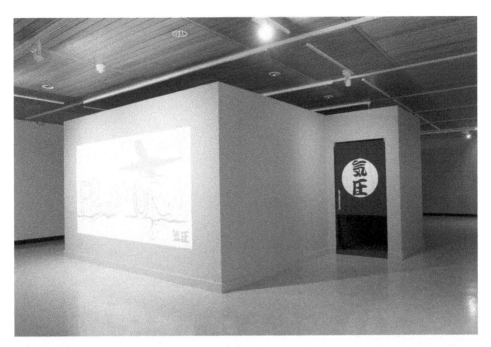

Figure 17.2 Rupert Cox/Angus Carlyle, Air Pressure, 2012, view of installation at Whitworth gallery.

was archive film, which we projected onto spaces of the site and then filmed. This was archive footage of the history of the protests at this site in the 1970s that were part of the famous series of Sanrizuka documentary films, made by the Japanese director Ogawa Shinsuke.

It was with these purposes that in the autumn of 2010 we arrived in Narita on the Shimamura farm to spend two weeks living in the building they called the egg house. The ground floor of the egg house is in a sense the working heart of the farm. It is where the various vegetables and animal products, essentially pork and eggs, are gathered from the fields to be prepared, weighed, and packed before being loaded onto delivery vehicles. As we walked around the farm, we could hear many different audible events that marked out the complex relations between the airport's activities and the farm's various human inhabitants—the land beneath their feet, the wind and weather, the other life forms, animals, and plants that shared that air and earth.

This juxtaposition was the source of the many difficulties we encountered recording on the farm, which were both ironic and tragic. For as we tried to record the more intimate sounds, we were often defeated by the racket of the airport, characterized by the regular overflights of landing aircraft and then the taxiing sounds of the planes passing on their way to the terminal building. Periodically drowned out by these sounds were sounds like the *tabi* shoes pressed into the soft brown earth,

Figure 17.3 Rupert Cox/Angus Carlyle, Air Pressure, 2012, video still.

the green squeak of onion stalks as they were gathered in armfuls before being planted, the snipping of secateurs, the crisp rustle of broccoli leaves laden with last night's rain, the raucous report of the tractor as its motor coughed into its first combustion cycle, the wheelbarrow's bright aluminum trundle. All of this was almost all of the time threatened by a horrible stew of whines, drones, and surges. There was no detail. Things were smudged and rubbed and muddled in a mess of idling engines and taxiing engines heard through the transparent, reinforced screen and metal grid, over the concrete blast walls.

One of the ways that we ultimately dealt with the difficulty of capturing clean recordings of the site was to layer many sounds on top of one another, trying carefully to change the volume levels so that each of the tracks could deliver the impression of something natural and whole rather than something fragmented and artificially treated. This thought was that an audience listening in an installation or to a CD should appreciate the human scale of what they were encountering. What we mean by this is that the volume of the smaller sounds—like the snipping of secateurs, the bright blast of bird song, the springing weighing scales, rain dappling the polytunnels—these should all evoke a scale or ratio that convincingly approximates the daily register of heard experience. By doing this, the other less usual sounds could become plausibly part of the represented life of the farmers and the farm.

From the start of the project, we knew that however we were going to present our recordings, it would involve relatively short duration media—seventy minutes on a CD, ten minutes for a sound film, nine minutes thirty-four seconds for the looped film gallery installation and even shorter durations for the tracks on the various CDs. This meant that we could never fully represent the interminable regularity of this overflight experience. Neither could we record as seconds, minutes, and hours the sense of time as an unsettling mixture of duration and rupture that these overflights imposed on the farming life.

Acting against the singular coming and going of regular overflights was the horrible stew of the taxiing sounds that started just after dawn and continued well into the night. There were times when we thought perhaps all we should present was this taxiing noise—because in a sense that was the predominant signature sound of the site. But this wouldn't work as a solution either because as well as the contrast between the overflight and the taxiing racket, there was also the contrast between the airport and the farm, living out its organic ambitions, and the audible marks of the flora and the fauna that share the soil.

These difficulties of recording so as to distinguish the relationships of these different sounds of the farm and the airport led us away from the commitment to only use sounds that we had recorded on the farm and to a series of critical creative decisions.

One decision was to leave the farm to source other kinds of material. Based on what Hayashi-san, our project manager, had told us and what we had seen in the Sanrizuka Imperial Ranch museum in Sanrizuka and in the natural history museum in Chiba prefecture, we located an area of woodland, tall cedars, and short scrub that might well have been similar to that area of land that the community of the Toho shrine originally came to settle in after it moved from the Tokyo bay area in 1945. We twice visited this area some twenty kilometers from Toho and made a series of recordings that we subsequently used in the various outcomes of the project.

Another decision emerged when the farmers told us of their sense that in the construction and expansion of the airport there has been a concomitant extension of noise and light into surrounding time and space. This has exerted a significant effect on animal, bird, and insect life. During our conversation we understood that Shimamura-san was telling us how the skylark (*ibari*) had been driven out through its habitat depletion.

This understanding guided us in making our first sound-film for the Royal Anthropological Institute (RAI) ethnographic film festival in 2011. Angus used a recording of a skylark that he had recorded in the South Downs near his home in Brighton, editing it into the sound mix of a film sequence[1] where we see Shimamura-san working in the fields. When we retuned to Toho in the spring, we realized what a terrible mistake we had made, for the previous absence of skylarks had merely been because of the season. We realized that the sky was full of skylarks spiraling into rising song.

A third decision took us even further away from the reality of the site. Angus found a recording of conversations between the air-traffic control tower at Narita and various planes flying overhead and landing on runway B that he had come across by joining an Internet forum dedicated to aircraft recording. This recording seemed to open a door to understanding something else about the way that repeated overflights effected the people living on the farm in Toho. Listening to the burst of static and the squelching sound of the conversation passing from one pilot to one controller, you got a sense not only of the regularity of these flights but also the wider movement of the aircraft in time and space. You could hear information being relayed that suggested a whole topography of managed space stretching up right from the farm into the sky above and across time zones into the places where the planes were coming from.

These three kinds of sound recordings changed the documentary scope of the project but were initiated and guided by the frustrations of our attempts to make sense of the sheer messiness of the sounds on the site. Counterintuitively they helped to draw us further into the sonic world of the site by building relationships with sounds that may not have been audible on the site but were nonetheless present in the lives of its inhabitants. This realization was both a creative choice and a scientific finding. The work of Hiramatsu at airports around Japan and of Matsui at Narita had shown that the most pronounced health effects of aircraft noise were conditions resulting from sleeplessness—that is, during the night when flights were suspended and aircraft noise was not audible on the farm. The latent presence of the noises from the airport in the farmer's bodies could be represented through scientific data as numbers and graphs except that as this was only one family it would be statistically irrelevant. Knowing this, we had considered using data generated by our own presence on the farm. This was data recorded by Professor Matsui, using sleep scan devices. We slept with these under our futon bed rolls, and each night they recorded the movements of our bodies and gave an impression of the kind of sleep that we had. Indeed, one of the first questions we asked Matsui in the morning when we were all living upstairs in the egg house was, "Did I sleep well?" "Did the data say that I slept well?" He might well tell us that we had an appalling night's sleep, but we might actually feel quite refreshed.

It was these personal experiences that led us to disregard a process open to us called sonification. This is a process where you take numerical data and turn it into sound, and while it would have extended our practice of recording sounds not audibly present on the site, the measuredly rhythmic and self-conscious aspects of this sleep data did not help to reveal the relational sense of the sounds on the site as other off-site recordings were doing.

A lot of the recordings we made were not usable, of course, because they were badly recorded or because they were not particularly distinct from something we had already recorded. Part of the disparity between the amount of resources we had available in terms of recordings and the ones we actually used is a result of two competing imperatives. The first was presented to us through the response

Figure 17.4 Rupert Cox/Angus Carlyle, Air Pressure, 2012, video still.

of the Shimamuras to our first film, which, being without dialogue or text of any kind, they regarded as without context. We were aware of this issue, for the current situation and background story to this farm were an enormously complex set of political, economic, technological, and ecological issues that had been addressed in books, film, and photographs over a period of more than forty years. This made any attempt at representation such as ours fraught with the risk of being submerged by the weight of competing interpretations. Context was necessary, but the question was how to avoid making our recorded sounds line up neatly as a corollary of these outside forces. We wanted to somehow preserve the messiness of the sounds at the site but make them sensible through the addition of outside recordings and of images. This was a different way of thinking about contextualization and gave reign to the second issue, which was mentioned above, about what to do with the disparity between the sheer number of recordings and the ones we would actually end up using. It allowed us to disperse the different sound recordings, visual material, and forms of writing across a number of outcomes—two sound-films,[2] an audio track in *The Wire* magazine,[3] a gallery installation, a CD and art book,[4] and an edited book[5]—that could stand by themselves but also act in conjunction with each other.

The installation was the central focal mechanism in guiding our decisions about how to deploy our different materials. It facilitated a process of critical thinking about how the spatial dimensions and physical composition of the box we constructed created a context for interpretation in a different but complementary way to the gallery pamphlet and wall text panels we had created. The choice to use a twin-screen projection and a 5.1 surround sound mix gave us the capacity to work together with the gallery technician so as to make the subtle shifts in volume

and transitions across different scenes and sounds as meaningful as the editing of the interview we transcribed in the pamphlet. Working in this way also meant relinquishing control of interpretation to the audience and hopefully finding in their differing reactions something of the sonic confusion and misapprehension that we had found as listening subjects on the farm in Toho and not a disavowal of the project. We established another kind of control over this material in the art book and CD that we produced where we combined different kinds of texts—philosophical reflection, a diary, an interview, audio track descriptions—with different images taken by ourselves and from official science sources and with the various tracks on the accompanying CD. With the CD and track listing, we were able to be more deliberate in guiding the audience by devoting specific tracks to different aspects of these contrasting sound signals and then putting them together within the book to create a particular kind of academic narrative. This was different from the way that we used the sound material in the first sound film and in the twin-screen film from the installation where we blended the sound material within a finite time line, breaking up each visual scene with a section of black screen so as to give precedence to the soundtracks.

Working in the ways described above meant that making academic sense of the project as research became part of processes of thinking back and of projecting forward through the material. That is to say, on the one hand tracking and assessing the various decisions taken in producing the material was a way of linking the project to methods of art-making, anthropology, and acoustic science. On the other hand, tied to these decisions were the varied and ongoing reactions to the different manifestations of the sonic, visual, and textual material that were part of a dynamic and somewhat uncertain process of public engagement.

Notes

1. This film, titled *Air Pressure: Narita Airport 1971–2010*, can be viewed online at http://vimeo.com/30538389.
2. *Air Pressure: Narita Airport 1973–2010* (2011) and *Ki-atsu: The Sound of the Sky Being Torn* (2012).
3. "Two Farms in Toho" and "The Wire Tapper 26," audio CD, *The Wire* 330 (2011).
4. A. Carlyle and R. Cox, *Air Pressure*, with audio CD (Frankfurt: Gruenrekorder, 2012).
5. A. Carlyle and R. Cox, *Risky Engagements: Encounters between Science, Art and Public Health* (Plauen: Flatlab, 2013).

INDEX